BEGINNER'S GUIDE TO
SCULPTING CHARACTERS
IN CLAY

3dtotalPublishing

Correspondence: publishing@3dtotal.com
Website: www.3dtotal.com

First published in the United Kingdom, 2017,
by 3dtotal Publishing.
3dtotal.com Ltd, 29 Foregate Street,
Worcester, WR1 1DS, United Kingdom.

Soft cover ISBN: 978-1-909414-40-2
Printing and binding: Everbest Printing (China)
www.everbest.com

Visit **www.3dtotalpublishing.com** for a
complete list of available book titles.

Editor: Annie Moss
Proofreader: Melanie Smith
Lead designer: Imogen Williams
Cover designer: Matthew Lewis
Managing editor: Simon Morse

CONTENTS

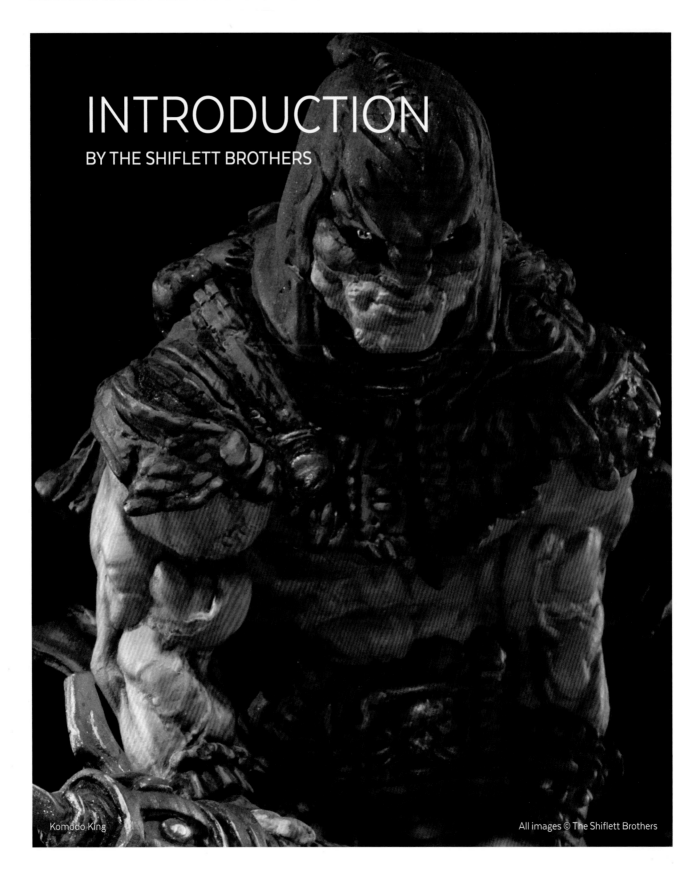

INTRODUCTION
BY THE SHIFLETT BROTHERS

Komodo King

All images © The Shiflett Brothers

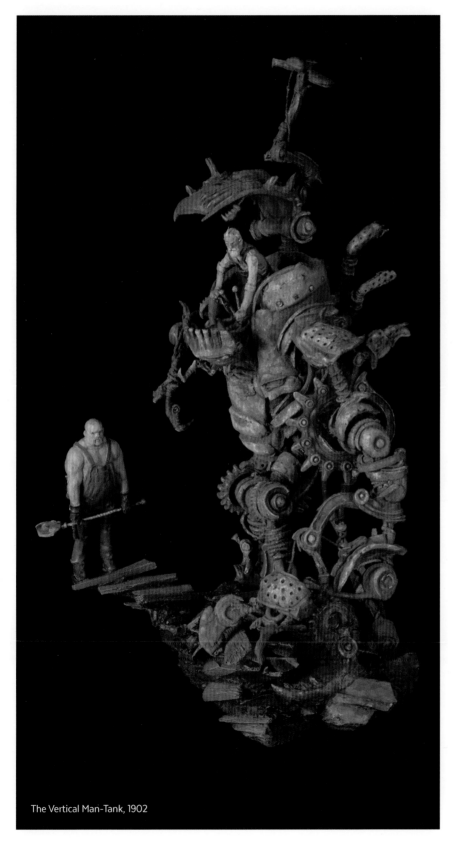

The Vertical Man-Tank, 1902

"THE TACTILE FEELING OF HANDS ON CLAY CANNOT BE DUPLICATED. IT IS A VISCERAL EXPERIENCE; IT IS A FORM OF ART THAT HAS ENDURED FOR ALMOST FORTY THOUSAND YEARS"

We consider ourselves to be storytellers. But unlike most storytellers, we tell our stories through the medium of clay sculpture. Our passion for clay sculpting began over twenty years ago when we were motivated to bring our favorite comic book and fantasy characters to life in three dimensions. The collectible statue market of comic book, movie, and video game characters did not really exist back then, so we began our sculpting careers just in time to ride the wave of the explosion of that industry. All this time later, telling stories through the medium of clay sculpting is still as exciting, relevant, and adventurous for us as it has ever been.

We love clay so much that we have never even drawn 2D pose sketches for the companies that hire us. Instead, we prefer to sculpt a super-fast, overnight "sculptural sketch" to let them see the basic pose and general idea in three dimensions, just as the final product will be. We believe this is a better way for us to convey the story we are trying to tell them. We have worked in the aforementioned statue industry, the toy industry, the video game and film design industries, and have created a line of original concept pieces, all the while remaining traditional sculptors. We have seen many of these industries veer in the direction of digital sculpting, and while we greatly

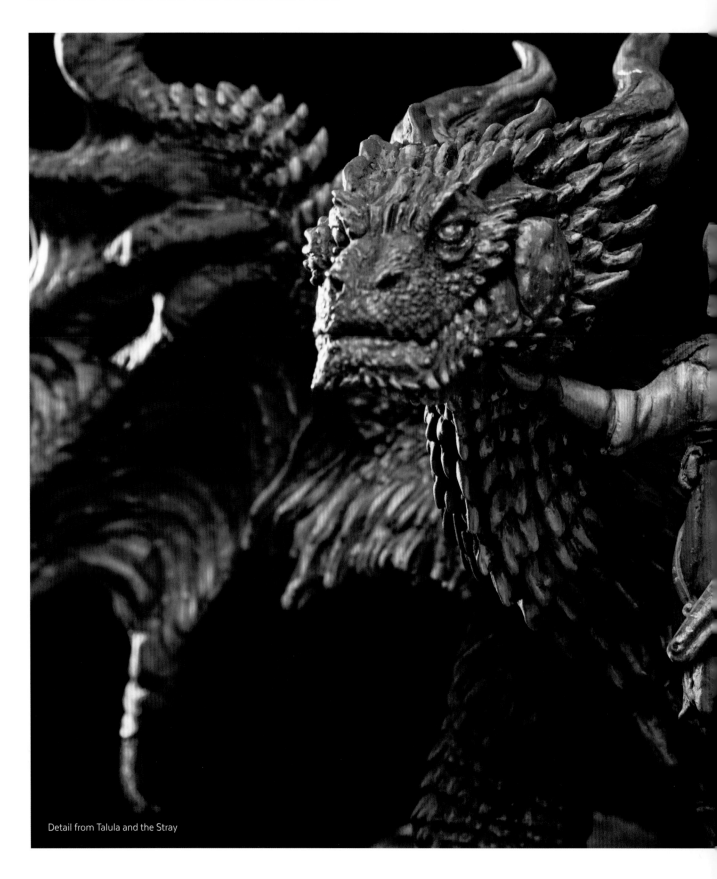

Detail from Talula and the Stray

respect the amazing digital work produced and the practitioners of this vibrant new form of art, for us, the tactile feeling of hands on clay cannot be duplicated. It is a visceral experience; it is a form of art that has endured for almost forty thousand years.

If your goal is to become a good sculptor, either digital or traditional, we believe that you should start by learning the basics in clay first, recognizing the importance of the relationship of shapes and forms in real space and the effects of gravity and weight on clay figures. Our digital sculpting friends agree that coming back to clay and getting their hands dirty periodically greatly improves their digital sculpting work.

While many of the old masters such as da Vinci, Michelangelo, and Bernini carved their great works out of stone, in the preparation and design phases of the work they sculpted clay models just as we do. In fact, Michelangelo's stone sculpture David, one of the most famous sculptures in history, started out life as a 12-inch clay model, the same scale we use for our sculptures. When we struggle with anatomy or detail we wonder: did the old masters struggle just like we do now? They may not have struggled like us, but it really is a comforting feeling to know that those artistic giants, so many years ago, were using clays that probably felt similar in their hands to the clays we use now, working at the same scales and employing processes not very different from the ones we use today.

As you will see, you now have a greater choice in materials and tools than ever before, from oil-based clays to water-based clays, and our favorite: polymer clays. We have always loved polymer clays and the advantages they offer by staying soft until you are ready to bake and harden the piece in a home oven (or with a heat gun) at a low temperature. Then you still have the option of doing more work on your piece, with more soft clay, re-baking the sculpture as many times as you want so that your piece can always evolve.

Chloe: Aviator for Hire

Deal with the Devil Bronze

The Dragon Crane, 1903

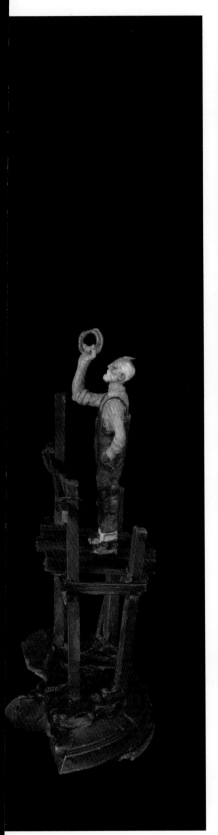

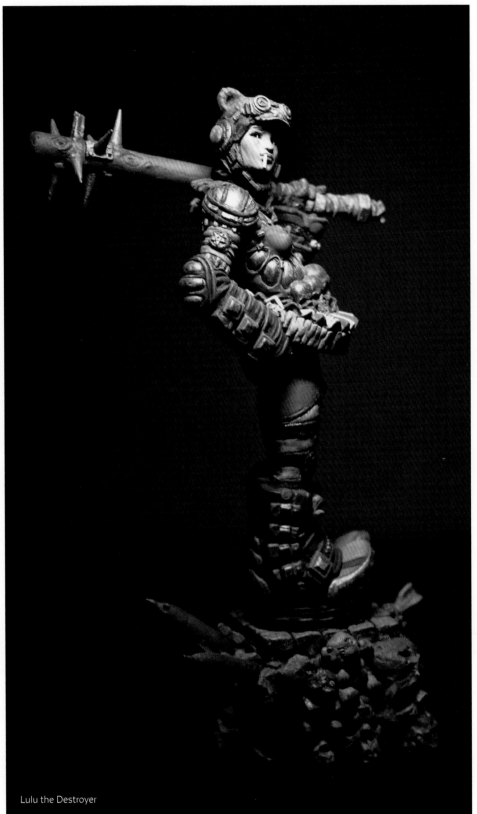

Lulu the Destroyer

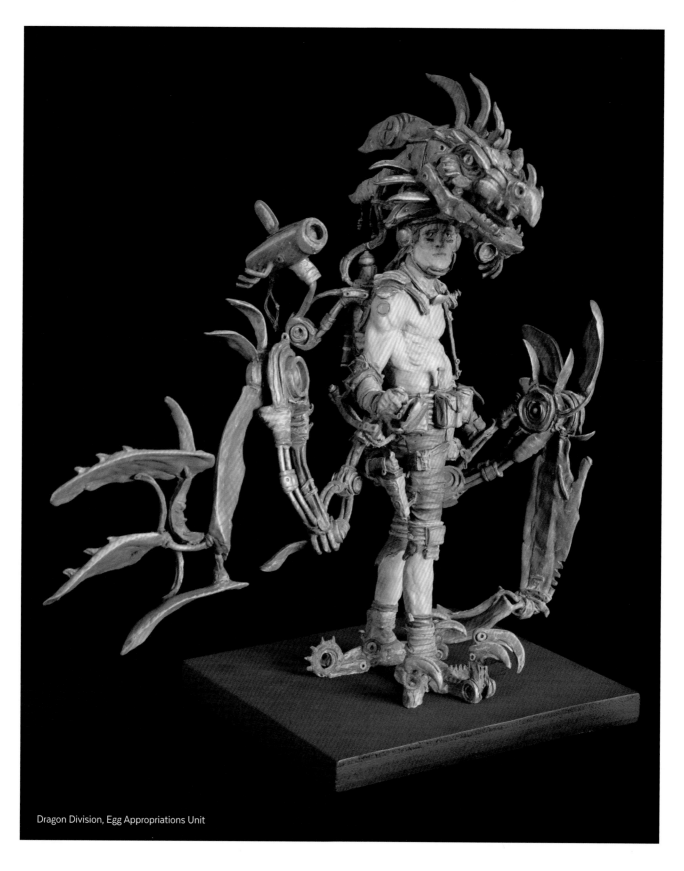

Dragon Division, Egg Appropriations Unit

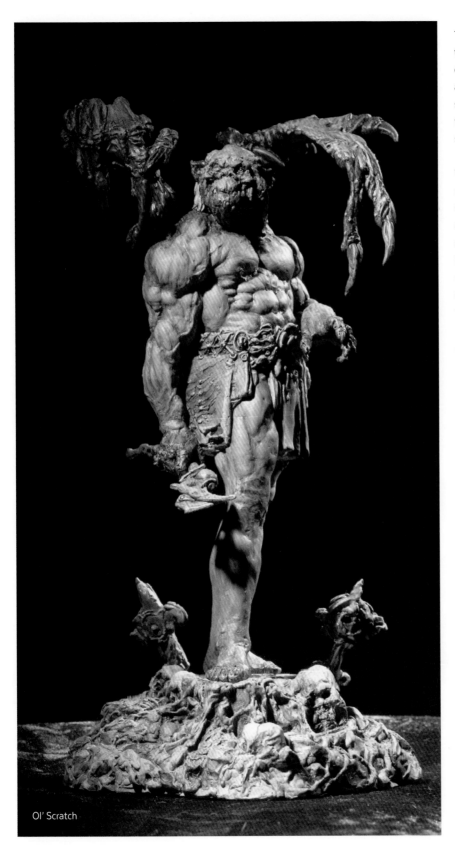

Ol' Scratch

Tools seem to come in every form imaginable these days. We use ball tools, loop tools, and even dental tools, but some of the most exciting advances in sculpting tools are made by the sculptors themselves. They create custom tools that fit their hands and their own idiosyncratic styles of working.

When you start sculpting, we advise you to not worry about achieving perfection in your sculptures. Worry more about dynamism, form, and character. Our artistic hero is actually not a sculptor, but a painter: the remarkable Frank Frazetta. What Frazetta teaches us is that great art is not necessarily created in the measuring, symmetry-seeking world of the very clean and the very precise, but can more often be found in the impassioned work of the artist seeking great composition, emotion, and evocative storytelling.

We also encourage you to check out the work of our contemporary, the legendary Japanese statue sculptor Takayuki Takeya, in addition to the groundbreaking sculptural work of concept artist Simon "Spiderzero" Lee and the work of Hollywood sculpting icons like Jordu Schell, Steve Wang, and Jose Fernandez. Even though you may not be able to sculpt like these artists yet (and neither can we!), their work will give you aspirational goals and a sense of where the cutting edge is in the art of clay sculpting in this genre.

This book will be an incredibly valuable resource for you, carrying you past so many mistakes that we made as beginners. It will guide you along the path of using the traditional art of clay sculpture to tell stories that are brand new and all your own.

We look forward to discovering what kinds of stories you will tell.

Brandon and Jarrod, The Shiflett Brothers

THE BASICS

Before any sculpting can begin it is important to ensure that you have the appropriate materials and tools for your project. It is also a good idea to gather your equipment together in a designated workspace for the duration of your project to reduce the amount of interruptions that can arise from searching for the appropriate tools, or from switching workstations.

In the following pages you will find information on the materials and tools that are commonly used in the projects of this book. You will learn how different tools

and materials are suitable for different purposes, how they can be used, cleaned, and how they can be stored to extend their usable life. This section has a handy guide to quickly making your own sculpting tools and suggests ways you can set up a functional workspace. At the end of this section you will also find some important health and safety advice which you will need to be conscious of when using these tools and materials. Once you have learned about the key sculpting apparatus and mediums and have discovered which are best suited to your needs, you will be well prepared for your first steps in sculpting!

MATERIALS

BY SEAN KYLE

ARMATURE MATERIALS

O1a The majority of sculptures you make, especially when you are starting out, will require an armature rig inside the body. Therefore the first step in sculpting is scaling your figure's skeleton in aluminum armature wire. This wire usually comes in different gauges, which indicate the wire's diameter; generally the higher the gauge number, the thinner the wire is.

O1b The larger the sculpture you are creating, the heavier the gauge of wire you should use. For more structural integrity, measure out a long length of wire (3-4 feet) and fold it end to end. Clamp the folded end into a vice, and the open ends into the chuck of a power drill. Stretch the wire as straight as possible, and then use the drill to quickly spiral your wire in order to double its gauge strength with a much more trustworthy grip.

O1c I would advise printing a static proportion diagram and marking on it the key skeletal points

that will define your armature (see pages 58-59 as an example). Once you have determined the scale of your skeleton, you can begin shaping the wire to fit. The armature wire will usually be wrapped in foil and clay, so extra traction is important to avoid your materials sliding around as you form the sculpture. For smaller statues, this can be achieved easily by wrapping a thin gauge wire tightly around the primary skeleton, giving the foil and clay something to grab onto.

O1d Once your rig is scaled, you would usually use foil to build up about half of the desired internal mass. This will mean you save money on materials and it will help you to avoid cracking when you fire your sculpture, which polymer clay would be likely to do if it were applied any thicker than around half an inch. You will find out more about armature creation in the Projects section of this book. Once you have your armature assembled you will be ready to start sculpting.

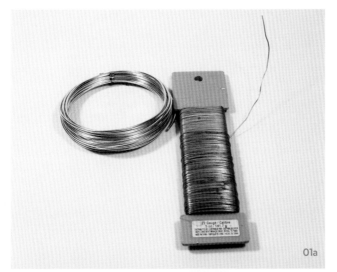

01a

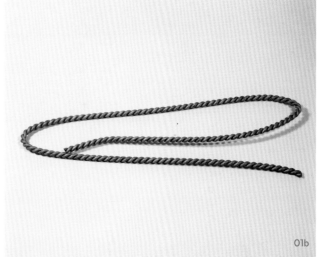

01b

01c

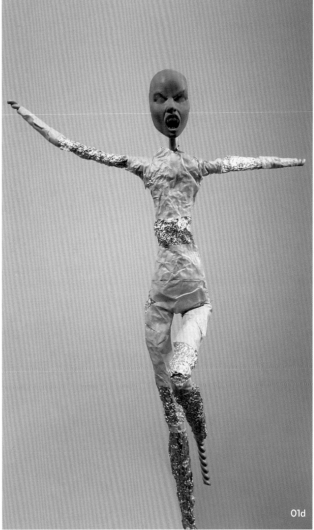

01d

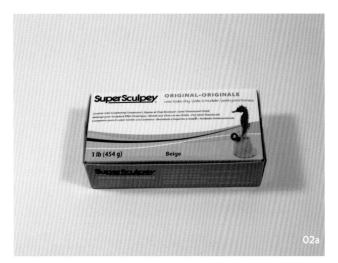

02a

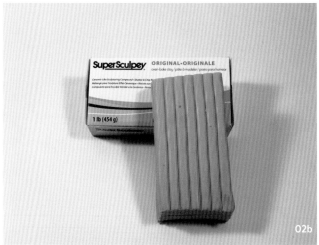

02b

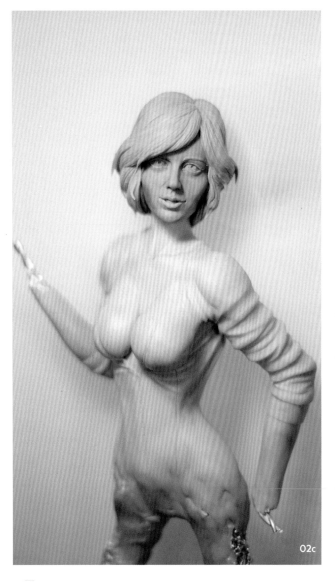

02c

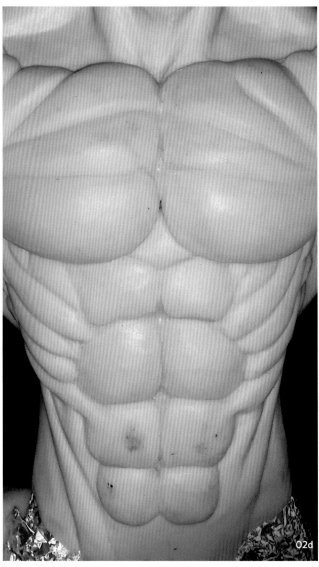

02d

POLYMER CLAY: SUPER SCULPEY ORIGINAL

O2a There are many different clays on the market, but I highly recommend Sculpey brand polymers, specifically Super Sculpey Original and Super Sculpey Firm, which are much more workable and have a longer shelf life than water-based clays or lesser polymers.

O2b Super Sculpey is incredibly soft, and can be stretched, pressed, shredded, and tooled almost infinitely with no cracking. It also has incredibly easy blending properties. Due to its extremely soft nature however, it can be difficult to capture fine details.

O2c Super Sculpey is beige colored and very slightly translucent, which makes it ideal for nude body forms. Try to keep your Super Sculpey around half an inch in thickness; use any more and you will risk cracks. You can smooth Super Sculpey to perfection with several light brush applications of 91% isopropyl alcohol (see more on page 23). Once you are happy with your nude form, you can either fire it or leave the piece soft for detail application, which gives you the option of making adjustments but will limit the amount you can handle the clay.

If you choose to fire your sculpture set the oven to no hotter than 130 degrees Celsius for no longer than thirty-five minutes. Let the sculpture cool naturally in the oven, as flash-cooling a hot figure will cause cracks throughout. If you are planning to bake your sculpture make sure you have used a non-flammable solvent during your smoothing process and take precautions against fumes that may be emitted from the solvent.

O2d Once Super Sculpey is fired and cooled, you can proceed to cut, sand, and polish your figure to whatever surface finish you desire. Be sure to clean the surface before further work to ensure you do not miss any fingerprints or sanding scars on your finish.

POLYMER CLAY: SUPER SCULPEY FIRM

O3a While similar in many respects, Super Sculpey Original and Super Sculpey Firm have very divergent properties and application. Firm has the same smoothing and firing properties as regular Super Sculpey; it is easy to oven-fire and safe to sand and polish after cooling. Both are similarly pliable and Super Sculpey Firm can also be used for nude forms, but its design and color make it more applicable to detailed work.

O3b A key first difference you will notice is color; Super Sculpey Firm is opaque gray as opposed to translucent beige. The gray hue allows for deeper evaluation when you are working under a light because the opaque gray makes value contrasts more evident, especially shadows. While I advise, at least for beginners, using Super Sculpey Original for the nude body form, I prefer using Firm for the head. Your sculpture's face is key to its success as a bad face can ruin a good body, so having that extra level of control and more trustworthy value contrast is very important.

O3c Super Sculpey Firm is also less likely to displace around your tool marks, allowing you to get beautiful, deep impressions without affecting the structure around it. Its greatest strength is in creating accessories: clothing, hair, armor, weapons, and more. The high contrast will allow you to control details much more freely, especially when applying individual lines in hair or texture to clothing. For armor and weaponry, the key benefit comes back to Super Sculpey Firm's tenacity to hold its form against tool displacement, specifically hard geometric cuts.

OIL-BASED CLAY: MONSTER CLAY

04a If you are interested in creating larger-scale projects or busts over a 1:2 scale, you will want to work with a large-scale medium. Monster clay is an oil-based, impermanent material, which will require a silicone mold if you want to cast the sculpture into resin for permanence. It is a reusable and versatile type of clay. At room temperature, Monster clay is rigid and stronger than Super Sculpey Firm. However, when kneaded by hand it will soften to a Super Sculpey-like consistency.

04b While Monster clay's default form is quite rigid (various densities are available depending on your preference and application), for either busts or large-scale sculptures an armature is still recommended. When introduced to high heat, Monster clay will fully melt into liquid, which allows for a multitude of applications that other materials do not. Monster clay can also be used in its liquid form as a casting material for making copies of a sculpture.

04c Rubber tools do not work very well on cool Monster clay, so it is best to use metal tools with this material. Once you have details in place on your sculpture, the Monster clay surface can be refined with a two-part smoothing process. First, you can use an alcohol torch to achieve pin-point heat-smoothing on your surface (see more on pages 30 and 196–199). Second, you can use a smoothing solvent such as turpentine or lighter fluid; be careful as these solvents are abrasive and can strip details away if you are not careful.

04a

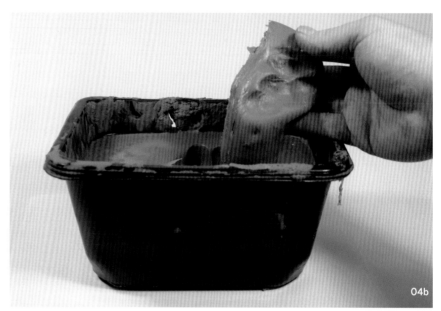

04b

04c

05a

05b

PLASTELINE: CHAVANT

05a Chavant clay is a non-drying plasteline, which is an oil-based clay. It cannot be fired. It is typically used for figure sculpting and prototyping where a high level of detail and a semi-rigid surface is preferred. Chavant comes in different densities, some as soft as Super Sculpey, which can be used interchangeably on the same figure depending on your purpose, or even mixed together.

If you are working with a softer Chavant clay, your figure will still need to be reinforced with a wire armature, but stronger grades can be built up independent of an armature. Hard Chavant is particularly useful for carving and creating rigid, geometric shapes, such as armor and weaponry, while a softer density is better served for flowing details such as hair.

05b For solvent smoothing, you will need to use turpentine or lighter fluid, as water will have no effect; isopropyl alcohol will have a limited effect and leave a chalky residue on the surface. Like Monster clay, Chavant is an impermanent material, which means it will also have to be molded and cast to secure a permanent prototype. Once molded, Chavant can be reused for sculpture and further mold-making.

TWO-PART EPOXY

O6a Magic-Sculpt and Milliput are two-part, extended-use epoxies. The ones shown in image 06a require you to mix components from two different containers, although there are other brands out there that supply the two components in a single stick (see page 177). Once the components are mixed together, they have a similar immediate consistency to Super Sculpey, but unlike Super Sculpey they are air-drying compounds. However, heat can be used to accelerate the cure time. These epoxies will allow you several hours of work time, with various consistencies throughout the duration, which can serve various purposes. The key benefit of epoxy is that when finally cured it is harder than plastic. This makes it ideal for reinforcing structural supports in your armature, as well as repairing structural damage in your prototype.

O6b The tensile strength of epoxy allows you to accomplish feats in prototyping that no other material would allow. My personal favorite use is for executing flowing forms, such as coat tails, capes, and even loose fly-away hairs that require a stronger hold once cured. For best results in this regard, allow your epoxy mixture to set for an hour or two until it has cured enough to be manipulated like a soft plastic or rubber, but is still soft enough to sculpt. This will allow you to sculpt free-flowing forms without concern for armature rigging or structural collapse.

REPAIRING CRACKS

If your sculpture cracks during firing, or even worse takes a nasty fall, epoxy can be used to fix it. Most brands are water-based, so repairing a crack is as simple as filling the damaged area in, skimming the surface with a straight-edge, and using a wet paintbrush to wipe away the excess. Once cured, the epoxy can be sanded to even out the surface. With a final application of a layer of spray-on primer, if filled and sanded well, the crack should be no more.

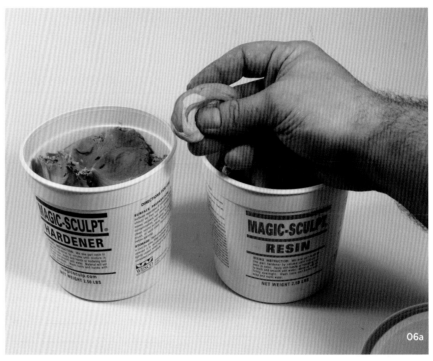

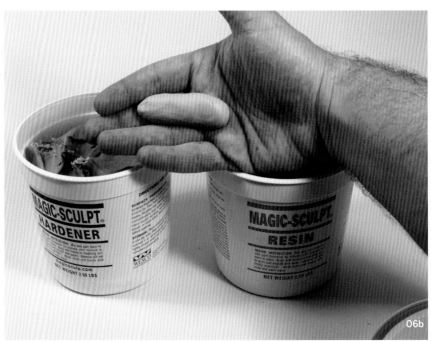

POLYMER CLAY SOLVENTS

07a Each type of clay has a solvent that suits it best for smoothing, although sometimes this will come down to the sculptor's preference. When working with Super Sculpey, or most polymers, the best and most affordable option is 91% isopropyl alcohol, also known as rubbing alcohol. Most clays have an oil base so water will not work as a solvent on them, and for polymers, neither will 70% isopropyl. 91% is strong enough to smooth away imperfections like fingerprints, tool marks, and flakes without stripping away detail from you sculpture.

07b Despite being the best option for polymer smoothing, isopropyl alcohol is still fairly abrasive and can remove detail if applied too heavily or brushed too coarsely. It will also dry out the oil base of your polymers, which can leave the surface tacky and prone to cracking and flaking. The best way to avoid this is to use multiple thin applications with a medium-to-small tip fine paintbrush. Coarse brushes, even when used carefully, can leave brushstrokes and damage the surface finish.

Try to smooth your sculpture along detail and line contours to match and accentuate the flow of your tool work. Going against the grain of the surface will not only distort your flow, but will also leave clay residue smeared and trapped in your line work. As you smooth, the clay you remove will create a watery, sometimes mushy residue; this is why it is good to apply the solvent very lightly, and keep a cup of isopropyl to the side to clean your brush after each application.

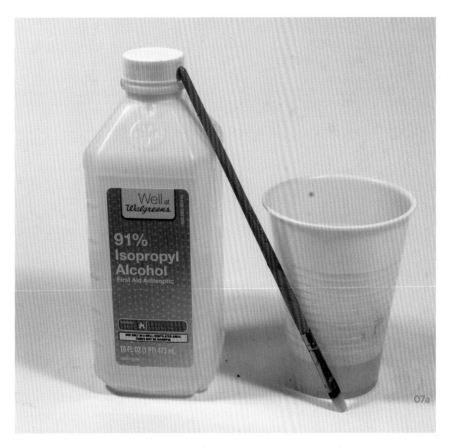

07a

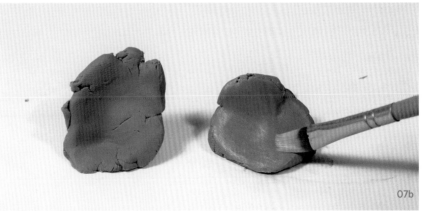

07b

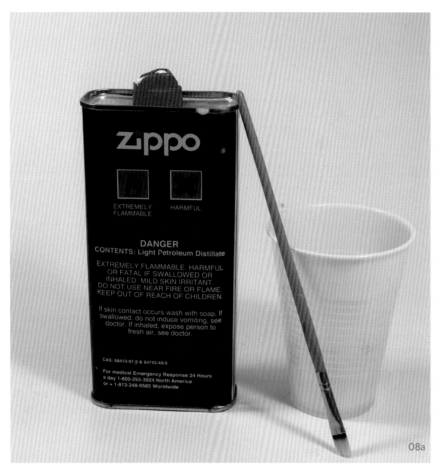

08a

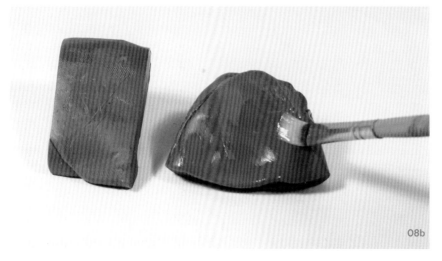

08b

OIL-BASED CLAY SOLVENTS

08a For more rigid sculpting materials, such as Chavant and Monster clay, you will need to use a stronger solvent. Isopropyl can be used as a solvent on softer materials of this variety, but typically will have weaker results, and will leave an unpleasant-looking white film on the surface. The two most typically used solvents for these mediums are turpentine (or turpenoid), and store-bought lighter fluid. Both will essentially serve the same purpose. Obviously you should keep these products away from flames; see page 39 for more safety guidance on solvents.

08b Regardless of whether you choose to use turpentine or lighter fluid, be warned that both types of solvents are incredibly abrasive. They will not only smooth away details faster than isopropyl alcohol; they will also absorb into the surface and actually dissolve details without them even being touched. This means application with light brushstrokes is absolutely necessary. Patience is also required as each application will absorb into the surface, making the outer layer of your sculpt considerably softer and more prone to distortion. It is best to apply a layer of solvent, allow it to absorb and disperse for a minute or two, and then repeat. If you are brushing out large swathes of residue, leaving heavy brushstrokes, or losing surface detail, then you are either using too much solvent or smoothing too quickly.

GLUES

09a When sculpting, from armature to finalization, you will want to keep a variety of adhesives to hand. When constructing your armature, liberal applications of superglue can be used to secure the aluminum wire bindings, as well as bonding foil and clay to the armature. Brush-on superglue is also useful when attempting to sculpt an open hand with polymer clay, as a thin brushing will allow you to add clay and detail individual fingers without constantly fighting to keep your clay on the wire.

09b For securing larger clay portions, I advise using Sculpey Liquid. This adhesive can be fired and has the consistency of PVA glue. It will stay wet and pliable until heated, and is effective for binding body mass to your armature, or adding clothing and details to a fired, smooth surface. Sculpey Liquid can even be used to ease smoothing between soft clay portions. Sculpey Liquid is best used as an adhesive by applying it lightly and then allowing the sculpture to sit for several minutes as air exposure will make the liquid stickier. Once fired, it is as sturdy as any standard adhesive.

09c For assembling various pieces of a figure together, I would advise you use either superglue or modeling glue. Modeling glue can be odorous and takes longer to set, but it is designed for this exact usage. Superglue sets nearly instantly, but can leave an unpleasant discoloration or film if applied too heavily.

09a

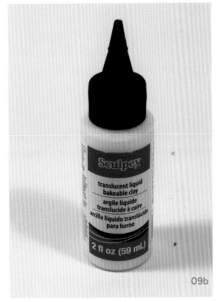

09b

09c

TOOLS

BY ALEXANDER RAY

LOOP TOOLS

01a Loop tools, or ribbon tools as they are sometimes called, come in a few different variations and the ones you choose will depend on their use and the size of sculpture you will be working on. They are small, often metal-handled tools with a loop of thin, flat metal at the end that is bent into various shapes.

There are also loop tools that are simply a handle, usually metal, with a thin piece of wire bent into a loop. In addition there are larger loop tools that are meant for larger sculptures. These tools generally have a wooden handle and either a thicker gauge wire or metal ribbon.

01b Loop tools are primarily used to remove material from your sculpture. They can also be used to scribe lines or to create wrinkles or texture. If you take a piece of thin plastic wrap or one layer of a sandwich bag and lay it over your clay, you can use the end of a loop tool to press into the plastic, leaving soft, organic lines in the clay.

Like most of the tools that will be discussed in this chapter, you can use a paper towel to wipe off any leftover material created by them. If necessary, use a solvent that corresponds to the sculpting medium you are using to clean the tool. These tools can be purchased at sculpting supply stores and most hobby or craft stores. In terms of storage, I prefer to keep these tools

in a high-walled tray, as I do with most of the tools I use.

BALL TOOLS

02a Ball tools are simply a rod protruding from a handle with various sizes of metal balls at the tip of the tool. These tools are typically made with a wooden handle and metal tips. Some come with only one tip and some have a different sized ball at each end of the tool. This can be useful because it means that you do not have to pick up a new tool for every single size of ball that you need.

02b The main use for this tool is to push clay around or stitch pieces of clay together. To move the clay around, simply move the tool over the clay almost as if it were a paintbrush to displace the clay from one place to another. Stitching clay together essentially means adding clay to your sculpture and blending the edge of one piece into the other.

02c Clay does not generally stick to these tools, but if it does you can remove any bits of clay with a paper towel, or by twisting the end of the tool into a spare piece of clay. This will grab any small bits from the tip of the tool. For storage, I like to keep all my hand-sculpting tools in a plastic tray.

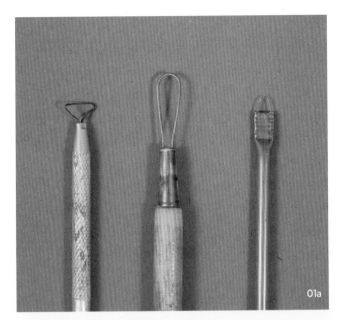

01a

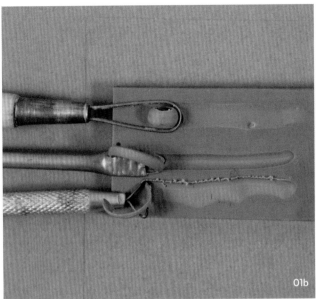

01b

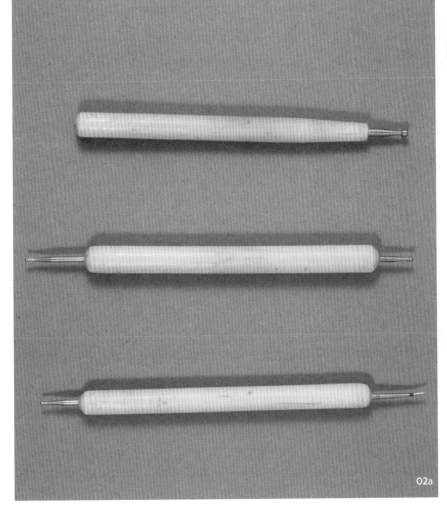

02a

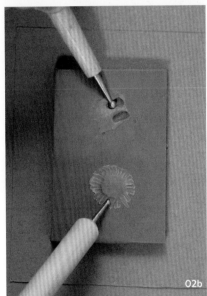

02b

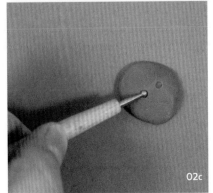

02c

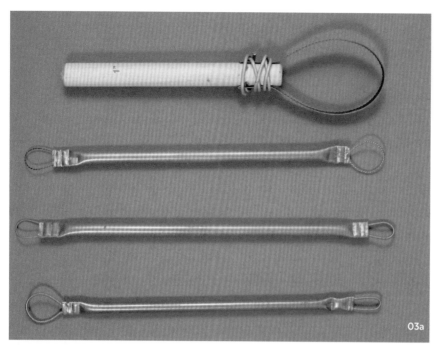

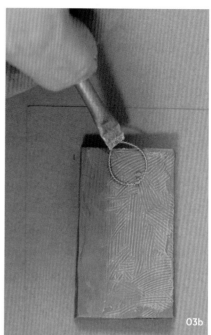

03a

03b

03c

RAKE TOOLS

03a A rake tool is any tool that has a jagged or saw-tooth-like edge that you use to literally rake over the surface of your sculpture. The primary function of this tool is to even out surfaces. These tools can be purchased online or in sculpture supply stores, or you could even make them yourself out of various materials such as guitar strings, band saw blades, or by wrapping wire around a loop tool to give the tool a tooth-like edge.

03b When you pull this tool over the surface of your clay, it displaces material from the high points of the surface and deposits it in the low points. At first glance, it appears as if you are scratching up the surface of your sculpture, but this is a necessary step in smoothing out the surface of the clay. There are many different types and sizes of rakes, and in order for your sculpture to benefit from this technique you will need to use progressively finer toothed rakes. You can then completely smooth the surface with a solvent and a brush, or use an alcohol torch (see next page) to remove any remaining tool marks.

03c This tool can be cleaned by heating it with a lighter and brushing it through a chip brush, which will pull off the molten clay, or you can take a spare piece of clay and press it into the surface which will cause any bits of clay on the tool to stick to the larger piece of clay. For storage, I again keep my rakes, along with most of my other tools, in a tray.

HOBBY KNIVES
AND BLADES

04a Hobby knives are some of the most versatile tools a sculptor can have and can be found at any hobby store and most hardware stores. These knives are metal-handled tools that have a chuck at the end. When loosened the chuck can allow you to remove and add several different types of blades. The two most useful blades that I use regularly are a straight blade and a curved blade. There are many different types of hobby knife blades, and each type often has a number associated with it. Generally the straight blade I use is #11 and the curved blade is #10. There may be some difference in shape depending on brand.

04b Hobby knives can be used to scribe lines, cut larger pieces of clay into smaller, more manageable pieces, cut precise angles, and can even be used as spatulas to apply clay to the surface of your sculpture. To clean them, use a cloth to wipe off any material that may be on the blades, but be very careful not to cut yourself.

04c Hobby knives are the most versatile but also the most dangerous of the tools on this list. Always be aware of how you are using the tool, being careful not to put your fingers in the way of the blade. The knives often come with plastic guards that fit over the tip, so always be sure to replace the guard after use. It is also a good idea to keep them blade-end down in a container so that you do not accidentally poke or cut your finger if you reach for the tool.

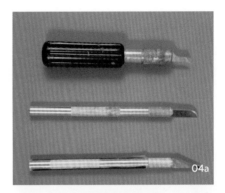
04a

04b

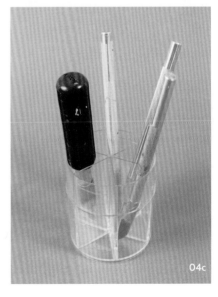
04c

KIDNEY SHAPES AND SCRAPERS

05a Kidney shapes, also known as finishing rubbers, are used to smooth out the surface of your sculpture. Kidney shapes are called as such because they are shaped like a kidney and are made out of a flexible rubber material. They are constructed in this way so that you can bend and curve them to fit the contour of the surface you are smoothing.

05b Holding the tool in your hand with four fingers on top and your thumb below, you can bend the tool to the desired shape and still have full control over the effect it has on your sculpture. Scrapers are similar to kidney shapes and finishing rubbers, but they are made of a very thin, flexible metal. Although scrapers can be used to achieve the same effect as kidney shapes they can also help to achieve much cleaner, angular surfaces, or be used as a rake if the scraper has a serrated tooth edge. Kidney shapes and scrapers can be wiped down with a cloth and solvent to keep them clean, and stored in a tray so that they are not bent or distorted. You can find these tools in most hobby and art supply stores.

NEEDLE TOOLS

06a Needle tools are exactly what they sound like; they are a handle (either metal or wood) with a needle protruding from one or both ends. I prefer to have a wooden-handled needle tool that has two different thicknesses of needle on either side.

06b These tools can be used to create lines in your sculpture, texture surfaces, or define objects that require a lot of detail. Needle tools are probably second in line, after hobby knives, as the most dangerous of the sculpting tools in this chapter. It is very easy to accidentally poke yourself with the end of this tool if you are not paying attention. I prefer to have two different thicknesses of needle on either side of one tool so that I do not have to switch between tools, but it is good to have a needle extending from only one side of the tool so that you can store it facing down in order to reduce the chance of injury.

06c To clean this tool, you can take a scrap piece of upholstery foam if you have some available and stab the tool into the foam to remove any bits of clay. Alternatively you can simply wipe the tool with a cloth or paper towel. Keep needle tools stored pointed-tip down in a cup or jar.

ALCOHOL TORCHES AND HEAT GUNS

07a If you are using oil-based clay to sculpt you can apply heat to your sculpture to achieve various effects. Alcohol torches and heat guns are great examples of the types of tools you can use for this. There are different types of alcohol torches, and the one shown in image 07a is a plastic bottle with a fabric wick and thin copper tube coming out of the top of the bottle. These can commonly be acquired online.

07b Alcohol torches are great for precision heating to slowly remove tool marks from a sculpture. To use the alcohol torch remove the cap and pull the wick from the bottom until only about 1/4 of an inch is exposed at the top. Fill the bottle about half way with denatured alcohol and replace the cap, allowing the wick to absorb the denatured alcohol. Once the wick is saturated, use a lighter or match to light the wick. The flame should only be about an inch high at most. If it is higher than this, extinguish the flame, remove the cap, and lower the wick. You can use the torch by lightly squeezing the bottle, which will create a concentrated flame coming from the copper tube.

To store, extinguish the flame, wait for the copper tube to cool, and replace the plastic cap. Keep the torch in a safe place away from any potential flames that could ignite the denatured alcohol inside.

07c Heat guns can accomplish the same effect, but are not as precise. They heat up clay, making it more pliable and easier to add to your sculpture. Heat guns can also be used to heat up a specific part of your sculpture which you may want to move, such as an arm or leg. By moving the heat gun over your sculpture with broad strokes you can achieve a very smooth, shiny effect if that is what your sculpture requires. Most heat guns have a switch that will allow you to select the intensity of heat coming from the gun. They can be found in any hardware store and online. To store, simply wait for the metal guard at the front of the gun to cool down, wrap up the cord tidily, and store the gun away.

In this book you will also see a number of ways to heat clay up before starting to sculpt, including using a microwave, an oven, and an electric food pan.

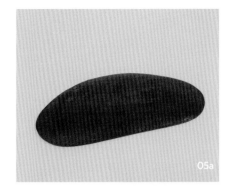
05a

05b

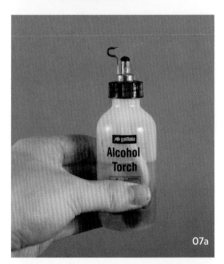
07a

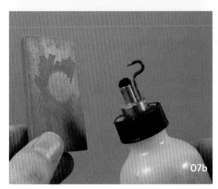
07b

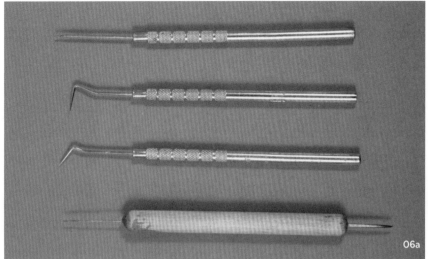
06a

06b

06c

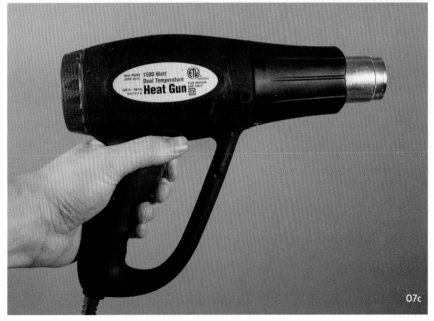
07c

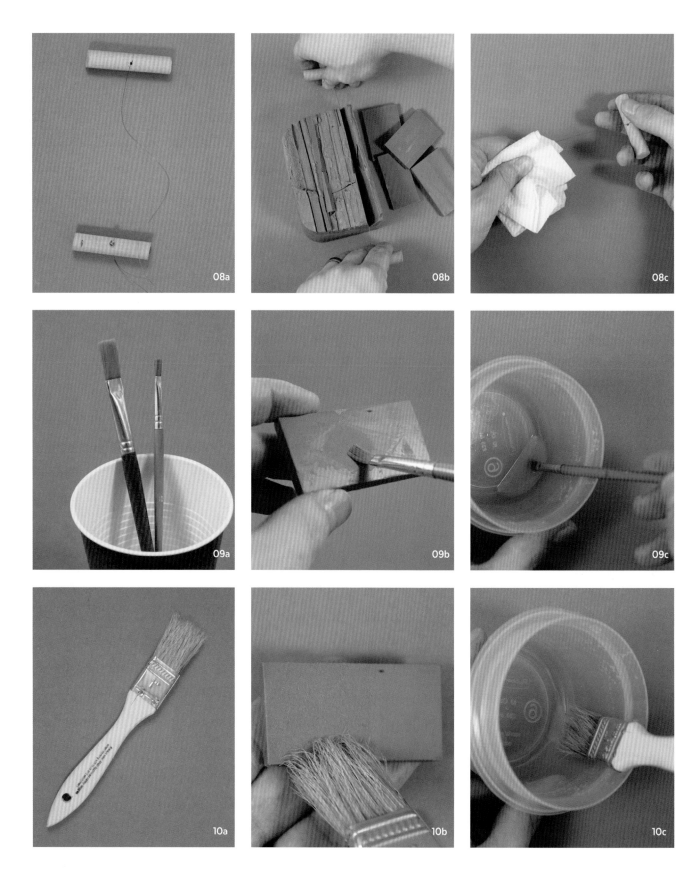

CUTTING WIRE

08a Cutting wires, or clay cutters, are tools composed of a piece of wire with a wooden dowel mounted onto either end. This tool is used to cut large pieces of clay out of larger bricks to make the clay more manageable. Cutting wires are most useful with soft oil-based or water-based clay. You may find that medium- and hard-density oil-based clays can be too hard in their room temperature state to cut through with this wire. You can find cutting wires at craft stores, ceramic supply shops, and online.

08b To use this tool, lay your brick of clay on a flat surface. Hold both wooden dowels of the cutting wire in each hand, and pull outwards to make the wire taut. Then pull down over the end of the clay brick, cutting out a slice. Now you have a much more manageable piece of clay that you can make even smaller and add to your sculpture. If you are very careful you can make clean, angular pieces of clay to use directly in your sculpture.

08c Once you have finished using the cutting wire, take a paper towel and clean off the wire to ensure that the next time you use it you will not have pieces of clay clinging to the tool. To store this tool, you can wrap it over itself and keep it in a zip-top bag so that it does not become tangled.

BRUSHES

09a Soft-bristle brushes are great tools for smoothing out clay or adding textured effects to the surface of your sculpture. These brushes come in many different sizes and can be modified to suit your particular needs. There are many different types of bristles available, but the best type for sculpting is synthetic-bristle brushes.

09b Used in combination with a solvent, you can use soft-bristle brushes to remove tool marks and blend areas that are uneven. You can also completely melt oil-based clay in a small cup of solvent to create a slurry mixture that you can apply to the surface of your sculpture in order to create texture.

09c To clean your brush, use solvent to get the bulk of the material off the brush. Wipe the bristles on a paper towel and repeat until the brush looks clean. Then use soap, ideally a dish soap, to fully clean your brush.

To keep the bristles from fraying you can coat them in a small amount of soap, but remember to wash your brush and dry it fully immediately before its next use. Store the brushes upright in a cup or jar to ensure the bristles do not become bent or damaged.

CHIP BRUSH

10a A chip brush is a brush that typically has bristles made of course hog hair. They are inexpensive and generally meant for only single use. You can use a chip brush to even out large areas of a sculpture by using the brush in conjunction with a solvent suitable for your sculpting medium.

For water-based clay, you can simply use water to brush over the sculpture to smooth out an area; you can use a solvent like lighter fluid or isopropyl alcohol to smooth out oil-based clay.

10b Chip brushes can also be used to add texture to your sculpture by tapping the end of the brush into the clay. The bristles of a chip brush can be cut down to achieve different textures, or you can take other tools like small rakes and repeatedly push them into the end of the brush to clean off your tools. Chip brushes can be found at any craft, paint, or hardware store.

10c Although these brushes are typically made for only one use, there is no reason why you could not clean off the bristles with the solvent used on your sculpture, then finish cleaning with soap and water. As with soft-bristle brushes, keep chip brushes stored upright, so you can use them many times over.

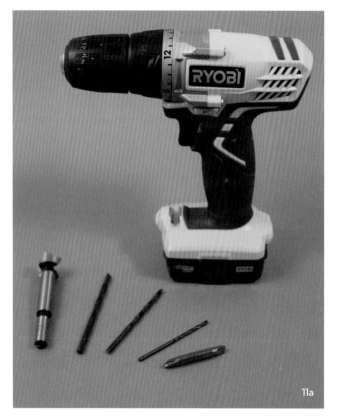

11a

11b

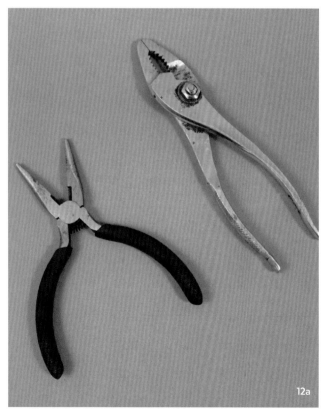

12a

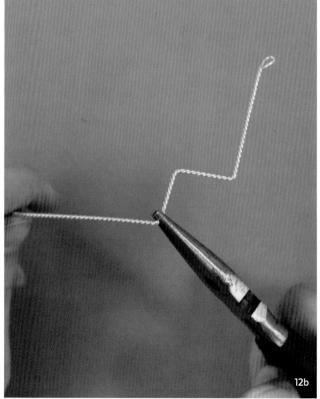

12b

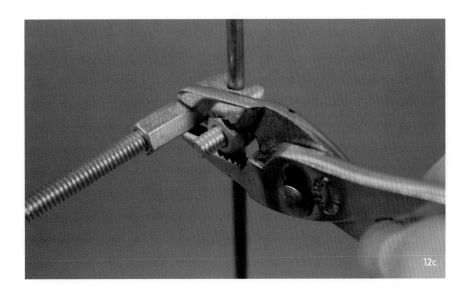

12c

DRILLS

11a Drills have many uses that range from building the structure for your sculpture to creating the armature, so it is a good idea to familiarize yourself with this tool and its parts. You will usually need a drill to create holes in your sculpture base. There are many affordable drills out there; check your local hardware store to see what they have available or, if necessary, read reviews and purchase something online. I prefer a somewhat smaller drill that cuts down on storage space and is not too heavy.

11b A figurative sculpture will require that you build an armature out of aluminum wire. Although there are a few ways to do this, I prefer to take two strands of armature wire, mount one end of each strand into the drill, and hold the other end with a pair of pliers. You can then engage the drill slowly to create a tightly spiraled strand of armature wire that the clay will grab onto nicely. This method strengthens the armature.

If your drill has a case, make sure that you store it there after each use so that dust cannot infiltrate the motor and diminish its life. It is also beneficial to have a spare battery so that if one runs out you do not need to wait for the battery to charge.

PLIERS

12a Pliers are tools that look very much like a pair of scissors. They consist of two arms that are joined together with a nut or pin. Unlike scissors, which are used for cutting, pliers are generally used for tightening and loosening nuts and bending wire. There are also various different types of pliers such as needle-nose, slip-joint, tongue-and-groove, and diagonal. For our needs in the sculpting process, the two best types of pliers are needle-nose pliers with wire cutters, and slip-joint pliers.

12b Needle-nose pliers have long extended jaws that taper to a point. This allows you to use them in tighter areas that require greater precision. The needle-nose pliers shown in image 12b also have wire cutters just before the intersection of each arm. This is very useful for cutting armature wire. Needle-nose pliers are also good tools for bending armature wire into a precise shape.

12c The other pliers that are used most often in sculpting are slip-joint pliers, so called because they have a joint that moves between the two sides of the pliers to allow the jaws to extend. These pliers are useful for tightening nuts on the armature.

If you had to choose between one of these, the needle-nose can do most tasks the slip-joint can, but having both makes your life a little easier. These can be found at any hardware store.

MAKING YOUR OWN TOOLS

13a Some of the most important tools I use are rakes. I use them more than any other type of tool, and the best part is that they can be homemade. For a fraction of the price that you might pay to purchase them, you have complete control over exactly what type of tool you want. The easiest, quickest, and most effective way to make these tools is to employ some brass tubing, old guitar strings, and the cutters on needle-nose pliers.

13b There are many sizes of tubing which can be used for making these tools, but for my needs I use 7/32-inch tubing here. The tubing usually comes in lengths from 12 inches up to 3 feet; I use a 12-inch length. Using the cutters on your pliers, crimp the tubing at about 6 inches from the end. Do not cut all the way through, just bend the tube back and forth and it will snap in half with little effort.

13c The tubing will be crimped on the end you cut, but if you take your pliers and squeeze on either side of the tubing it will open up again. Now, take a guitar string and cut a length of about 5 inches. Bend the middle of the string around the barrel of any cylindrical object such as a pen, or even another piece of brass tubing; it can be whatever size loop you would like the tool to have. I find a short wooden dowel to create a loop.

13d Once you have a smooth curve in the string, stick both ends in the end of the tubing leaving about 1/2 an inch or so exposed. Using your wire cutters again, crimp the end of the tool about three times. Turn the tubing over and crimp those same three places to ensure you have the guitar string secured inside the tubing. And that is it; you have a fully functional rake. These tools can be made so quickly that sometimes I make a specialized tool mid-sculpt.

SETTING UP YOUR WORKSPACE

14a When you are sculpting it is important to have a well-organized, clean, and comfortable workspace. The creative process is quicker when you can locate all your tools and materials with ease. A table that is situated at a comfortable height is essential so that you are not hunched while you work. I use a drafting table with an adjustable height setting. I would suggest using a table with enough space to allow ample room for all of your supplies and your sculpture. You will also need a comfortable chair as you may be sitting for extended amounts of time as you work on your sculpture.

You will also need an appropriately located light source. Your light should be located a little forward of the space above your head. This allows the sculpture to be illuminated properly, but also allows you to see the shadows and contrast in the sculpture while you work. If your room has a ceiling light that should be suitable, but if not you can purchase a tall lamp or mount a work light onto an adjustable stand.

14b A tray, jar, cup, or combination of these will keep your tools organized. I use a plastic tray for all of my tools. I have become familiar with the tools I use and can locate them quickly and easily even though they are all in the same container, but you can have separate containers for different tools so that locating each type of tool is a little faster. If you are using water-based clay, you will need a plastic bag to keep it in while you work so that the clay does not dry out.

Finally, it is a good idea to leave enough space in your work area for a laptop to display reference photographs. If you do not have a portable computer, make sure your table is situated against a wall so that you can print out photographs and pin them to the wall.

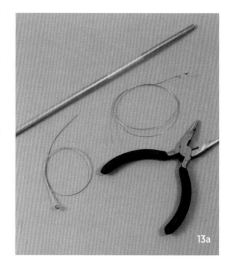

13a

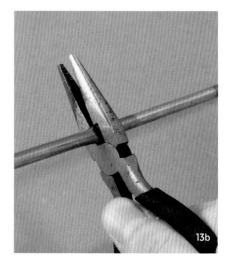

13b

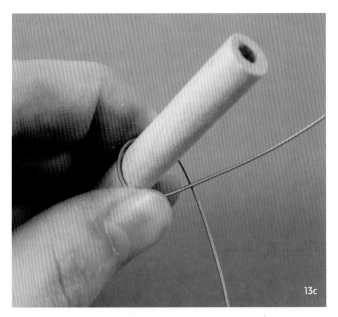

13c

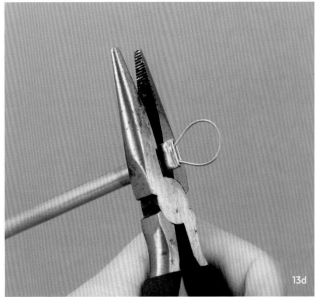

13d

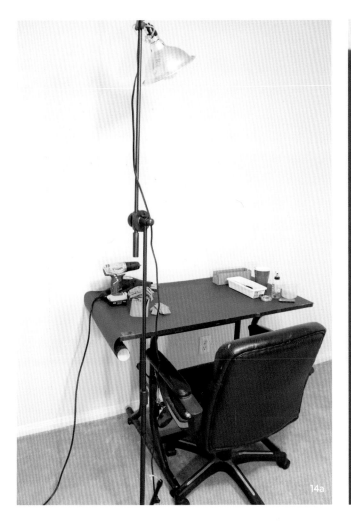

14a

14b

HEALTH AND SAFETY

In this chapter we have provided some basic health and safety information for the materials and tools you will encounter in this book; however, this is by no means exhaustive and before you use a material or tool for the first time you should always check the manufacturer's safety instructions and data sheets to ensure you are taking full precautions when needed.

Below, each type of scenario is marked with a symbol; as you read through the project section of the book you will see these symbols included at the end of relevant steps to act as a reminder for you to consider the necessary safety precautions as you work.

As general advice, it is a good idea to keep your workspace tidy and free from clutter to avoid knocking hazardous items over. Materials should not be ingested so keep products away from food or drink, and always keep your sculpting materials and tools out of reach of children.

SHARP OBJECTS

KNIVES, HOBBY KNIVES, AND CUTTING WIRE

All knives and blades should be used with caution. Make sure that your fingers are positioned away from the blades and always work in a motion that moves the knife away from your body. When changing blades in hobby knives, hold the blades by their flat sides. Ensure that knives and blades are stored away safely in a drawer when not in use.

Similarly, when using cutting wire ensure that you hold the wooden handles in order to avoid cutting yourself. Do not apply pressure to the cutting wire with your hands and never use a cutting wire that is broken, frayed, or at risk of snapping when in use.

WIRE CUTTERS AND PLIERS

Make sure your fingers are positioned away from blades when using wire cutters and pliers. Before closing pliers, make sure that your fingers will not be trapped between the plates. Do not leave pliers or wire cutters lying open and always store the tool safely away in a drawer when not in use.

EXPOSED WIRE

When creating armatures and your own tools you will be manipulating and cutting aluminum, steel, and copper wire. Once cut the ends may be sharp so be aware of protruding wires that may catch your skin or clothing.

HEATING CLAY

HEAT GUNS, ALCOHOL TORCHES, AND LIGHTERS

Alcohol torches and heat guns, if not used carefully, can cause burns or fires. Always follow the safety instructions of the tool's manufacturer. Do not use these tools near flammable materials or sprays. Protective gloves should be worn for any heat gun or torch that is used for an extended period of time and may be hot to hold. Allow the tool to cool before safely storing it when not in use. The same safety precautions should be followed with smaller tools such as lighters. You should also make sure the area you are working in is well-ventilated in case of fumes.

MICROWAVES, OVENS, AND HOT CLAY

Not all clays are suitable for heating or firing so always check the material's packaging and data sheets before attempting to heat. Make sure you know what temperature your material should or should not be heated to by reading the manufacturer's guidelines, as some clays when heated at high temperatures will give off fumes that can be harmful. If the material does emit fumes, make sure you heat the material in a well-ventilated area and, if necessary, wear a protective mask.

Whether you use a heat gun, alcohol torch, lighter, microwave, oven, or any other means to heat clay, always make sure you do not burn yourself with the hot material, particularly if the clay becomes molten. If the material is too hot to touch, allow it to cool slightly and wear heat-protective gloves to protect your skin.

POWER TOOLS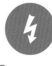

DRILLS AND ROTARY TOOLS

When it comes to drills and rotary tools, follow the safe-use instructions provided by the tool's manufacturer. If you are unsure how to use the tool appropriately, use a manual tool for the

task instead. Always make sure you keep your free hand and any clothing away from the drilling area. If you are using power tools on hard materials, protective glasses and gloves are recommended in case of loose shards of material. If the tool has a long cord ensure that this is kept tidily away from where you are working and where people may walk so that the cord is not damaged and it is not a trip hazard. When the tool is not in use it should be switched off, unplugged, or have its battery removed, and stored either in its original case or in a drawer or cupboard.

SUBSTANCES

DUST

When you are sanding or drilling clays and materials such as epoxy, you should take precautions against the dust that is produced. You should always try to protect your eyes from dust, but some materials also produce dust that can irritate the skin or are harmful if inhaled. Wear a dust mask, protective glasses or goggles, and gloves. You should also work in a well-ventilated area; you can also invest in a dust extractor.

EPOXY

Epoxy can irritate the skin so it is a good idea to wear gloves when using this substance. If your skin does come into contact with epoxy make sure you wash your hands thoroughly with soap and water. Avoid contact with eyes and do not ingest.

CLAY SOLVENTS AND GLUES

When using solvents such as turpentine make sure you keep them away from flames and avoid contact with skin and eyes. Solvents should be applied with a cloth or brush, never with your hands. Use gloves if necessary and also make sure you use solvents in a well-ventilated area to avoid inhaling the fumes. Secure the cap on the solvent's bottle when not in use to avoid spillages.

The same precautions should be followed for glues. Make sure skin and clothing is kept away from the glue when you are applying in order to avoid items becoming stuck to you. Do not inhale or ingest glues. Keep all glues and solvents stored away in a drawer, cupboard, or on a high shelf, away from direct sunlight and extreme heat.

AEROSOLS

Aerosols such as dulling spray should also be used in a well-ventilated area. Do not use aerosols with, or near, flames and do not inhale. Ensure that you use the aerosol away from your body, and particularly make sure you keep the spray away from your eyes. If in doubt, wear protective glasses and clothing, a mask, and gloves.

Do not use aerosols for continued time periods; if you need to use them a lot remember to take fresh-air breaks away from your workstation. Always store aerosols away from flames, extreme heat, and direct sunlight when not in use; a drawer, cupboard, or high shelf is again recommended.

APPROACHING ANATOMY

There are various practical aspects to consider when creating characters in three dimensions including the size, pose, and features of your figure. You will need to consider how your sculpture will balance, how weight will be distributed, whether the character's forms are proportional, and ensure that the sculpture is anatomically correct.

This section will provide you with a general introduction to the essential anatomical considerations of sculpting a three-dimensional figure and give you handy tips for improving the pose and shaping of your character. You will see how you can check the proportions of your character, create balanced posture, build and define muscle forms, and accurately place facial features.

ANATOMY FOR SCULPTING

BY DJORDJE NAGULOV

Sculpting the human body is one of the most rewarding projects an artist can undertake. Yet the seemingly fractal complexity can leave you feeling lost and frustrated. There are many interconnected parts but once you abstract and simplify the human form, it will all start to make sense. In this chapter I will not give you detailed information on individual bones and muscles, as you can find a wide range of anatomical references already out there, from books to anatomical reference figures; instead I will offer general guidance to help you approach anatomy when sculpting for the first time so that you know how to best tackle this vast subject.

01 BASIC MEASUREMENTS

Using the proportions of the head as a basic measuring tool has been a technique practiced for centuries. Most people are around seven and a half heads tall, with eight heads in height usually reserved for superhero figures. The head can also be used to rough out practically all body proportions, from the size of your hands, which are about as big as the face, to the placement of your nipples, which are roughly two heads down from the tip of the cranium.

In time, you will come to rely less on this trick as your experience grows and instinct takes over,

01

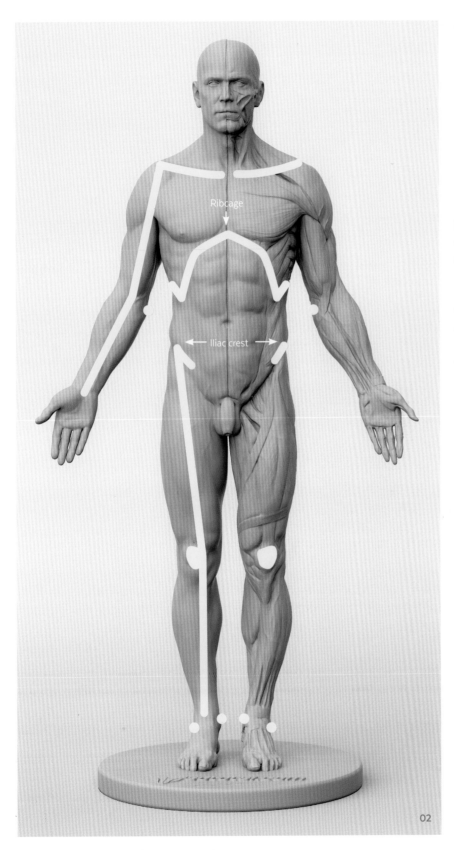

Ribcage

Iliac crest

02

but good proportions are absolutely crucial for a figure to look right. When in doubt, regardless of the pose of your sculpture, you can use this measurement technique to check a multitude of related proportions. Just to use a few examples, the shoulders are about two heads wide, arms are about the length of three heads, and the torso should be about four heads long from the tip of the cranium to the groin.

02 USE THE SKELETON AS A GUIDE

The skeleton provides a hidden road map for muscle placement on the body. Areas where the bone is close to the surface of the skin are often known as "bony landmarks" and they provide a lot of information as to where the muscles should go. At the very least, marking the outline of the ribcage and the two points of the iliac crest at the hips is essential. Likewise, marking the right angles of the shoulder blades is enough to define practically the whole back. As for the limbs, knees, and elbows there are several visible anchor points as shown in image 02 which help make sense of the forearms and lower legs.

Seek these landmarks out and mark them on your sculpture early, long before you shape a single muscle. Doing so takes out a lot of the guesswork when you are placing the main forms on your model. The human body can contort itself into all sorts of bizarre poses, but knowing how the muscles relate to these protuberances will help you to keep your forms organized.

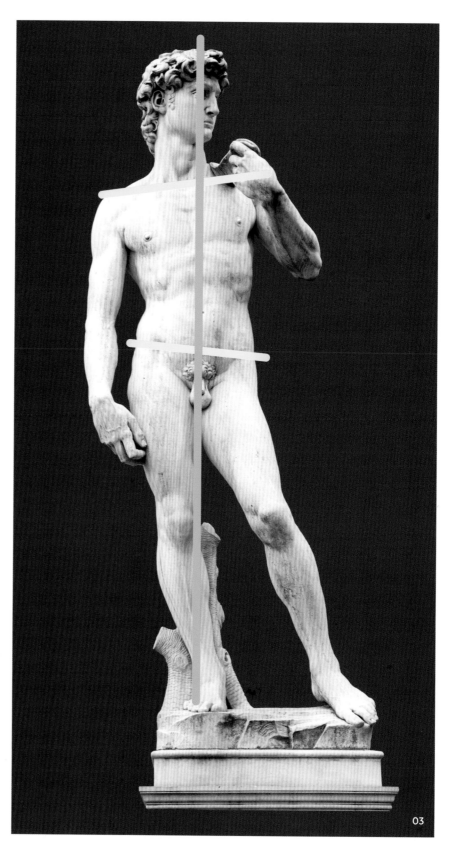

03

03 POSTURE AND BALANCE

Pay attention to how the figure is balanced as a common beginner's mistake is to create a sculpture that feels as though it will fall over. A common standing position involves us placing one foot under us, in line with the head, while the other leg is extended out. This swings the hips in one direction, while the shoulders lean in the other direction to compensate. This resting posture is called "contrapposto" and is often the key to producing natural-looking sculptures. A rigid T-pose, regularly seen in game development, is good for digital animation but saps the life out of a model.

04 NATURE ABHORS A STRAIGHT LINE

If you have any noticeable straight forms in your anatomy sculpture, then something has gone wrong. Nothing on your body is perfectly straight. For example the limbs have bends and fingers have unexpected angles.

You can trace beautiful S-shaped curves throughout the human body, from the shape of the spine to the sartorius muscle plunging from hip to knee across the inner thigh. Sometimes these curves are literally S-shaped, such as the clavicle. In some cases the curve may only exist from a certain angle, flowing from form to form. Finding and replicating these sinuous curves will breathe vitality into your sculpture.

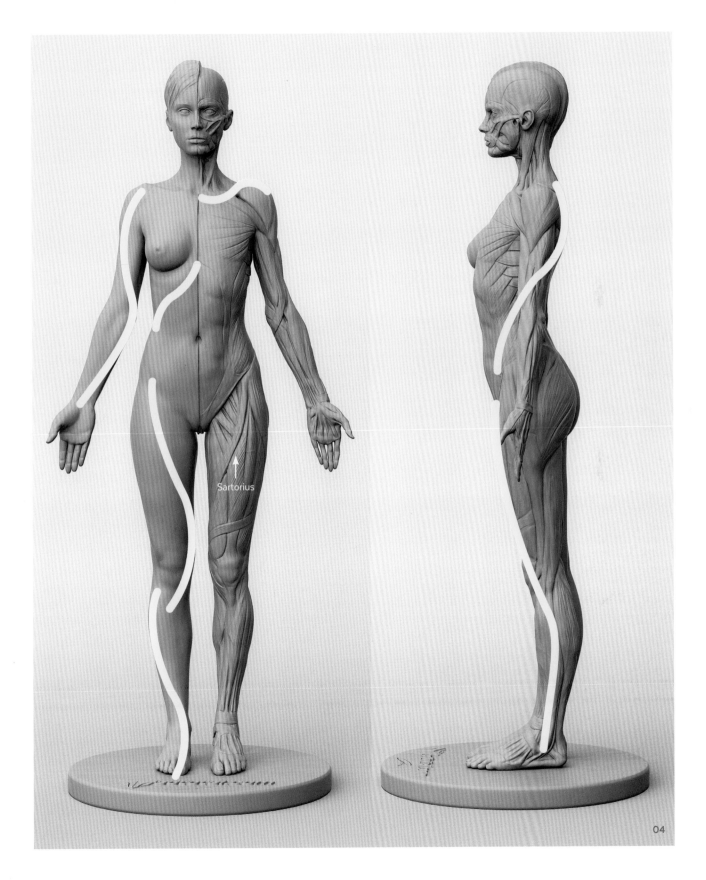

Sartorius

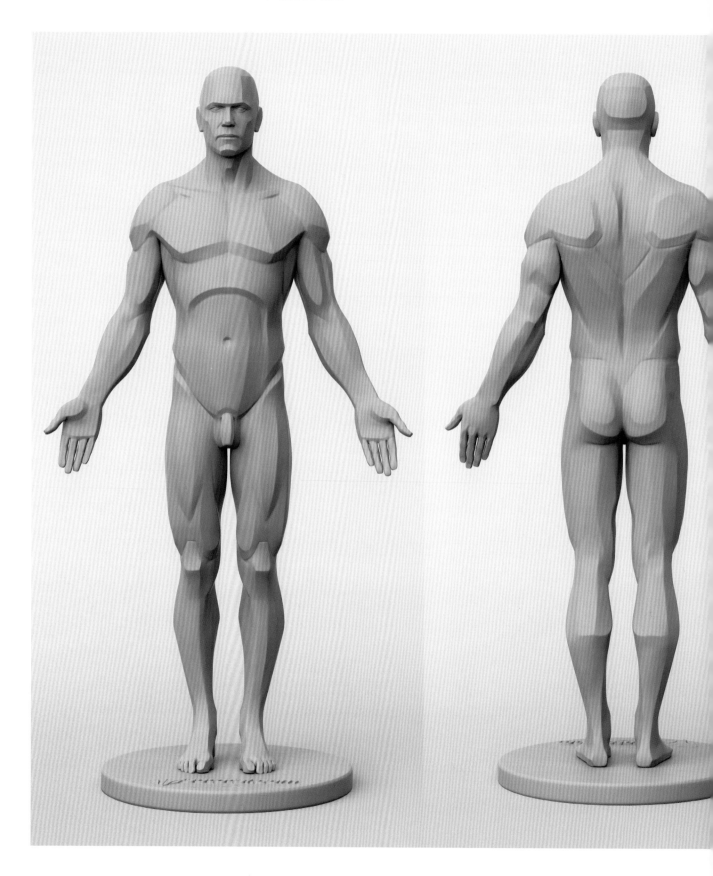

05

05 PLANES AND ANGLE CHANGES

Human anatomy is complex as all the shapes are curved and flow together, so it can be difficult to discern what is actually occurring. However, both the body and face are composed of a multitude of discretely defined planes. A useful trick for new artists is to use a reference built out of planes, whether it is an anatomical reference figure or an online resource.

In image 05 you can see the human figure simplified into defined planes. The success of a sculpture can often come down to whether the underlying planes of the forms have been respected and whether angle changes where one plane borders another are correctly placed. Using planes will also help to give you a good silhouette.

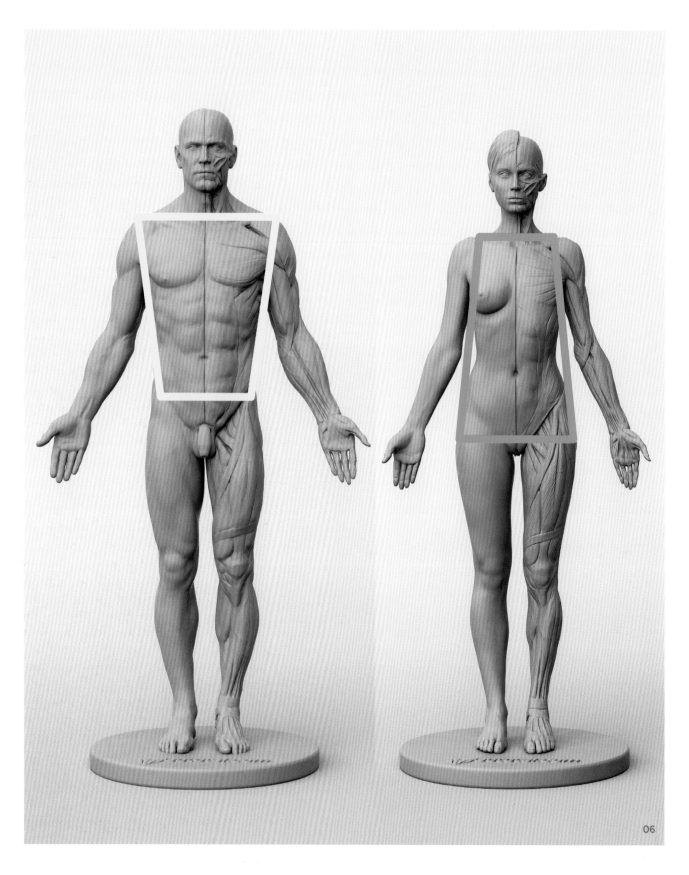

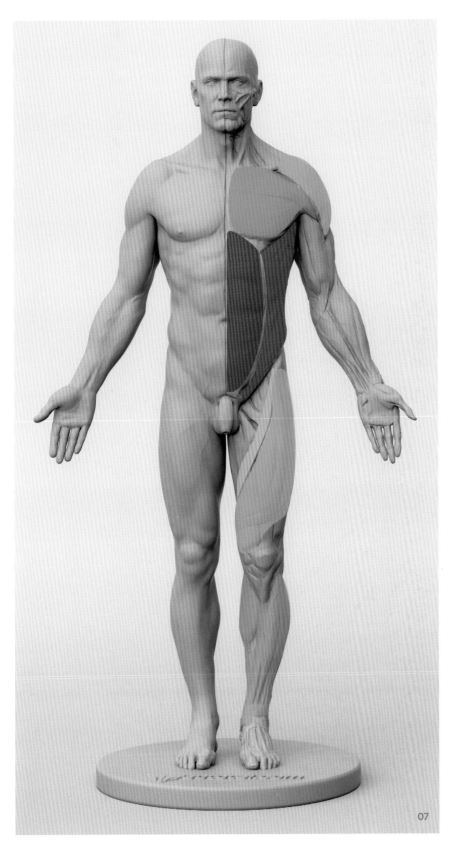

07

06 GENDER DIFFERENCES

Even though men and women share most of the same features, differences in skeletal proportions, muscle mass, and fat distribution add up to a lot. As a result of this it is usually easy to discern what gender someone is, even from a distance.

Women tend to have a smaller ribcage, a larger pelvis, and less muscle development than men. The male body generally has more visible muscles to sculpt, whereas forms on the female body are generally softer. In addition to these obvious high-level differences, the distinctions continue further in more subtle ways, such as the shape of the palm or the angle of the elbow. A useful trick to remember is that at a distance, the abstracted trapezoids that you can see in image 06 are what the eye sees first when judging gender.

07 INTERCONNECTED MUSCLES

Once you have worked out the proportions, placed the bony landmarks, and shaped the primary volumes, you can finally get into the muscle forms. The muscles fit around each other like a big 3D puzzle that is a lot of fun to work out. Knowing their names is less important, in my opinion, than knowing their origins and insertions. Use anatomical references to learn where the muscle forms are, and how their shapes connect together. Forearms and lower legs particularly will test your mettle, so spend time learning where those muscles go.

Do not forget that skin goes over everything, unless you are doing an écorché sculpt in which the muscles are exposed. Sculptures can look perpetually tense and like they have zero body fat if this is forgotten.

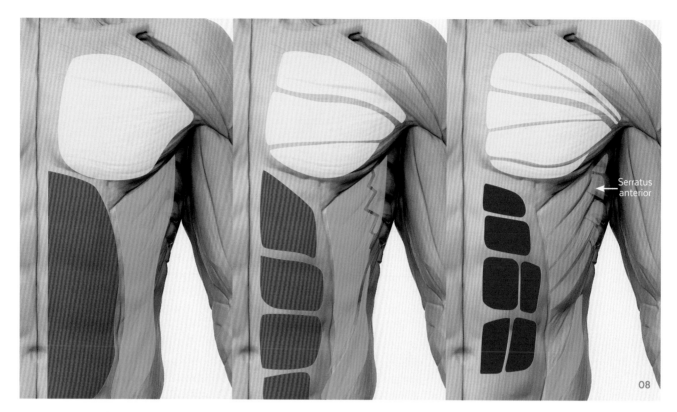

Serratus anterior

08

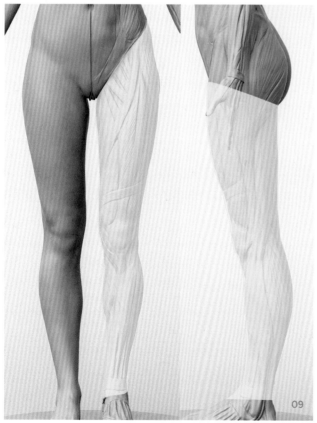

09

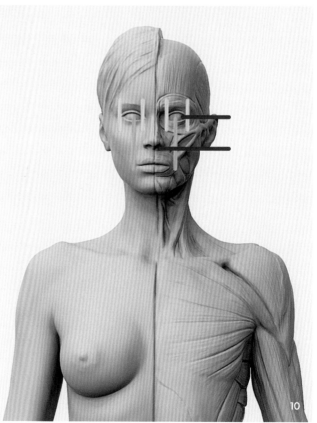

10

08 PRIMARY, SECONDARY, TERTIARY

The most common mistake new sculptors make is to jump into the juicy details too early, before the primary forms have been fully defined. If you do not pay due respect to blocking out the primary shapes first, you can easily find yourself struggling with forms that will not fit correctly. Any large muscle group should be added as an overall volume first, and only later be broken down into individual forms. Further striations and shape breakdowns may serve to reduce the schematic quality the sculpture might initially have.

However, it takes painful experience to overcome this compulsion to start putting in muscles and other fun elements before the sculpture is ready. For example, immediately attempting the zigzag of the serratus before you have shaped the ribcage properly will cause you problems. Layer in the detail slowly, and your sculpture will be the better for it.

09 THE IMPORTANCE OF SILHOUETTES

As you are sculpting you need to constantly evaluate the silhouette of each part of your model. A painting needs to look good from just one angle, but a sculpture needs to look good from every angle. Using a leg as an example, you can see in image 09 that the large muscles there form a complex shape together, one that shifts from view to view. The outline of the leg results from the interplay of forms, where often one muscle takes over from another to describe the silhouette. The silhouette is also important in terms of posing, as you need your sculpture to be dynamic and readable from as many angles as possible.

10 MEASURING TRICKS FOR THE FACE

We tend to perceive the human face as fairly flat, when in fact it is anything but. As with the rest of the body, it is full of subtle plane changes that you need to be aware of. To help with the correct placement of features, artists have worked out many useful shortcuts.

Human facial features all relate in fairly simple ways: the eyes are usually a distance of one eye apart; the ears join the head parallel with the corner of the eye and the bottom of the nose; the mouth is generally about as wide as the pupils (although this can vary slightly from person to person). Knowing how the skull underneath informs the features on the surface is essential, especially when sculpting expressions. Parts of the face will move around, but the bone remains in place.

By keeping in mind these fundamentals as you sculpt you will be able to develop characters that are believable and relatable to the human eye.

"YOU NEED YOUR SCULPTURE TO BE DYNAMIC AND READABLE FROM AS MANY ANGLES AS POSSIBLE"

PROJECTS

In this section you will discover five detailed tutorials from skilled professional sculptors who share a wealth of knowledge and experience to get you started with your first character sculptures! With these projects you can create a sci-fi character suspended in space or a fantastical mermaid basking on a rock; you can build a stylized mech with robotic proportions, a bust of a rustic dwarf, or a minuscule underwater alien emperor.

Each tutorial offers something different, enabling you to learn about - and practice working with - a wide range of materials, tools, and techniques. The talented sculptors take you from building bases and armatures through to blocking in and form building, and finally to detailing your work and adding finishing touches.

As you read these tutorials you will find hazard symbols which indicate that there is related safety information that can be found on pages 38-39. Now turn the page to delve into a comprehensive introduction to sculpting with clay that will set you on your way to an exciting future exploring this tactile and immersive art form.

SPACE CADET

BY ALEXANDER RAY

MATERIALS

Aluminum wire (light & medium gauge)

Brass rod

Brush-on clay solvent

Cable grip

Coupling nut & T-nut

Dulling spray (optional)

Five-minute epoxy

Matte coating sealant spray

Oil-based clay (medium density)

Threaded rod

Wooden base

TOOLS

Alcohol torch

Allen wrench

Ball tools

Bubble wrap

Chip brush (optional)

Drill & bit (optional)

Heat gun

Hobby knife

Lighter (optional)

Loop tools

Mechanical pencil (optional)

Needle tool

Nuts & bolts

Plastic cup

Pliers

Rake tools

Soft-bristle brush

Wire cutters

In this tutorial we will create a female sci-fi character, a futuristic space cadet based on Charlie Bowater's character illustration, *Low Gravity*, using traditional sculpting techniques. I will walk you through the process step by step, starting with how to choose the best sculpting medium for the piece and the type of tools you will need to complete the project effectively. I will show you how to use tools such as rake tools, loop tools, and hobby knives, in addition to materials that will give your sculpture a clean, professional appearance, such as clay solvents.

This tutorial will also cover several valuable sculpting topics including basic human anatomy, complicated shapes like the hands, and all the necessary steps needed to effectively create a human figure. We will explore the process of how to build an armature, pose a character in a way to give the final sculpture a sense of movement, and several other sculpting tricks you can use to create an interesting and dynamic character.

Throughout the tutorial you will see how designs can change as you work and learn how to address various problems that may occur in the sculpting process. All of the information provided in this tutorial can be applied to any other sculpting project. Once you have read through this guide you can use the following techniques to create your own sci-fi character or anything else from your imagination. As you are working through this project remember to take everything step by step, do not be intimidated, and enjoy the process!

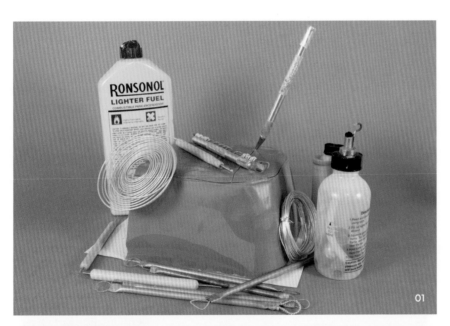

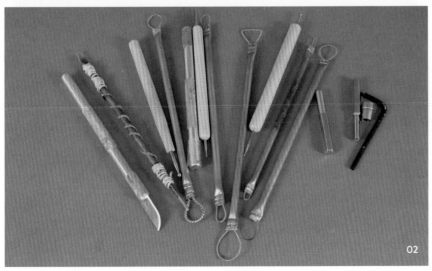

TOOLS AND MATERIALS

01 The best way to get started is to gather all the materials needed for your sculpture, making sure everything you require is readily available. There is nothing worse than starting a project and then having to break the momentum of your workflow because you need to find a tool. Make a checklist of the items that you will need for your sculpture (such as the list at the start of this tutorial) and assemble them in your workspace. I will discuss each of the items you can see in image 01 in detail in the following steps.

02 There are many different tools you can use to sculpt with. When approaching a sculpture project, ask yourself a few questions to decide which tools you will need. How big is the sculpture going to be? What type of sculpting medium are you working with? How soft or hard is the sculpting medium?

The project we are working on here is relatively small, about 1:6 scale, and will be sculpted in medium-density oil-based clay. This means that we will need to use smaller tools so loop tools, ball tools, and guitar string rakes will do the trick. Since we are working with oil-based clay, you can use an alcohol torch and a heat gun, and a brush-on solvent to achieve a smooth finish.

03 We will use loop tools to remove material from the sculpture. You can make your own loop tool by taking brass tubing and a short length of guitar string gently bent into a U-shape. Insert both ends of the string into the brass tube. Once you are happy with the amount of loop extending from the tube, use a pair of wire cutters to crimp the end three times to ensure the wire is secure and will not shift while you are working with it.

04 Rake tools are, in my opinion, among the most important sculpting tools. Looking at the rakes in image 04 it is apparent that the guitar string used for this rake has a "toothy" appearance. This may seem counterproductive to evening out a surface, but they really do work! By removing material from the high points on the surface of the clay and displacing the material into low points, the surface is gradually leveled.

05 Another set of important tools are ball tools. Unlike the loop and rake tools, which I like to make myself, I prefer to just buy a set of ball tools. Most of the ones I use are double ended with each end having a different sized ball. Later in the tutorial you will see that ball tools are great for stitching clay together and adding texture or details. By moving small amounts of clay around with ball tools you can create a form that can then be refined with the loop and rake tools.

06 Hobby knives are incredibly versatile tools for any sculptor. They can be used to remove or add material from a sculpture. The curved blade (top in image 06) for instance works really well as a spatula with which to take little pieces of clay and blend them into a surface. Since we will be sculpting some mechanical-looking pieces for this character, the regular blade (bottom in image 06) will be useful for cutting in hard angles and surfaces.

07 Alcohol torches and heat guns are also very useful to any oil-based clay sculptor. They can be used to heat up a surface to make raking more expeditious, and if used correctly they can transform a surface from rough to smooth by melting tool marks. An alcohol torch can be used for small areas whereas a heat gun is best for heating up a larger surface area. However, be careful not to heat the clay too much as it may become liquefied and droop; do not allow your tool to dig in to the clay. Also remember that the clay will be hot to the touch.

Refer back to pages 26–37 for advice on using all these tools.

08 Because clay is soft, and will not on its own hold a complex shape like the human form we will be sculpting, we need to create a support system. This is where the armature comes in. We will create a skeletal structure out of aluminum wire, and then mount that skeleton onto a support structure to hold the sculpture firmly in place which will enable clay to be added to it. The support structure will be comprised of a wooden base, a brass rod, a threaded rod (a metal rod that has threads like a screw from end to end), and some various nuts and bolts in addition to some five-minute epoxy. I will cover this process in the next few steps.

ARMATURE BUILDING

09 To make the armature wire, cut two strands of medium-gauge aluminum wire with wire cutters, place one end of each strand into a drill, and tighten down the drill chuck which holds the wire in place. Hold the other end of the wires with a pair of pliers. Engage the drill; the two strands of aluminum wire will twist around each other to form a very tight, uniform spiral pattern. This pattern will provide a surface that the clay will grip onto well. Because the aluminum wire is relatively soft you could twist it by hand if you do not have access to a drill.

Three pieces of this twisted wire are needed for the armature: one long and two shorter pieces of equal length. The longer piece will serve as the legs, torso, and head of the skeleton, while the two shorter lengths will be used for each arm.

03

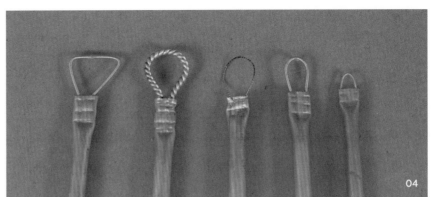

04

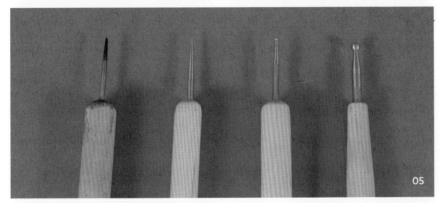

05

06

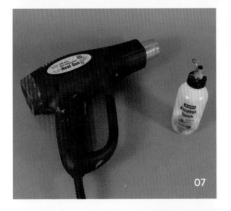

07

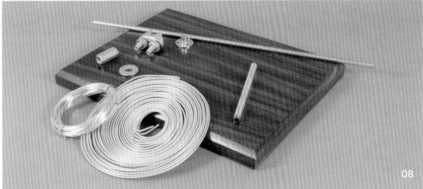

08

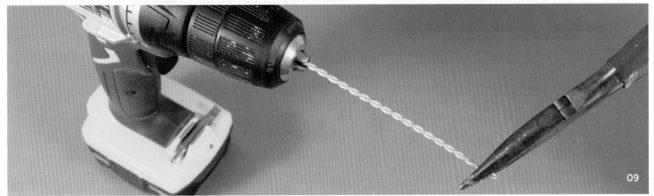

09

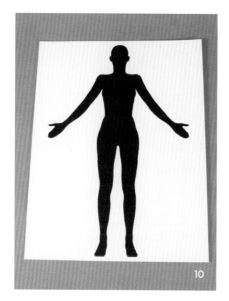

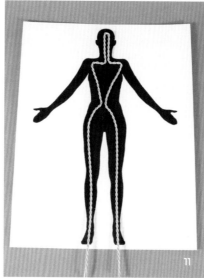

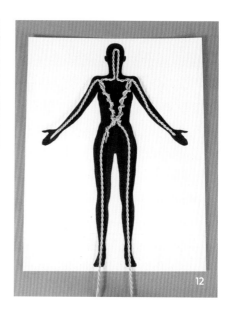

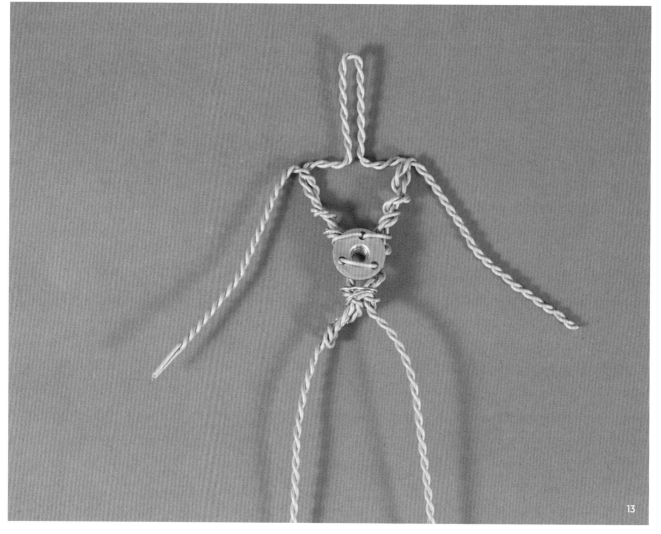

"HAVE MORE WIRE THAN YOU THINK YOU WILL NEED. IT IS BETTER TO HAVE THE WIRE TOO LONG THAN TOO SHORT"

10 In my opinion, the best way to make an armature is to have a drawing or printed template on a piece of paper on which you can lay the armature in order to make sure the aluminum wire is within the confines of the object you are sculpting. In this case, you will be sculpting a female character so create a basic female silhouette image on a computer and print it out so that you can lay the armature directly on the paper. This will help you ensure the size is correct. Silhouettes are widely available online if you do not want to make your own. If you do not have access to a computer or printer you could draw a silhouette freehand or by tracing over an image.

11 As mentioned, the first and longest piece of twisted aluminum wire will comprise the legs, torso, and head of the character. Lay the wire over the left leg, allowing some of the wire to protrude past the end of the foot. This extra length will give you the option to mount the figure to a base if you choose to do so later.

Use your hands to make a slight, curved bend in the wire where the middle of the waist will be, then create a sharp bend that leads to the shoulder, and another sharp bend to the head. Create a U-shape for the neck and head area, and then repeat the shape on the other side. Make sure that you have more wire than you think you will need. It is better to have the wire too long than too short.

12 Now you need to add the arms. Like the legs, allow the armature wire to extend past the wrist of the silhouette. Once you have begun sculpting, you can always cut the wire shorter to meet your needs. Each arm will lead up the shoulder where you can use your fingers to twist around each side of the torso leading down to the waist. The final touch is to add a little bit of wire where the bends at the waist come together so that the armature will not spread apart.

13 You may eventually want to remove the finished sculpted figure from the support base, so we are going to mount a T-nut to the wire skeleton that will attach onto a threaded rod support. This means you can unscrew the threaded rod from the back of the character once it is finished rather than cutting the rod.

To secure the T-nut to your armature, thread one strand of light-gauge aluminum wire through the holes in the T-nut, almost as if you are sewing on a button. Use a pair of pliers to ensure the wire is tightly secured.

MAKING A BASE

14 For the base I will just use a piece of wood that I have lying around. It happens to look quite attractive, but you could use any piece of wood for this purpose. The only stipulation for the base is that it needs to be at least 1/2 an inch or more thick so that there is enough depth for the metal rod to mount into it properly. This will make the armature as a whole secure.

15 The first step in creating the support structure for the armature is to mount a brass rod into the wooden base. The rod I will use is 3/8 of an inch so I will use a drill bit (a drill attachment used to create holes) of the same size to create a hole positioned centrally along one side of the base, about 2 inches from the edge. Apply a bit of five-minute epoxy to the end of the rod to make sure that the rod is secure and will not begin to wobble as you work on the sculpture. Slide the rod into place, making sure it is at a 90-degree angle to the base. ⚡❗

16 The next piece of the base you need to add is the threaded rod that connects the vertical brass rod to the aluminum armature. You will need a cable grip, coupling nut, threaded rod, and an ordinary nut. First, unscrew the right nut from the cable grip and thread the coupling nut in its place. Second, screw the threaded rod into the other end. Third, thread the nut onto the opposite end of the threaded rod leaving about 1/2 an inch of exposed threads. This extra space is where you will attach the T-nut that has already been mounted to the armature.

17 Before you begin adding clay to the armature, thread the aluminum body onto the support structure, and then bend the armature into a pose. The benefit of using aluminum wire for your armature is that it is soft enough to easily bend into shape, but it is strong enough to support all the clay you will apply. This will be useful if you decide to change the pose of your character later as you will be able to gently heat up the clay at a joint, for example, and bend it into a new position.

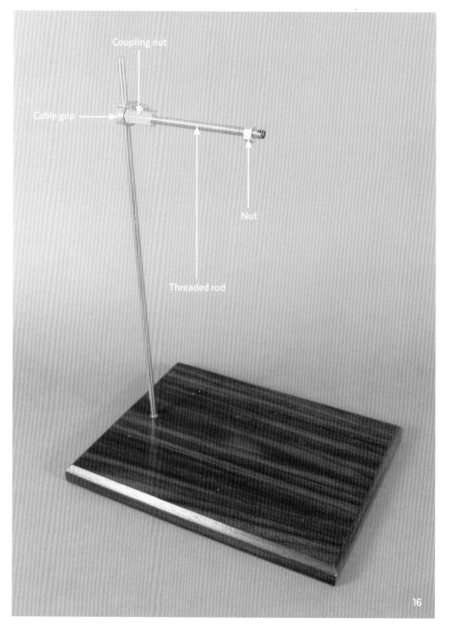

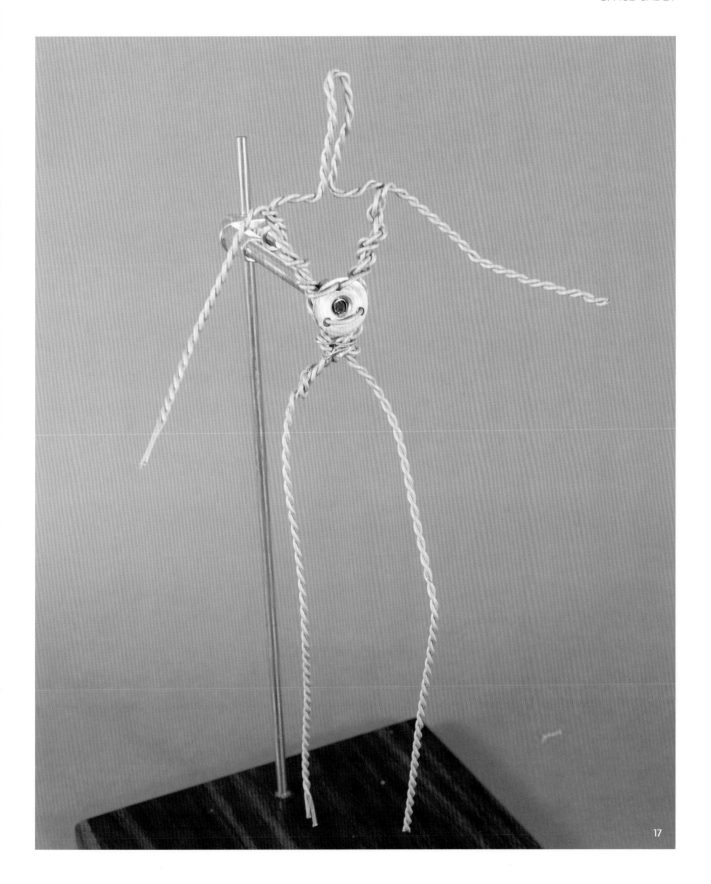

17

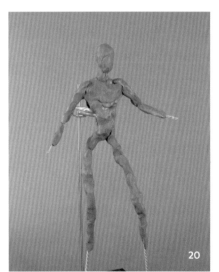

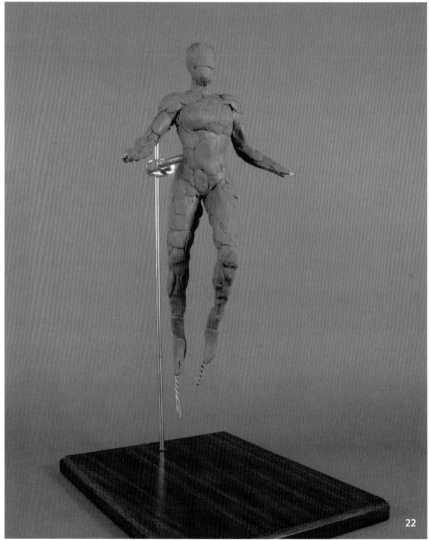

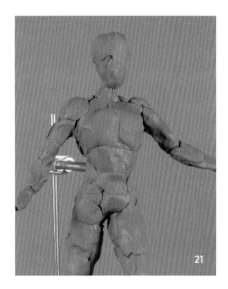

BLOCKING IN WITH CLAY

18 Now that the armature and base are finished you are ready to start adding clay! I will use a brand of oil-based clay called Monster Clay. It is a hard clay that requires heat to make it malleable, but this hardness allows for greater detail and you will be less likely to damage your sculpture if you accidentally bump it. In order to work with this type of clay, you will need to cut it into manageable chunks. Use a large knife to cut slices out of the large clay block. 🔵

19 Cut those slices into even smaller bars. As mentioned, this clay is hard and needs to be heated. You could warm it with just your hands, but that would take some time. To speed up the process, microwave a couple of these smaller bars at a time. Use a high heat for about 15–20 seconds. This will make the bars softer so it will be much easier to pull off little pieces of clay to add to the sculpture. When you take the bars from the microwave press lightly on them in order to make sure they have not become too hot on the inside. Hot, molten clay can cause burns. 🔥

20 Now that your clay is warm and malleable, it is time to add the first layer to the armature. There is no need for finesse in this step, just use your hands to quickly add a layer of clay to the entire wire structure, except to the hands and feet. Since you took the time to wind two strands of aluminum wire to make the armature skeleton, the clay will hold to it really well.

21 Once the armature is covered (except the hands and feet) you can start to build up the various anatomical shapes of the body. This is a matter of looking at references and slowly adding more and more small pieces of clay until you feel confident that you have roughly captured the shape of your character. For more advice on sculpting human anatomy see the chapter on pages 42–51.

Do not worry about how the surface of the clay looks in this step. Once all the basic forms are there we will go over the entire surface with a coarse rake tool to unify the separate pieces of clay.

22 Start to bulk out the torso, arms, and legs of your character. Again, do not worry about the hands and feet just yet – we will add those later. The objective here is to keep adding more and more clay with your hands until you feel you have captured the shape you want. Sculpting is a process of adding and subtracting, so throughout this tutorial we will be adding and taking away material to achieve the desired look.

23 This part of the sculpture is really exciting; the more clay you add, the more the form of the figure begins to take shape. Further bulk out the chest, thighs, and arms. As you add clay, try to mimic the separation between the larger shapes and muscles of human anatomy. For example on the arms the muscle by the shoulder is the deltoid, below that are the biceps and triceps, and below these is the forearm.

Continue to add clay, forming larger muscle shapes in the legs by bulking out the thighs and lower leg. Add a separate piece of clay for the kneecap. You can now also add rough pieces of clay as placeholders for the hands and feet. We will redo the hands later but adding them roughly now will help you visualize the figure as a whole.

24 Back anatomy can be challenging, but since we are sculpting a female character the back will have a softer appearance as opposed to a male body-builder, for example. As with the rest of the figure there is no need to be really detailed with any of the anatomy at this point. Add some blobs of clay to the top of the back to give the impression of shoulder blades. Then build up clay symmetrically down the back leaving a separation down the center where the spine would be. You can also add to the rough shape of the buttocks at this point.

25 When you created the armature you left a length of wire extending past the bottom of the feet so that, if needed, the feet could be mounted to the base for added stability. That is exactly what we will do here. The armature is stable, but it can be a little bouncy as you work, so curve the wires until they barely touch the wooden base. Then add a little more clay around the wire and squeeze it together onto the base so that the figure will move less as you continue sculpting. To do this you may need to adjust the position of the figure on the mount so the feet are closer to the board by loosening the nut and moving the armature down.

REFINING THE FORMS

26 I tend to jump around in my process, working on different parts of the figure to keep the overall progress even and the finish balanced. This has the added benefit of keeping me interested in the project. In image 26 you can see that I start to gently rake over the entire surface of the sculpture with one of the rake tools we made earlier. This tool will bring together all those small pieces of clay you have been layering up.

27 Focusing on the legs, use a rake tool to remove material by pulling the tool from the inside of the upper thigh line outwards. Do this on either side of the crease (refer to image 27) to smooth out the transition between the hip and thigh. This will eliminate the sharp edge that loop tools can create, giving a natural bend where the leg meets the hip. This edge will be further softened when you rake the surface with finer rakes as the sculpture progresses.

WARM-UPS

Before you start working on a big project it is a good idea to warm up. Personally, I have a few different sculptures I work on for fun, and I work on these for a few minutes before starting my main project in order to get my hand used to the movements and the feel of the tools. It is particularly useful to warm up on the same medium you will be using for that particular project as different mediums alter how tools feel.

28 The shinbone runs from the knee to the ankle in a slight curve. Use a loop to create two trenches down the lower leg either side of where this bone would be. Then go back over the surface with a rake and smooth out the transition. You can also add more clay to the kneecap at this point. Carve out the shapes in the knee with a loop tool and then refine them with a rake tool.

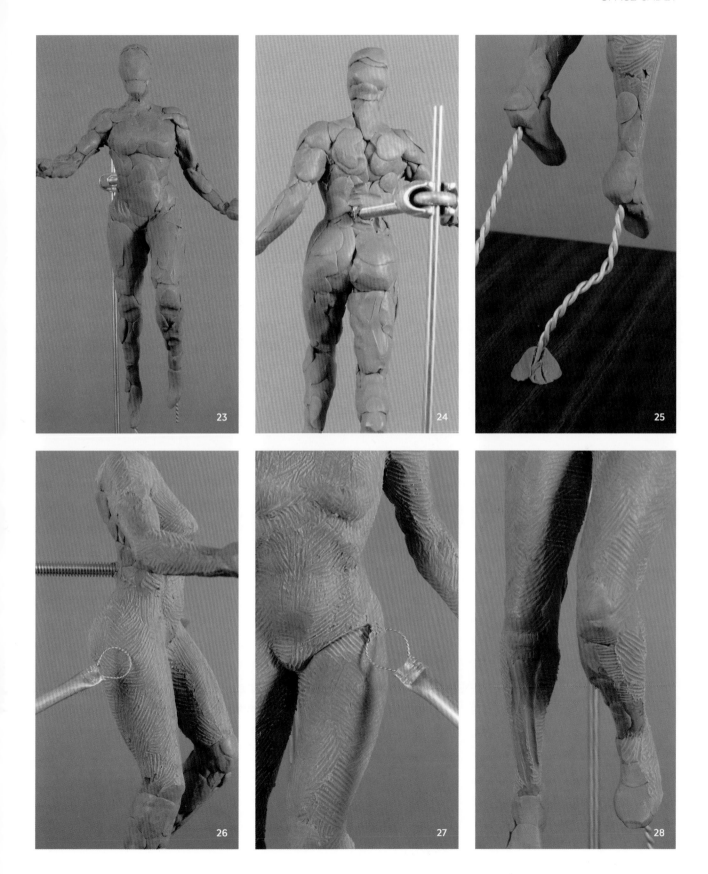

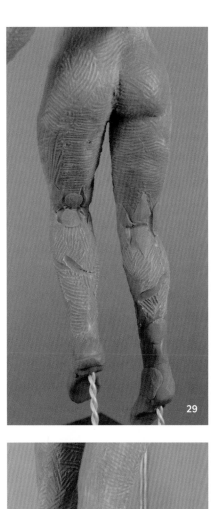

29

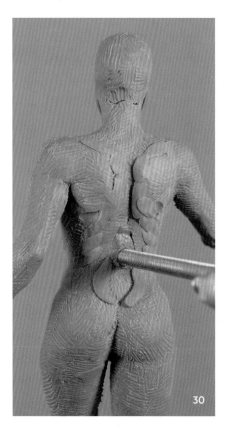

30

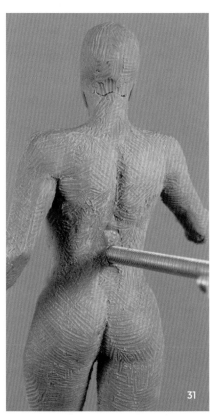

31

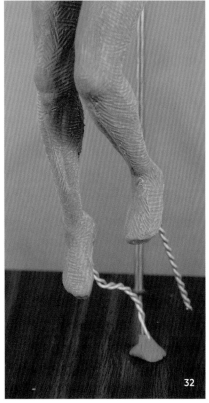

32

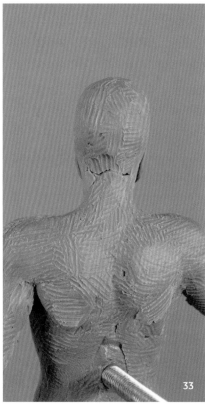

33

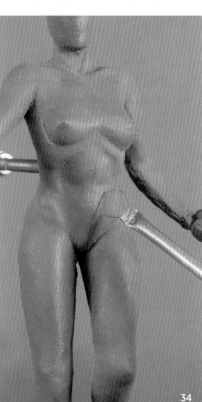

34

"THE BEAUTY OF THIS MATERIAL IS THAT ANY MISTAKE CAN BE FIXED"

29 Working now on the back of the leg, define the shape of the calf as well as the area behind the knee. There are muscles that run along either side of the back of the knee as well as a slightly raised area between them. Apply clay in small sections to both sides and the middle of the back of the knee to indicate these anatomical details. Then carve out a little bit of clay in between to form the natural indents of the knee and finally rake everything together.

30 To continue refining the character's forms, apply more clay to the back to further define the shape of the muscles. The forms on either side of the spine will be relatively symmetrical. In image 30 you can see that clay is added to bring out the shape of the shoulder blades, in addition to the lower back.

31 After the muscle-forming material is added onto the back, blend the new clay into the figure using the ball tools. Then use a coarse rake to further blend the shapes into the surface.

By repeating the process of adding clay and then refining with a rake tool, the upper body of the character will slowly take shape. It is good to try to attack all the different anatomical areas of the figure evenly so that you achieve evenly proportioned body parts throughout.

32 At this point, you can add clay to build up the feet. A good tip for areas like hands and feet is to use your own body as a reference. Because this character will be wearing clunky boots however, it will not be necessary to sculpt each individual toe.

Looking at my own foot I can see that the ankle bone on the inside is slightly lower and positioned further forward than on the outside. Also, the inside of the foot curves in while the outside is relatively straight from the back of the heel and gradually curves out into the toe area. Build up these shapes on your character using small pieces of clay and then rake them down into the basic shape of the foot.

33 I decide to turn the head to the left, and in doing so the back of the neck cracks. This is a result of the clay becoming harder as it cools down. You could avoid this issue by heating up the clay around the neck, but it is an opportunity to show you that even if something like this happens all you need to do is add a bit more clay, blend it into the crack, and rake over it. The beauty of this material is that any mistake can be fixed.

34 The best way to achieve a smooth, unified surface is to use increasingly finer rakes. When we originally blocked out the anatomy the surface was raked with a coarse rake. Now that all the forms have been refined, you need to use a finer rake to go over the surface again. This may seem repetitive, but it is the best way to achieve a smooth surface and create natural transitions between the anatomical forms.

SUGGESTING MOVEMENT

If you were to sculpt a figure with its hands at its sides, its legs straight, and its head facing forward with a blank expression, it would not have a great deal of personality. This may result in the viewer losing interest in the piece. A simple yet effective way to counter this is to make slight turns in the pose to suggest movement. These subtle alterations to the positioning of the head and body will help the viewer to engage in the sculpture.

SCULPTING HANDS

35 The hands have been saved until now when the body forms are largely refined because the hands can be quite complicated. Use a hobby knife to slice the clay around the wrist where the hand will join. Snip the armature with wire cutters so that there is only a very short amount protruding from the clay. Once you have started sculpting the hand, this little bit of exposed wire will help you to secure the hand to the wrist.

36 I like to create a completely separate armature for hands. For this sculpture the character's right hand will be closed into a fist so you will only need an armature for the left hand. The first step, just like the armature for the body, is to make a drawing to use as a guide. If you use a piece of tracing paper and did require an armature for both hands, you could simply flip the paper over to give you a second hand. This would save time and help ensure that the armatures for each hand were the same size.

37 To make the armature we will bend the wire and lay it over the drawing to make sure it fits within the confines of the shape. The armature does not need to be overly complex. Take two 8-inch lengths of light-gauge aluminum wire and twist them together as you did with the skeleton armature. This length may prove to be too long, but once you have the hand shape you can snip off any excess with a pair of pliers.

Lay the wire along the length of the thumb making a roughly 45-degree bend where the thumb meets the palm. Make another bend at the tip of the index finger, this time doubling the wire onto itself. The next bend is made well below where the natatory ligament would be to ensure you do not hit the armature while sculpting. Repeat this process for the rest of the hand until you reach the opposite side of the palm, then make a 90-degree bend and bring the wire back to the base of the thumb.

38 The process for defining the hand is the same as for the rest of the figure so you now need to cover the wire in clay. Apply the clay to the hand before attaching it to the wrist. As the hands belong to a female character they need to be delicate and have thinner fingers than a male might. The initial application of clay will look too bulky, so achieving a more delicate form is a matter of thinning the hand down while being careful to avoid exposing the armature wire.

Once the hand armature is covered in clay, use your hands to apply it to the end of the character's wrist with some pressure. Then add a small amount of clay where the hand and wrist meet and blend the seam together with a combination of a ball tool and rake.

39 Now the hand needs to be refined. This can take some time because the fingers are so small; however it is important to be patient until they are finished. Just like the rest of the body, they will come into shape eventually. Stick to fine rakes and loop tools when refining hands to avoid accidentally removing too much material.

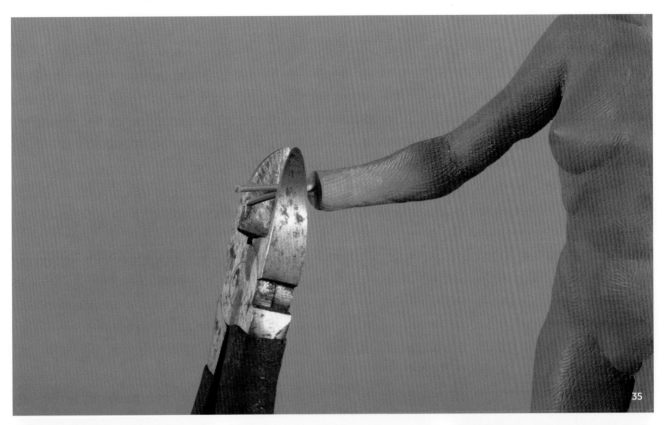

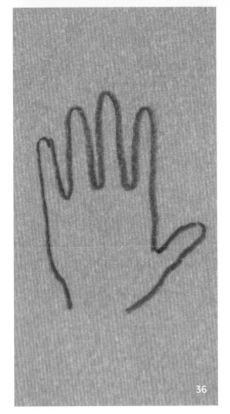

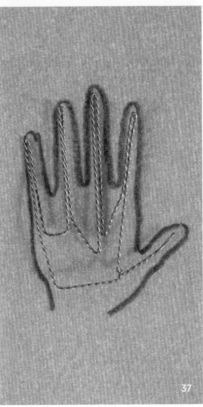

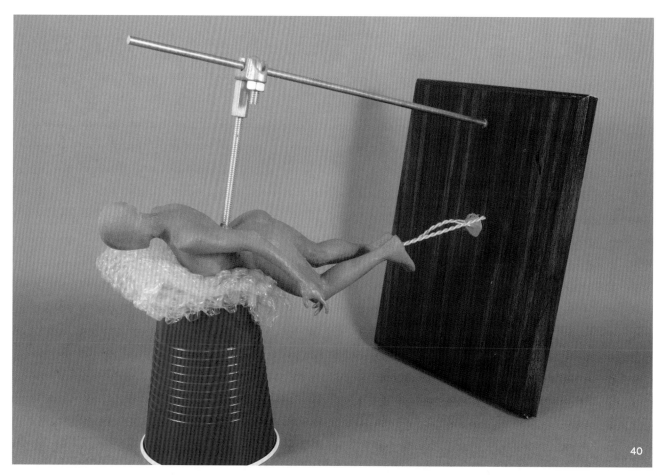

40 The pose of this character makes it difficult to reach parts of the hand. To address this issue take a stable object like an upside-down plastic cup and add some folded bubble wrap on top. This will give the sculpture something soft to rest on so that it will not become damaged. It is also important to have the support situated so that the sculpture is relatively level to avoid too much pressure on the clay. Now you will be able to access any part of the hand.

41 As mentioned, the character's right hand will be in a closed position, so you will not need a second armature. The armature is only necessary for the open left hand because it would have been very difficult to refine the shape of the fingers without the wire support. You can bulk out the closed hand with a large square piece of clay to form the fist, then a few smaller blobs of clay to act as the thumb and finger. You can also indicate the separation of the fingers with a hobby knife.

42 The more I look at the figure, the more I feel it should have some sort of prop, so we will place a futuristic pistol in the character's right hand later on. To make the pose a little more dynamic, bend the arm so that the pistol will be held upwards. To do this, use an alcohol torch and steadily heat up the area around the elbow by quickly waving the flame over the clay. Do this gradually over several passes to soften the clay all the way to the armature without it melting off. Once it is sufficiently soft, you can gently bend the arm upwards. 🔥

43 Now that the arm is bent, you will need to adjust the shape of the anatomy. When you bend your arm the muscles take different shapes. The biceps tighten and appear larger, and the lower inside of the forearm becomes broader close to the elbow. You will need to remove some of the clay from the back of the forearm and add more clay to the inside of the forearm and biceps to make the proportions look correct. Make sure you refer to anatomy references as you do this.

44 Returning to the hand of the raised arm, the rough blobs of clay you initially added to bulk out the hand need to be blended together. While you do that, continually add more pieces of clay to build up the more prominent forms of the hand such as the knuckles and the bulge on the side of the closed palm. You can also add a "worm" (that is, a thin cylinder) of clay for the raised index finger. This will act only as a placeholder for now while you sculpt the rest of the hand. You will need to reinforce that finger with armature wire in the next step.

Blend these forms together each time using a ball tool so that you can get a clear sense of how the hand is taking shape.

45 Because the figure will be holding a futuristic pistol, the index finger needs to extend to fit over the trigger. To accomplish this, remove the previous placeholder finger and add in a little piece of armature wire bent into shape with your fingers. To form the finger, add some clay around the wire, rake over it, and repeat the process until the finger has taken shape.

MODELING THE FACE

46 Now that we have tackled the body, we will begin to focus on the face. The face should have realistic proportions so here is a good set of rules to follow: the eyes are placed halfway down the face between the chin and the top of the head; the nose is halfway between the eyes and the chin, and then the mouth is halfway between the nose and the chin. Mark these lines on the head by lightly cutting into the clay with a loop tool. Indicating a central line down the middle of the face will also help you with symmetry.

47 Similar to the lines mapping the placement of the facial features, draw a line with a loop tool that is a little more than halfway between the front of the face and the back of the head. To ensure each side of the head will have the ears in the same place, stand directly above the sculpture and look down at the top of the head to match up the lines. For now, add basic ear-shaped pieces of clay as placeholders. We will not address the ears fully until the other areas of the head have been sculpted in order to avoid them being damaged in the process.

48 At this point it may feel like the face will never take shape, but be patient and persistent and it will get there. To define the facial features start by adding blobs of clay to build up the more prominent areas of the face such as the cheekbones, brow, nose, and lips. To do this, take a pinch of clay, roll it between your index finger and thumb to soften it, and then apply it to the face with some light pressure.

49 Much like the rest of the figure, the face is a process of adding clay and raking it down several times until you feel you have achieved the correct look. In this step, rake over the blobs of clay that make up the facial features to blend them into the rest of the face. It is important to do this as it keeps the shapes clean and uniform, which will allow you to focus on what needs to be worked on.

50 After raking the surface, use a small ball tool to define the general shape of the eyes. This is essentially a rounded oval shape with tighter corners at each end. For this step, think of the eyes as being closed. In the coming steps we will add greater detail such as the separation between the eyeball and lids in addition to the folds between the lid and the character's brow.

You can also refine the nose by pinching two very small pieces of clay, rolling them into balls with your fingertips, and applying them to either side of the nose to form alae (cartilage surrounding part of the nostrils). Use the ball tool to give them definition and add in the two nostrils.

51 Use the same technique to define the character's lips, but instead of relying on a ball tool, also use a needle tool so that you get a sharp separation between the lips. Take two very small pieces of clay, warming them in between your index finger and thumb so that the clay is very soft and easier to manipulate. Apply these pieces of clay to each lip using a combination of the needle and ball tools to blend the lips into the face.

52 Now, using the ball tool again, push the clay above the eyes upwards to create the basic shape of the eyebrows. Use the needle tool again to draw out the shape of the eyes and eyelids. Do this by creating lines to represent the fold between the brows and each eye, as well as a line between where the eye meets the eyelid.

In addition to these lines, use a small-tipped ball tool to create a depression on either side of the mouth. This will give the character a very slight smirk.

53 With a gentle touch, rake the surface with the finest rake tool you have until the face has been completely smoothed. Once that is done use a small, soft-bristle brush dipped in clay solvent to smooth out the surface. However, be sparing with the clay solvent as too much solvent can cause the surface to become muddy. ❶

Lastly, take two ball tools of different sizes. Use the larger to create a recess in the eye to form the iris, and then use a smaller ball tool to push into the center of the iris to create the pupil. I have chosen to have the character looking off to the side, which will give the sculpture a little more character.

SCULPTING THE COSTUME

54 This character wears futuristic armor organized in a series of symmetrical shapes that are meant to look like metal plates. To create these plates take a marble-sized piece of clay and flatten it with your fingers. Then use the wooden handle of one of your tools to roll the clay out into a flat, even sheet. Next, use a hobby knife to cut out the shapes you want for the plates. ✄

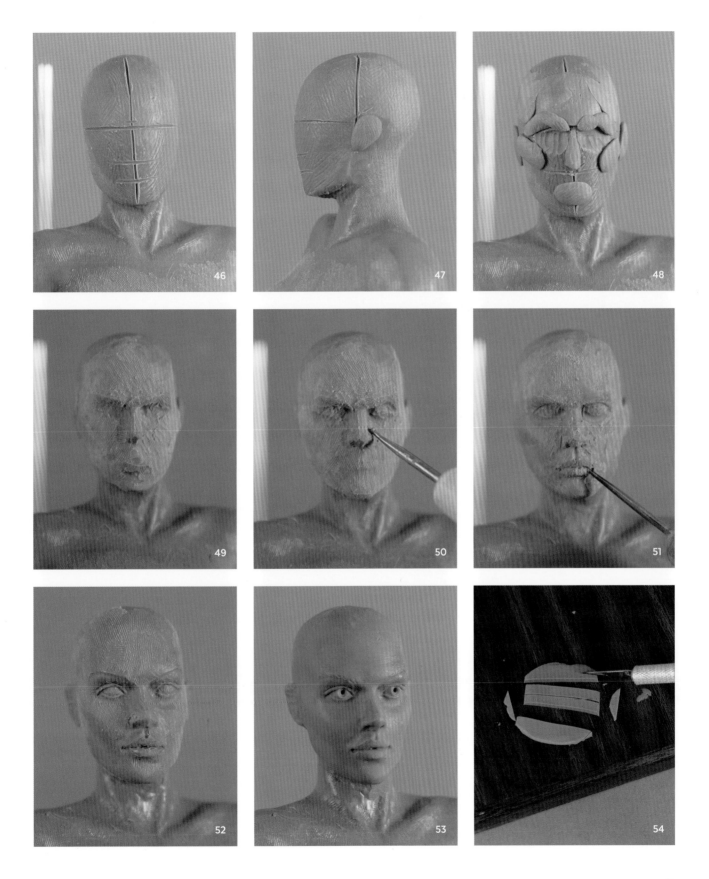

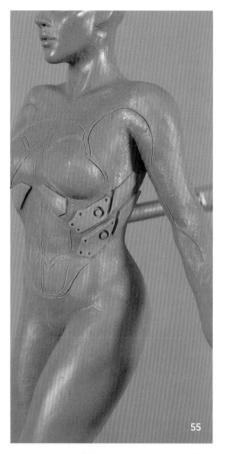

55

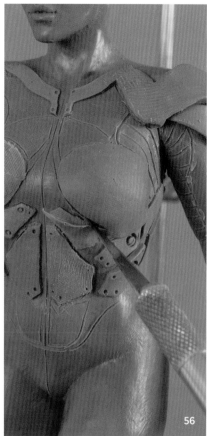

56

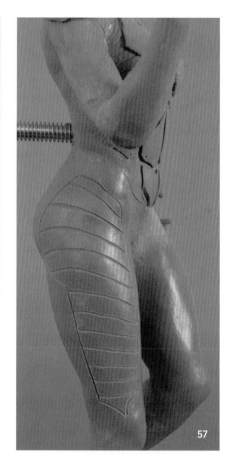

57

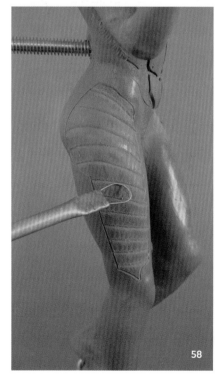

58

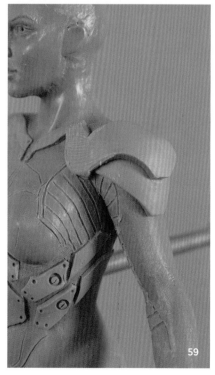

59

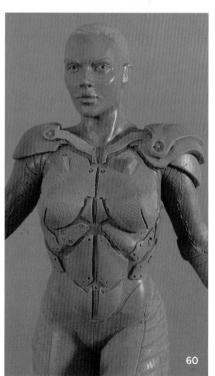

60

61

55 Now that the shapes have been cut out, press them onto the body by lightly applying pressure. Make sure you do not press too hard as the clay plates are thin and will distort if you are not careful. This also affords you the ability to remove the plates without too much trouble if you do not like the placement. For the rest of the armor on the chest continue rolling out clay with the wooden handle of a tool, cutting shapes, and then applying them to the figure until you are pleased with the design.

56 Another way to add chest plates to a figure is to roll out the clay (just as you did in steps 54 and 55), then lay the flattened sheet of clay over the chest. Use a hobby knife to cut off any part of the plate you do not want to remain on the sculpture. This second method comes in handy when you are sculpting complex shapes that need to fit together.

57 Since this character is a futuristic space cadet, the outfit needs to have several different design elements that will add visual interest to the piece no matter which direction it is viewed from. Use a pointed loop tool to carve out a design on the outer side of the leg to give the appearance of padding stitched into the fabric of the character's outfit. Repeat this step on the other leg as well.

58 I mentioned when we were refining the basic forms that using a loop tool to carve out a line leaves sharp, unattractive edges on either side of the cut. These obvious tool marks take away from the realism of a sculpture. To soften the edges on both legs, gently take a loop tool to each side of every carved outline. You may be tempted to rake over the entire pattern from top to bottom, but doing so will deposit clay into the

recessed lines. Apply the same stitched padding pattern and softening technique to the inside of each arm as well.

59 This character should have a bold, tough look, so create some heavy shoulder armor. Just like the plates on the chest, roll out some clay with the handle of a tool, but this time the flat plate should be thicker than before. Cut the pieces into a shape that can drape over the shoulder and come to a point in the middle of the deltoid as you can see in image 59. Repeat this process three times to make the armor look like several thick pieces of metal stacked on top of one another.

60 To add interest, arrange more armor on the chest, abdomen, and shoulders in a pattern that you feel works for your character. This figure has a combination of symmetric design and asymmetric weight offered by the larger shoulder armor to balance the aesthetics.

Cut out and apply pieces that mimic the shape of the human collar bone, as well as two trapezoid shapes on the chest, to add more layers to the armor. Use your instincts to decide on all of these detail elements. Try things to see if they work; if they do not, you can remove them and try again.

61 In addition to cutting out various shapes with the hobby knife, it is helpful to source other items that can act like a cookie cutter to cut shapes out of clay. I unscrew the top half of a pen I have lying around the house and find that I can cut perfect circular shapes to add to a few different areas on the sculpture. Using this helpful trick saves me a tremendous amount of time and effort.

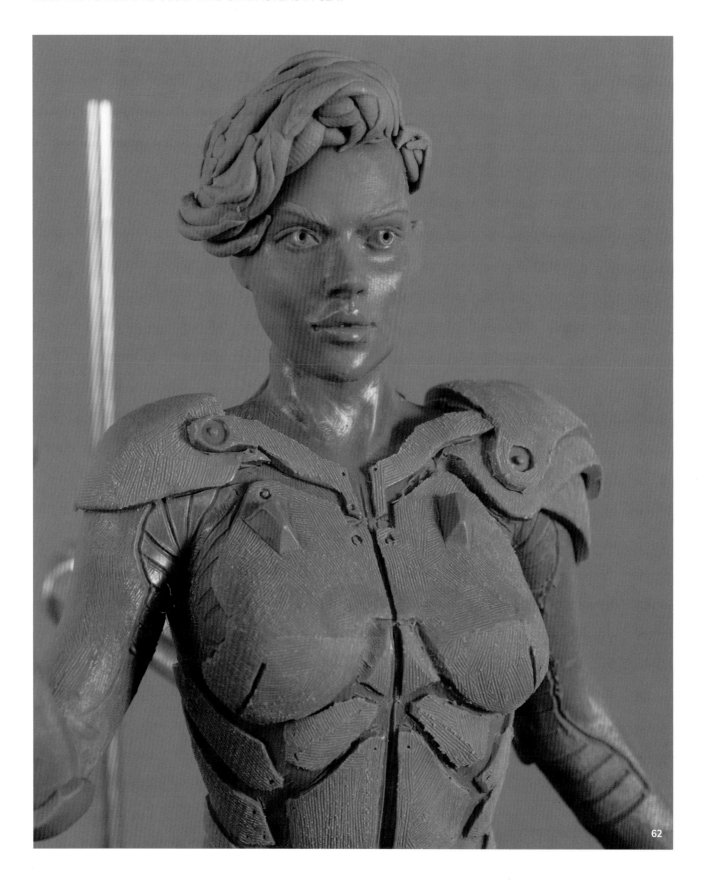

62

SCULPTING HAIR

62 It is time to add some hair to the character. We could have done this earlier in the process, but addressing the costume first can help to inform you of the type of hairstyle that will suit your character. Because there is a large piece of bulky armor on the right shoulder, the hair can be heavier on the left side to balance out the overall look of the figure. Take small pinches of clay, roll them with your fingers, and layer them over the head until you get a general shape that looks appealing.

63 Next, bring all those separate pieces of clay together using the heat gun to warm up the hair for a few seconds. Heat the hair enough to allow all the pieces of clay to rake together easily. You do not

CREATING SYMMETRY

A good way to make sure that your sculpture is symmetrical is to look at it in a mirror. This is most useful when sculpting a portrait. You may not notice errors when looking at it normally, but seeing the sculpture reversed can reveal, for example, if the facial features are not aligned properly.

A lot of sculptors experience this problem when they are learning, myself included. Keep a small hand mirror near your workstation and check the progress of your sculpture often. Over time, you will learn to compensate for this issue and only use the mirror once or twice to check your work.

want the clay to melt as this would cause the tool to gouge into the clay. Clay cools down relatively quickly, so repeat this process a few times to rake all the clay together. 🔥

64 Once you have raked the surface down use the side of a needle tool to mark in lines for the hair. Space the lines far enough apart to give the impression of hair strands without actually sculpting in every single strand. You can also have some strands dipped down and others raised up to make the shape of the hair a little more dynamic. If you do not do this, the hair could look too rigid and unrealistic.

65 To finish the hair, use a soft-bristle brush to apply clay solvent to smooth the surface out. Repeatedly brush the solvent in the direction of the hair, which will eliminate any tool marks. Again, be careful not to use too much solvent as this can make the surface muddy. ❗

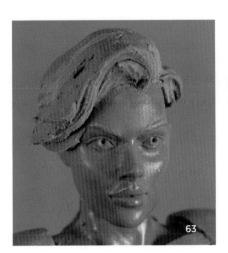

CREATING EARS

66 Now that the head is mostly complete, we can work on the ears without fear of damaging them. The first step is to use a needle tool to draw the basic shape of the ear forms such as the folds and recessed areas on the inner ear. This will help you work out where to add and remove clay. All ears are slightly different but follow the same general rules. Like the rest of the anatomy, it is best to gather some references to help you in this step.

67 Next, use a loop tool to scoop out the recessed areas. The largest areas are in the middle of the ear, between the folds at the top and back of the ear, and the small diagonal incision above the earlobe. Add a little bit of clay to the large fold on the inside of the ear and then use a medium-sized ball tool to blend in the added clay and shape the folds.

68 The rough shape of the ear has been established, but the forms need to be refined by raking the transitions in the folds. To do this use a small, fine rake that has a tight bend to enable you to reach inside those small areas of the ear. Lastly, use the brush and clay solvent again to smooth down the clay. ❶

69 Instead of sculpting another ear on the opposite side, I decide to cover the ear with a mechanical shape that is meant to be a communication device. Use the cookie-cutter technique from step 61 to create two concentric circle pieces of clay. Then use a drill bit to stamp in a design in the middle of the top layer. Once the figure is finished we will take a short length of light-gauge aluminum wire to fabricate an antenna and mouth piece for the communication device that the character would speak into.

DETAILING THE COSTUME

70 Another great tool for a sculptor working in clay is a stamp. A stamp is anything that you press into the surface of the clay to create an effect, and the best part is that it can be made from just about anything. Looking around the house I find a small Allen wrench that will be great for adding a patterned texture to this character. I use the end of the tool to carefully stamp out a perfect honeycomb pattern on the inside of each thigh.

71 Going back to the armor on this character, use the same techniques and processes that you used to create the chest pieces to add details on the back. You can also use the stamp technique to create a linear design going down the back of the character. The particular stamps I use here are two different sized drill bits that have recessed areas which leave a mechanical, sprocket-like design. These really fit into the overall futuristic look of the character.

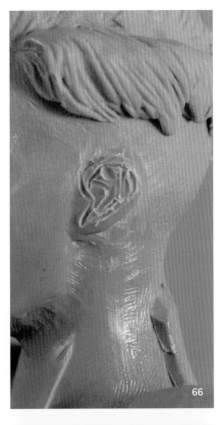

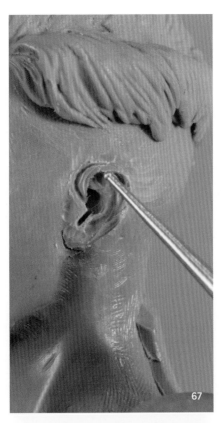

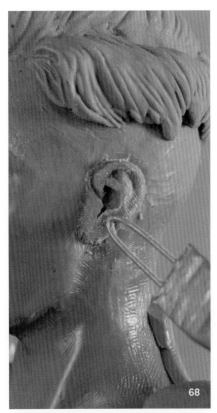

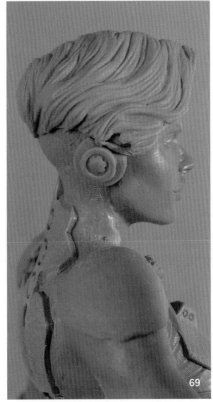

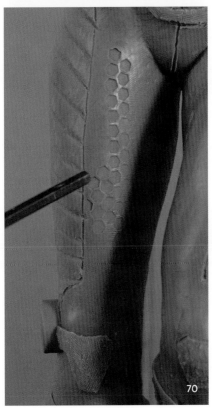

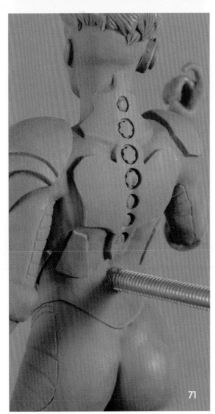

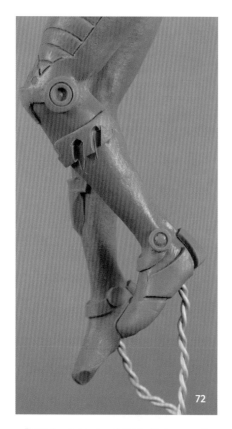

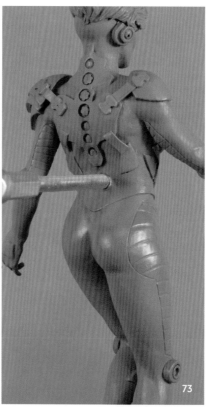

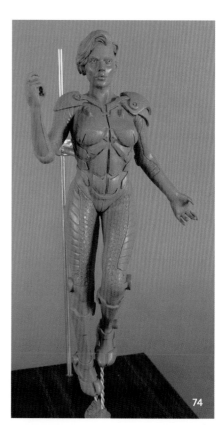

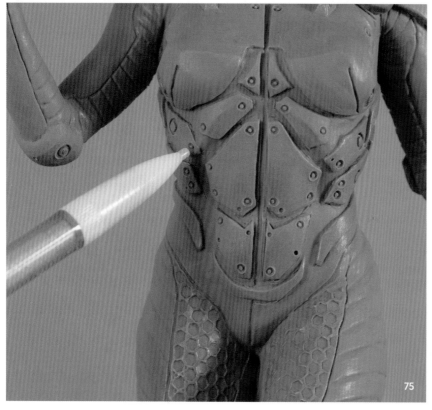

72 To add visual interest to the legs, cut out some more armor shapes with the hobby knife and play with their placement on the sculpture until you are happy with the design. Use the circular cookie cutter to create disks on the outside of the knees and then use the hobby knife again to cut shapes out of a sheet of clay to form knee covers.

Instead of adding a completely separate boot, recreate the same plate design from the torso onto the lower legs to suggest that they are constructed from several separate pieces lying on top of the character's suit. You can also use the stamp technique from step 71 to add more detail to the design.

73 The character's suit needs to be more complex and have elements that add to the believability of the design. To achieve this add strips of clay to form belts bridging between the armor plates on the back. Roll out a sheet of clay and then cut a rectangular shape and two smaller squares. The rectangular piece will serve as the strap, and the two square pieces can be shaped into buckles securing the strap to each armor plate.

ADDING FINAL DETAILS

74 One of the most important final steps in the sculpting process is to use loop tools and fine rakes to refine all of the detail and carefully smooth out the surface of the entire sculpture. Use a variety of these tools in different sizes and shapes to allow you to reach every nook and cranny of the sculpture. This step, although it can be tedious, will remove any light tool marks and fingerprints that may be present on the sculpture.

75 As I work on a character I continue to play with the design. For this sculpture I think the armor should show rivets or screws. Now that the character is raked and smooth all over you can go back and stamp smaller details into the surface exactly where you want them.

For this new stamp, use a mechanical pencil with the lead removed. This will offer you a very small hole with a little protrusion in the middle that looks convincingly like a screw. Remember to look around your house for anything that you might be able to use as a stamp!

76 As the sculpture is nearly complete we no longer need added support from the armature wire protruding from the character's feet. Take a pair of wire cutters and snip the wire level with the clay. Add more clay to the bottom of the foot to cover any exposed wire. As a final touch, take the Allen wrench again and lightly stamp a pattern onto the underside of the foot to emulate the look of boot treads. ✄

77 To create the futuristic pistol for the character to hold, take a block of clay and cut it into a clean rectangle using a hobby knife. Carve out a basic shape for the front half of the gun and then cut out a couple of perfect circles from a flattened plate of clay. These circles can then be applied to either side of the pistol. Next, use the hobby knife to scribe in join lines and cut out more details to make the weapon more visually interesting. Finally use the tip of a mechanical pencil to stamp in some tiny details.

Once the pistol is finished, gently bend the fingers out a little, place the handle of the pistol in the character's grip, and gently wrap the fingers back around the handle. After the pistol is in place, you can cut out a small triangle of clay and carefully apply it to the underside of the gun, behind the index finger.

78 Once the design is finished and the sculpture has been completely smoothed out and cleaned up with fine rakes and loop tools, it is time to use the clay solvent to smooth the surface even more. Using the soft-bristle brush again, carefully brush over the sculpture, being careful not to ruin the detail. Brush the surface in several directions to avoid leaving strokes in the surface. Again, be sparing with the clay solvent to avoid making the surface muddy. ●

79 Earlier in the tutorial we made a mechanical earpiece for the character. Now we need to make a vertical antenna that will emerge out of the earpiece and a microphone to curl around the front of the character's face. To create a spiral form for the antenna, take a short length of light-gauge aluminum armature wire and wrap it around a needle tool. Next, slide the wire off the needle tool and bend the top half of the wire into a straight line.

The microphone is made from another short piece of wire with a couple of bends in it that you can gently make with your hands. Apply a small piece of clay to the end of each piece of wire to look like sound receptors. Check that the antenna attaches to the sculpture then set it aside for one final step.

80 The sculpture is now complete, but before you can start photographing the finished piece, you need to seal the clay with a matte coating and apply a dulling spray. Sealing the clay is not absolutely necessary, but it will make the clay less likely to dry out over time, which would cause cracking. A layer of dulling spray will give the surface a unified finish and eliminate shine when you take photographs. Once the sculpture has been sprayed the antenna can be reattached. Make sure you use these sprays in a well-ventilated area. ●

77

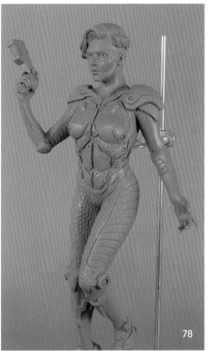

78

79

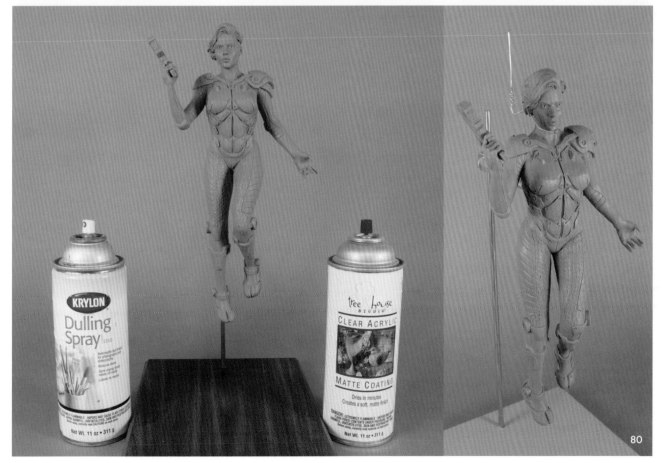

80

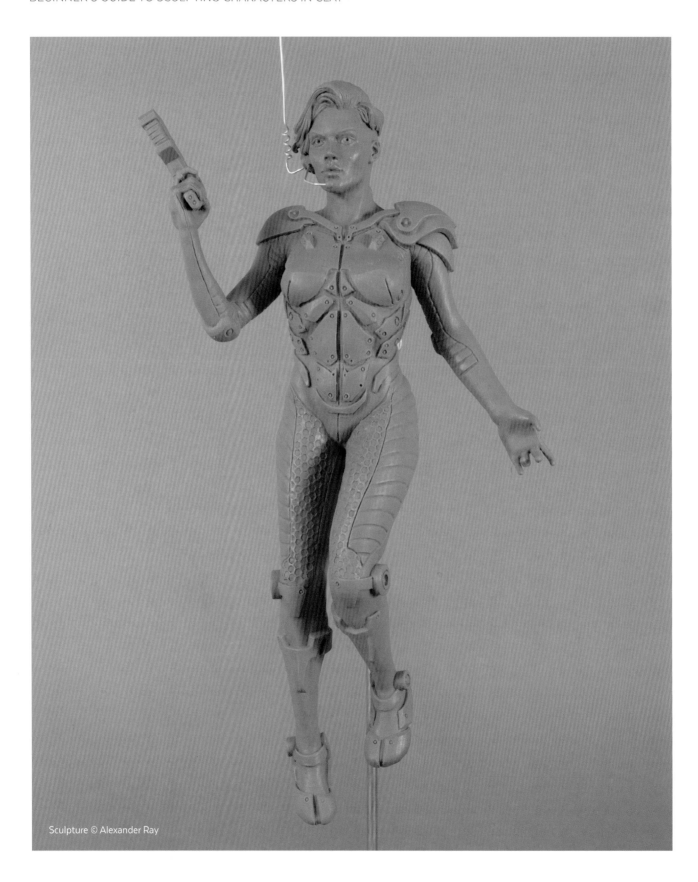

Sculpture © Alexander Ray

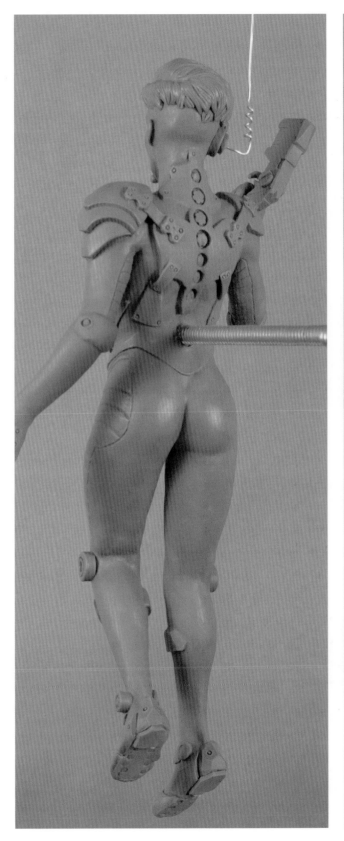
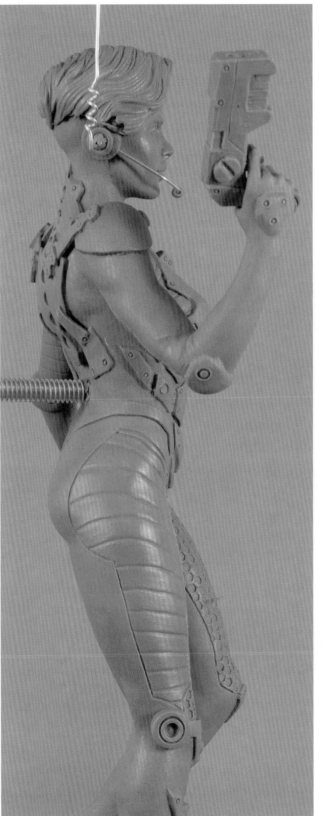

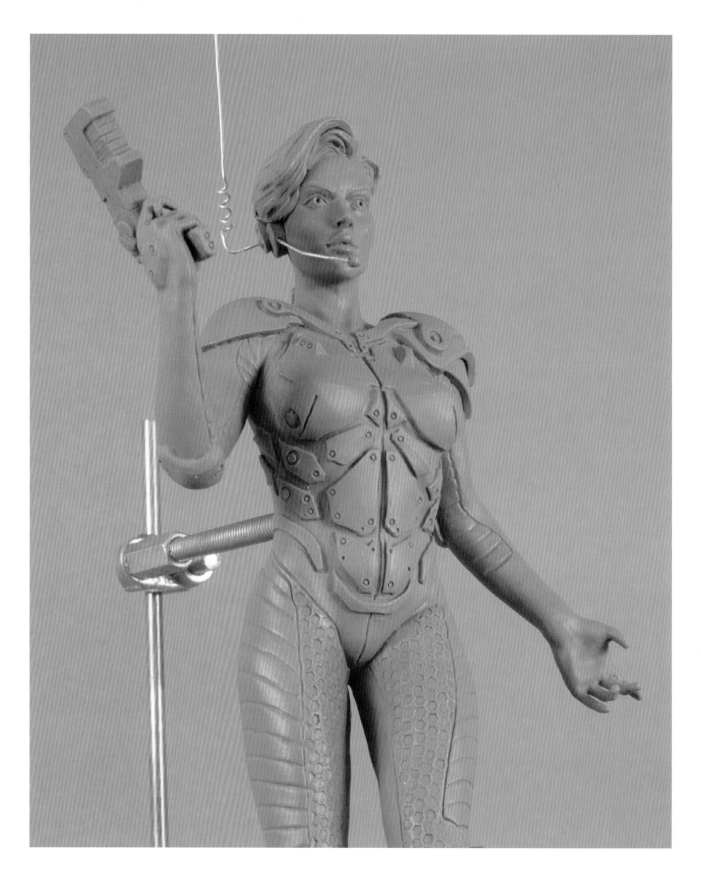

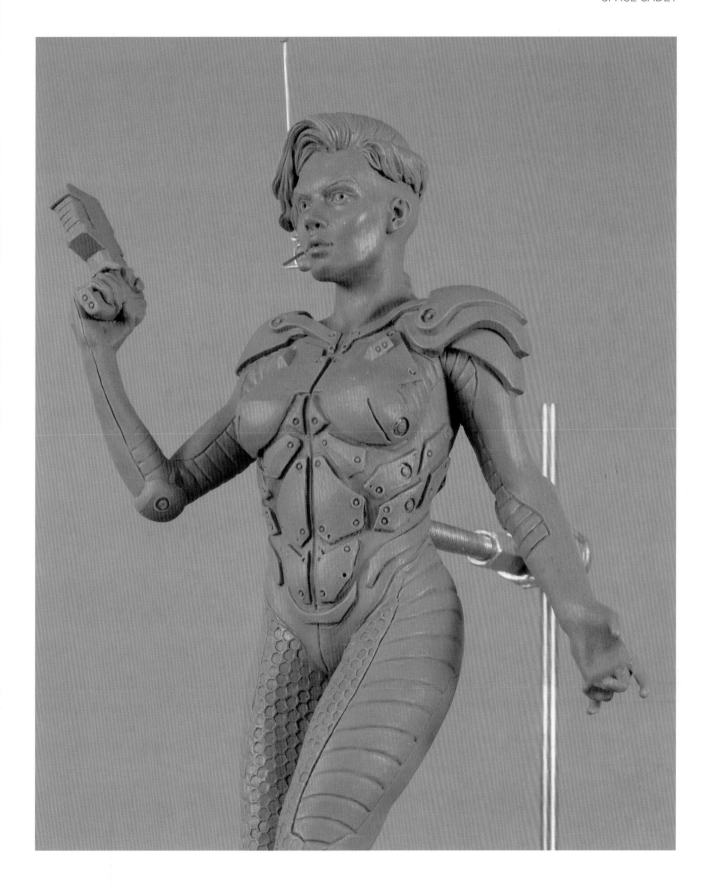

N.I.L-8 | Wax and resin | © Alexander Ray

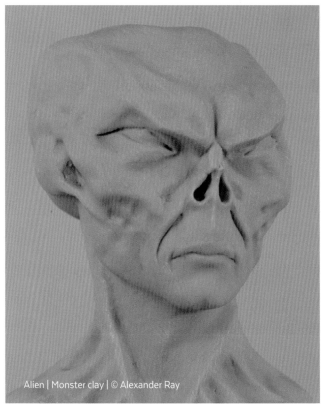

Alien | Monster clay | © Alexander Ray

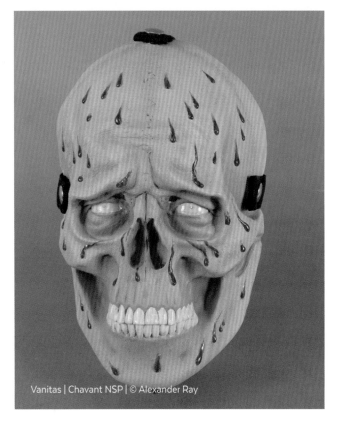

Vanitas | Chavant NSP | © Alexander Ray

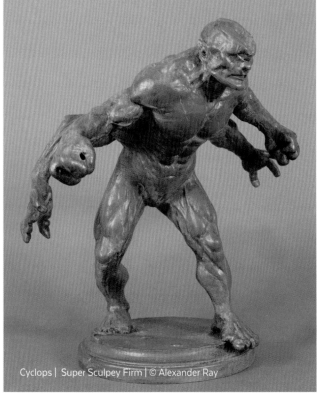

Cyclops | Super Sculpey Firm | © Alexander Ray

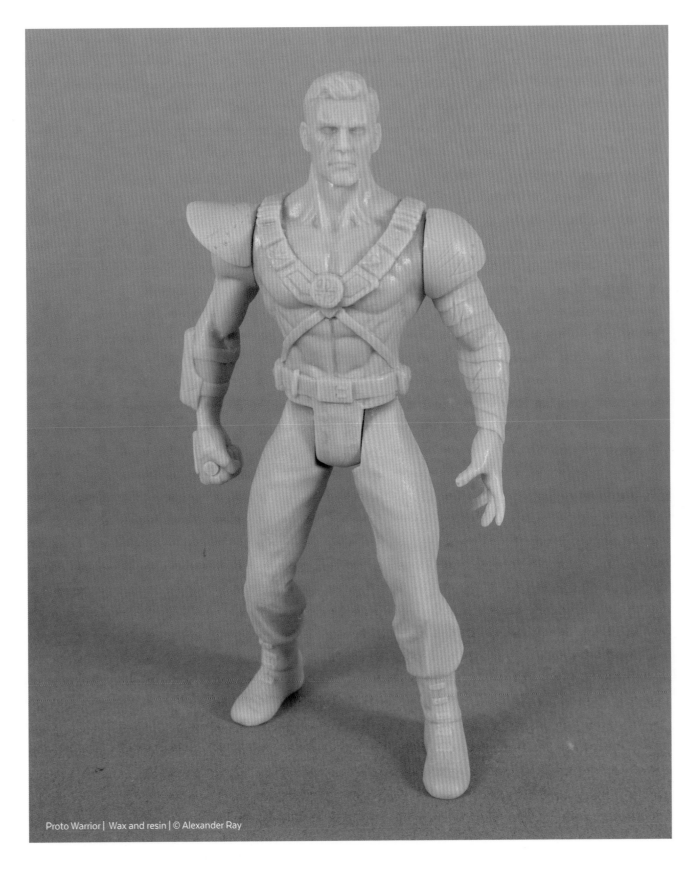

Proto Warrior | Wax and resin | © Alexander Ray

MERMAID

BY JENNIFER HENDRICH

MATERIALS

Aluminum wire (4- & 14-gauge)

Cardboard or newsprint

Florist wire (30-gauge)

Oil-based clay (medium density, red & gray)

99% rubbing alcohol

Wooden base

TOOLS

Aluminum foil

Ball tools

Camera (optional)

Drill

Hobby knife

Loop tools

Kidney tool

Oven

Paint scraper

Paper towels

Pliers

Rake tools (including a guitar-string one)

Small brush

Wire cutters

Wooden sculpting tool

In this tutorial I will demonstrate how to sculpt a mermaid basking on a rock from start to finish, sharing the thoughts that go into the process of creating a beautiful, graceful fantasy figure with lots of movement and eye-catching elements. I will show you how to build up the form and anatomy of the figure piece by piece, starting with the skeleton and moving on to muscles and flesh. This will give you a detailed breakdown of a character-based sculpture so that you can then transfer this knowledge to a variety of future sculptures.

As part of this I will cover how to assemble a simple unconstrained armature. It is common for sculptors to plan out their sculptures fully and to create an armature that is secured to a base before sculpting. This is very important for medium- and large-scale sculptures. Since I work in a small format, I like to keep my armature free of constraints during the sculpting process. I find this helps with the creative process and it also makes it possible to experiment and achieve more expression and movement in a sculpture. It is always possible to add in wires for support in any pose you end up with and you can worry about connecting the figure to a base later.

PREPARATION

01 Before you start a sculpture, I recommend having in mind a good idea of what you want to sculpt and what you want it to look like. Think about what kind of emotion and action you want to convey. What do you want the viewer to feel or think when they look at your sculpture? Do you want the mermaid to be happy, sad, relaxed, or stressed? How will you tie in all of the elements from the mermaid to the rock? To begin then, draw some small sketches, also known as thumbnails, in a sketchbook, trying out different poses and compositions.

02 Most importantly in these preliminary stages, you should collect all the references you will need to help yourself during the sculpting process. While I will describe the placement of different anatomical components in detail, referring to references will be a necessity as you work through the sculpting process. It helps to understand what something looks like and how it moves before trying to recreate it. I recommend studying the skeleton, muscles, and clothed and nude anatomy of humans and animals from life, books, and photographs. If you can sketch humans and animals in a sketchbook it will help you to understand them. Scale models and écorché figures are also very handy to study from since you can hold them in your hand and study them in different lighting.

For this project I gather reference images from the internet and anatomy books: human references for the skeleton, muscles, and female body as well as fish fins and fish scales. You could go out to the beach to collect real seashells and rocks to get a feel for the textured surfaces. I also have scale human anatomy and skeleton models that I can touch and study, which I recommend.

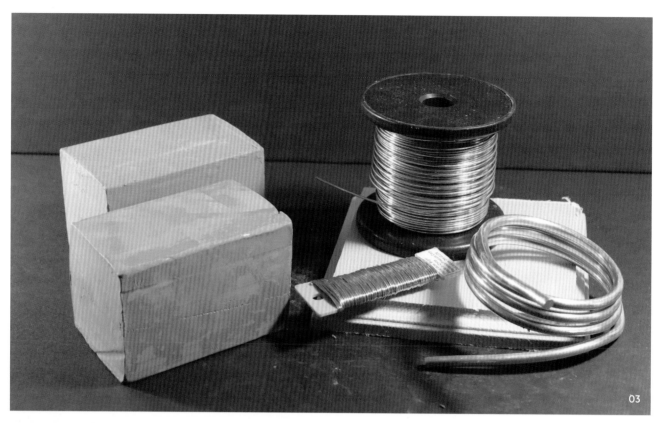

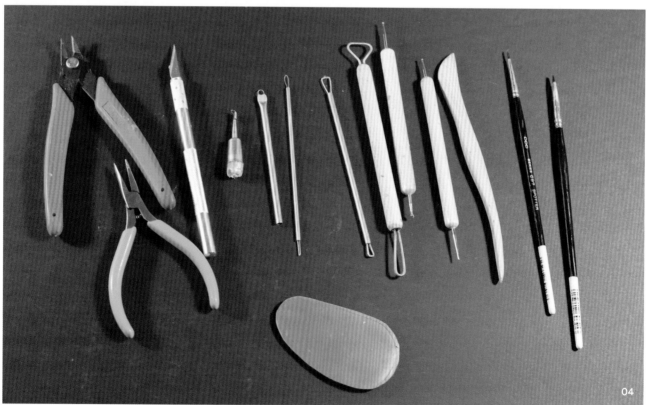

MATERIALS AND TOOLS

03 I prefer to use medium-density oil-based clay. This clay, when heated up, is easier to manipulate, detail, smooth, and clean up than other clays. The clay will not expire as long as it is covered in plastic film; dust will stick to it easily if left uncovered. It will not dry like water-based clay and it cannot be baked in the oven like polymer clays. It has to be molded and cast to make a permanent copy.

I will use two colors of clay for this sculpture: red clay for the mermaid and gray clay for the rock. I will use 30-gauge florist wire in addition to 4- and 14-gauge aluminum wire for the armature. I will also use a wooden base large enough to place the sculpture on.

04 You will need an assortment of tools and equipment for this tutorial: wire cutters and pliers for working with the wire armature; a hobby knife for cutting clay; loop tools for detailing, drawing, and carving; ball tools for detailing; a kidney shape for carving; a wooden sculpting tool like the one you can see in image 04 for carving, flattening, and smoothing; and rake tools for raking the surface to loosen clay and blend it together. I also use 99% rubbing alcohol and a small brush for cleaning up the surface of the clay. Other equipment I use includes a conventional oven for heating the clay, paper towels for cleaning up, a paint scraper, and aluminum foil. Make sure all your tools and materials are laid out, ready to use.

05 In preparation you will need to heat up the clay to make it easy to work with. I turn on my oven to approximately 38 degrees Celsius, a temperature with which I am comfortable handling the clay using my bare hands. Warm the clay blocks in the oven until they are soft throughout, then slice them up with a paint scraper on a dish made from aluminum foil. Take only the chunks of clay that you will need, leaving the rest in the oven to stay soft. To protect the surface you are working on, lay out cardboard or newsprint. 🔥

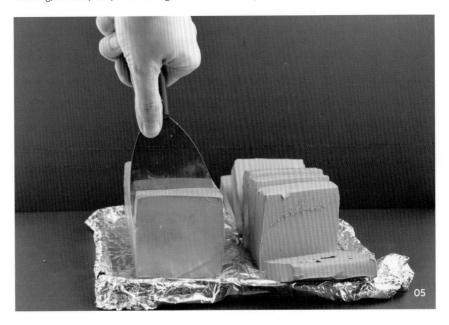

05

CREATING THE ARMATURE

06 The mermaid will be a posed figure approximately 10 inches tall. As mentioned in the introduction, we will not affix the armature to the base in order to give ourselves more freedom in posing. Begin your armature by cutting approximately 40 inches of the 14-gauge aluminum wire with a wire cutter. Fold the wire in half, leaving two equal lengths of wire, then twist the two wires together about 7 inches down from the open end for a length of about 3 inches – this will be the spine. Cut the wire at the fold.

07 You should have about 7 inches of wire in length for the shoulders and arms, and 10 inches in length for the pelvis and tail. Fold down the arms from the top of the spine. You can keep the legs separate from each other for now until you start forming the tail; this will help you to ensure you have correct human proportions when you form the pelvis. Cut a bit more of the 14-gauge wire for the head and bend it in half, making it long enough to support the head and neck, and also to stick into the top of the torso.

08 Now cut plenty of the 30-gauge florist wire with the wire cutter. Starting from the spine, wrap the wire around the armature evenly. This will help the armature grip the clay and keep it from slipping off the slick surface of the aluminum wires. Go from the spine down to the end of each leg and up again so that it criss-crosses. Then do the same from the top of the spine to the end of the arms and back again. Wrap the head and neck armature in 30-gauge florist wire as well, leaving the lower parts unwrapped so that you can "stick" it in the top of the torso later.

Using pliers, hide the tips of the florist wire in the armature so that they do not poke out in order to avoid potential injury. ✂

09 Planning out the body proportions, think about the type of figure that the character will be. I want it to have a strong fantasy feel so I will make the limbs long and exaggerated to show elf-like grace. Using a set of pliers and referring to a skeleton reference, start bending the armature to form the limbs: estimate the width of the shoulders for each arm and bend the arms down; then estimate the width of the pelvis and bend the legs down from the leg sockets; next estimate the length of the upper arms and bend the elbows; finally estimate the length of the lower arms and bend the wrists slightly. Twist the legs from where the knees would be down to the bottom to form the tail.

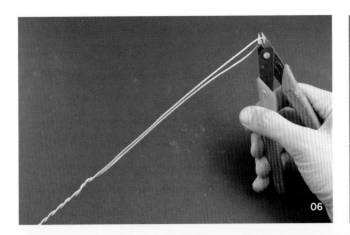

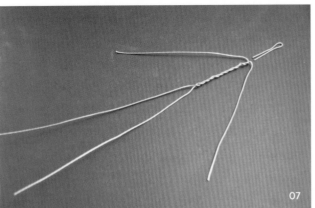

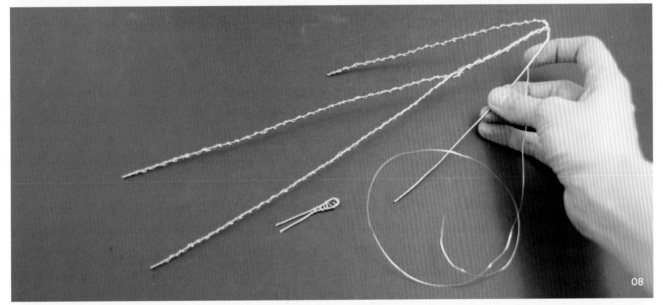

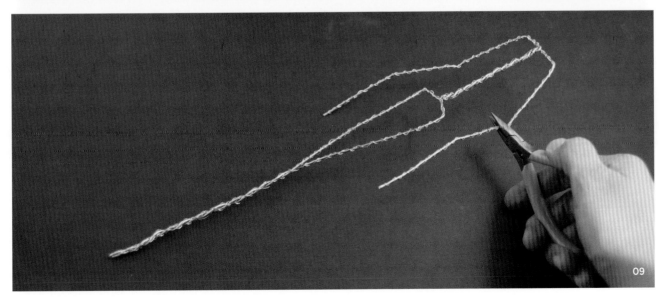

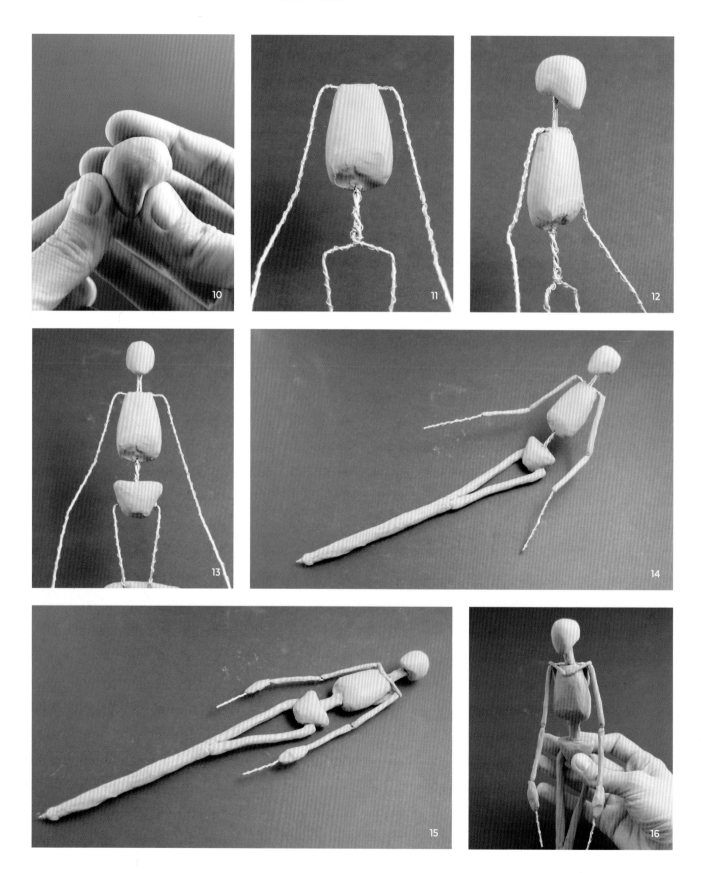

BLOCKING IN BONE STRUCTURES

10 We will now begin working with the clay. Start the skeleton by defining the larger bone structures, the bony masses that will define the figure's form, such as the skull. Keeping a skeleton reference to hand, form the skull relative to the proportions of the body by taking a chunk of clay and shaping it in your hands to form a ball. In image 10 you can see how I form the clay into more of a skull shape. The skull does not have to be accurate for now, so just roughly form the cranium and jaw, and then set the skull aside.

11 To make the ribcage, roll an egg-shaped mass in your hands with the bottom cut out, wider at the bottom than at the top. Estimate the length and width of the ribcage and its placement on the spine, then wrap the clay around the spine wires, keeping the mass of the ribcage in front of the spine while covering the back of the spine. Leave enough room on either side of the ribcage for the arms to fall straight down from the shoulders.

12 Now you can attach the skull to the rest of the armature. Insert the head armature into the base of the clay skull where the neck connects to the skull, behind the jaw. Leave the length of the head armature wires exposed; they should be the length of the neck. Next insert the wires at the base of the neck into the top of the clay ribcage.

Make sure the skull can be removed again because it will be much easier to detail the skull in your hand when the time comes. When the head is removed it will also allow better access for detailing the upper torso.

13 To make the pelvis, form a rounded triangular shape in your hands that is broad at the top and narrow at the bottom. Estimate how big the pelvis is on the spine then place the pelvis at the bottom of the spine, keeping the mass of the pelvis in front of the spine. Make sure that the hip wires come out of the sides of the lower half of the pelvis. I leave space in the lower spine between the ribcage and pelvis so that this part remains flexible.

14 To form the limbs, we will roll long, narrow tubes of clay and wrap them around the arms, upper legs, and tail. They do not need to look exactly like real bones since they will be covered up later with muscle and flesh. Define the elbows on the arms by leaving a small space between the upper and lower arm, so that you can bend the elbow more easily. Estimate how long the upper legs are and add tubes of clay, then add a thicker, longer roll of clay for the length of the tail. Make sure the armature wires are centered in these tubes of clay and not visible.

15 You now need to fill in the rest of the spine and make temporary hands. Roll out two stumpy tubes of clay. The first tube is for the neck: wrap it around the armature between the skull and ribcage. Wrap the other tube, for the lower spine, around the armature between the ribcage and pelvis. Flatten two bits of clay for the hands temporarily for placement. These are shaped more like mitts but should be approximately the size the hands will be.

16 Move on to work on the shoulders, which consist of bones called the clavicles and scapulae that run along the front and back of the shoulders and rotate up and down with the shoulders. They are visible under the skin so they need to be accurate. Referring to anatomical references, form small, long tubes for the clavicles and place them from the front and center of the top of the ribcage to the top of the arm socket. Form flat triangular shapes for the scapulae and place them on the back of the ribcage. Keep the clavicles and scapulae loosely connected because as we pose the character, these will change position.

ADDING MUSCULATURE STRUCTURE

17 Moving on to the muscles of the body, continue to refer to human anatomy and muscle references. Since this is a female fantasy figure, I will keep the muscles thin and soft looking. Roll a small piece of clay in your hands and flatten it into the shape of the pectoral chest muscle. These are wide flat muscles that connect the chest to the upper arms. For the abdominal muscles in the middle, roll a tube of clay, flatten it, and connect it from the bottom of the ribcage to the middle of the pelvis. Rough out the side abdominals with simple tubes, connecting them to the side of the front of the ribcage down to the pelvis.

18 Now work on the muscles of the front of the arms. To create a deltoid muscle, form a flat triangular piece of clay, wrapping it around the top of the arm just under the clavicle. Now roll a tube of clay for the biceps, which run from the armpit to the elbow pit. Form another tube of clay for the brachioradialis muscle that wraps around the lower arm from the outside of the upper arm to the base of the thumb. Add these to the figure and repeat for the other arm.

19 Turning the figure around, work on the muscles on the backs of the arms. The triceps on the back of the upper arm are a little larger than the biceps. For the first arm roll a tube of clay and connect it from the back of the armpit down to the elbow. For the back of the lower arm, roll a tube of clay and attach it from the inner elbow down to the side of the hand above the little finger. Repeat for the second arm. Add small bits of clay to define the elbows and blend them in a bit.

20 Moving on to the muscles on the front of the leg, first add clay between the two legs to fuse them together. You can then start to define the leg muscles just to get some definition in the hip section of the tail. Add the front thigh muscle group with a long tube of clay for each side. Flatten each tube slightly and make the top of each one narrow. Connect the tubes from the tip of the pelvis and blend into the knee area on each side.

21 Now work on the muscles on the back of the legs and the gluteals by adding a tube of clay down the back of the legs to fill in those groups of muscles. To form the gluteals roll a half-egg shape of clay and connect it from the back of the pelvis across to the side of the tail. The gluteals should be loosely attached to the tail because when the tail bends at the pelvis, this muscle will change position and shape.

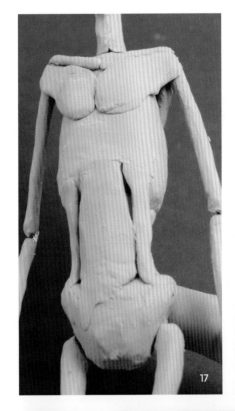

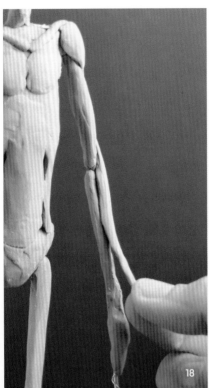

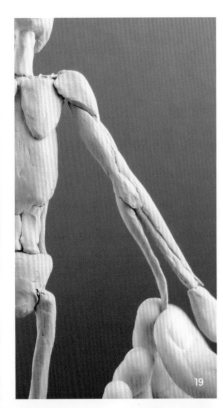

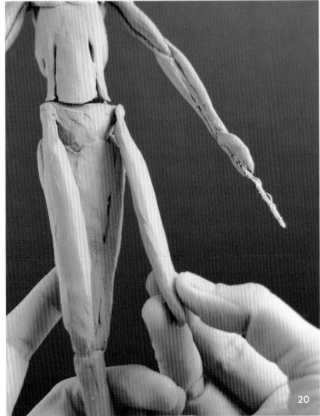

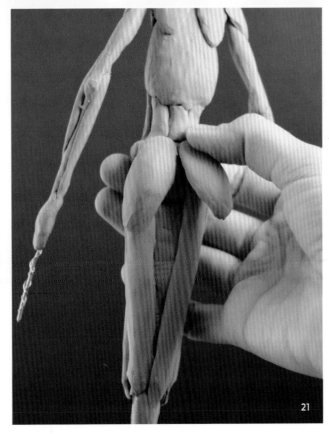

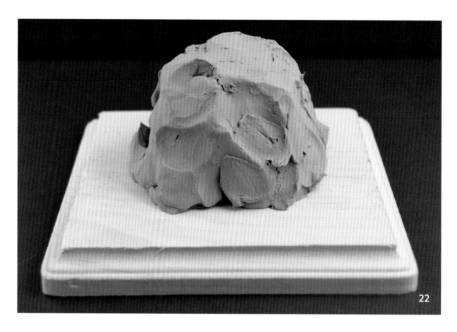

22

FORMING THE ROCK BASE

22 You can now briefly move from the figure to the rock it will rest on. Grab some slices of gray clay and place them on the wooden base. Using your thumbs press the sides down to the base. Keep everything rough and uneven as the rock is there to complement the character's pose; we do not want to pose the character around the rock. You can shape the rock more after you have settled on the final pose. I keep the figure free from the rock because I want to give myself freedom to change the pose as the sculpture develops.

POSING THE FIGURE

23 At this point in the process you are ready to start posing the figure. You can pose her by simply bending the armature wires. Referring to your thumbnail sketches and human references, try different poses while thinking about the emotion and movement you want to express with it. I think about balanced compositions because she is basking on the rock and at rest. I also consider the line of action and complementary curves in the form. If I come up with any poses that I like, I take a few photographs so that I can go back to them if I want.

24 When posing a clay sculpture, it is important to make sure that the pose works from all angles. The character needs to look balanced and the composition needs to work from all angles as well. Try to make sure that she does not look like she is falling off the rock from the sides, top, back, and other odd angles. Ensure that there are appealing curves in the pose from every perspective. It can be useful to take photographs from different viewpoints at this stage because it is easier to see if something is wrong in a photograph. Keep turning the sculpture around, adjusting the pose, arms, tail, torso, and head as needed.

25 In image 25 you can see that I add a chunk of clay to the side of the rock to support the figure's gesture in this pose. I blend the clay into the rock with my thumbs. I choose this pose because it shows a lot of movement even though the figure is at rest. She is leaning on the rock and bending over with her arms supporting her upper body, which creates visually appealing curves. Her tail balances her out with its own curve. I make the lines of the body and arms direct the viewer's eye to her head because I want them to know that the mermaid is looking at something far off in the distance.

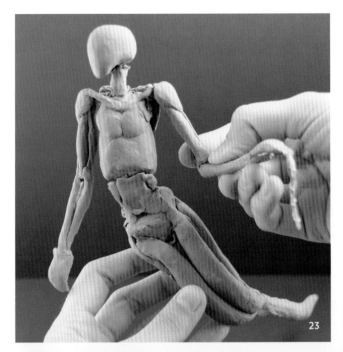

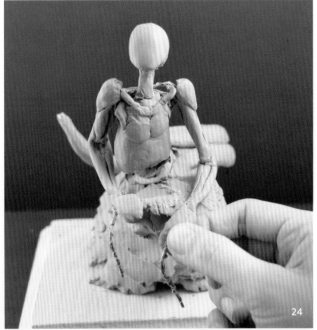

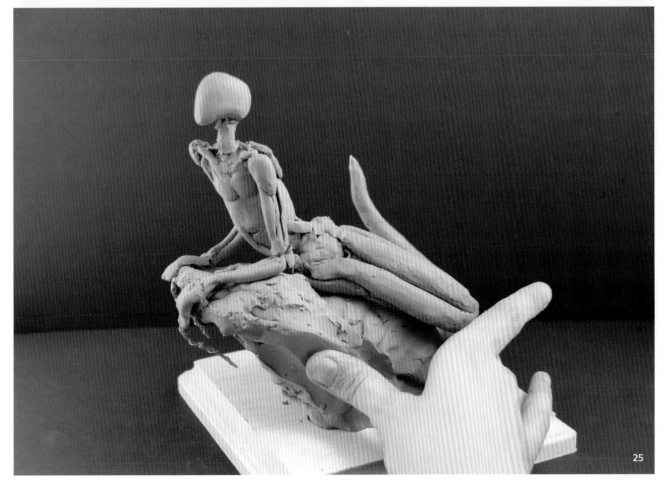

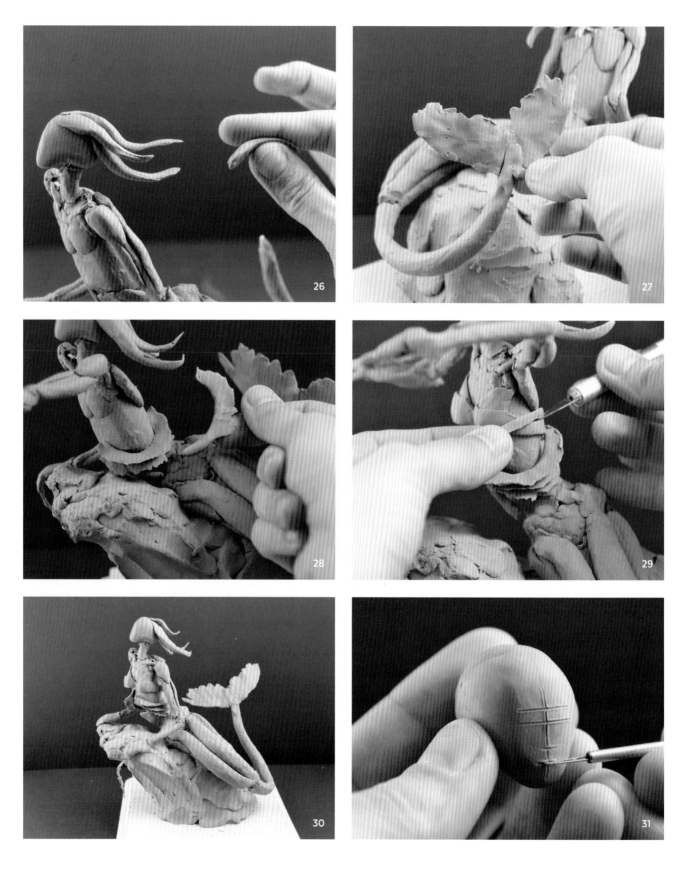

ROUGHING OUT
ADDITIONAL FEATURES

26 After posing the figure you can add rough temporary hair to create some movement. Roll long tubes of clay that represent locks of hair. To taper them out like hair, push your thumb down the length of them. Attach the tubes of hair loosely to the back, sides, and top of the head and play around until you find something that works with your composition. I want to suggest an ocean breeze so I sweep the hair back and out behind her head to imply that it is being blown by the wind. This is only temporary hair, so a general shape is fine; you do not need to detail it yet.

27 Referring to fish references, make temporary tail fins by rolling two balls of clay and elongating them, smoothing them out with your thumb and forefinger. Make them look similar to fish tail fins for now. You can taper the tail at the end slightly to make it appear more delicate. Now that we have added another element you may need to adjust the position and angle of the tail so that the fins fit into the composition and complement the figure.

28 Add temporary gills by rolling six tubes using your hands. Experiment with different positions for the gills and how they work with the composition. I decide to place the gills on the lower ribs because they look like frills. Bend the arms up so that you can gain better access to attach the gills and bend the arms back down when you are finished. Curve the tubes around the ribcage, following the natural curvature of the ribs, and then flatten them out with your thumb and forefinger to protrude from the ribcage. Try not to hide too much of the figure's anatomy with the gills.

29 Next add details to the upper torso. To indicate the breasts, add two tear-shaped pieces of clay to the chest. The breasts fall lower on the pectoral muscles, above the end of the sternum. For now cover the breast area with a bikini top: add a tube of clay and pinch it thin like fabric, wrapping it around her chest and back. Use a hobby knife to cut it thinner around the back to indicate a strap.

30 Begin to adjust the character's pose by bringing the arms back down into position. As I add details to the figure, I constantly reassess the position of the limbs; for example I adjust the position of the hands and arms to reveal more of the gills and chest. I also adjust the shoulders, one up and forward, the other back and down; I twist the torso a bit, always referring back to human references.

ADDING DEFINITION
TO THE HEAD

31 Now that you have roughed out the sculpture you can start to define the skull. Make sure you refer to skull anatomy references while completing this step. Remove the head and neck from the figure and remove the temporary hair from the skull. Using a loop tool, map out the proportions by drawing lines across the front of the skull (see page 72 for a reminder of these proportions). Draw small lines to mark approximately where the eyes, brow ridge, nose, and mouth will be positioned, and a long vertical line to indicate the middle of the skull.

"IF THE JAW IS LOOKING A LITTLE UNEVEN, ADD A BIT OF CLAY TO ONE SIDE AND BLEND THAT IN"

32 With the proportions of the skull mapped out, you can now define the planes of the head. As reference, I use a physical model of a skull with a light; to see the planes that I am defining, I rotate the skull model in the light. Use your thumb or finger to lightly push the clay, dragging your digit across the plane. Define the eye sockets by digging your thumb into each side of the nose just below the brow line and down to the jawbone. Next define the brow ridge at the top of the nose, then the cheekbones, temples, and jaw.

33 To define the facial structure in more detail, use a loop tool to dig a little deeper into the eye sockets, so that there will be room to put eyeballs in them without the eyes protruding. Define the nose by adding a small piece of clay then blend it in with your fingers. Subtly dig clay away from the nose down to the chin. Draw a line again where the mouth will be, then dig into the mouth and open it slightly for expression.

34 It is now time to add clay on the facial features. Roll a tiny ball of clay that will be approximately the size of an eyeball at this scale and cut it in half. Take each half and place them directly in the middle of each eye socket. Ensure the eyes are vertical in the middle of the head.

To add the eyelids, use a tiny ball tool to lay very small rolled-up pieces of clay over the bottom and top of the eyeballs. For the lips, lay a tiny piece of clay over the top and bottom of the mouth opening.

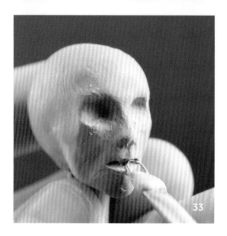

35 Using a ball tool, blend the eyelids into the surrounding eye socket. The upper eyelids overlap the lower eyelids at the outer edges of the eyes. The eyelids wrap around the top and bottom of the eyeball three-dimensionally so refer to references to make sure you portray this correctly. Define the tear ducts using a ball tool to push the ends of the upper and lower eyelids together. Push the clay between the eyeball and lower eyelid corner up slightly, then draw the ball tool along the upper lid, bringing the corner down.

Blend the clay on the nose, smoothing the sides of the nose into the front of the face. Define the nostrils by adding two small balls of clay and blending them in. Use the ball tool to define the nostril holes, then draw the tool along the edge of the nostril to create a crease. Next blend the lips; the upper lip runs over the lower lip.

36 Having sculpted the face, compare the size of the head to the rest of the body. I find a few areas on the skull that require touch-ups. I add a few pieces of clay to the brow and cheekbones and blend the clay into the skull with my thumb. If the jaw is looking a little uneven, add a bit of clay to one side and blend that in. Also add two pieces of clay to the sides of the head for the ears and blend those in.

37 Moving on to defining the hair, you can again create locks of hair by rolling out many tubes of clay of different lengths and widths, using your thumb and finger to flatten and smooth them so that they taper at the ends. To keep the locks from potentially falling off the head, twist two pieces of florist wire together and stick them into the locks (see image 37). To prevent the longer locks from drooping, take the twisted florist wire and run it further through the locks. The ends of the wire can then be used to attach the hair strands to the clay head.

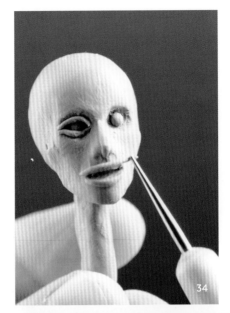
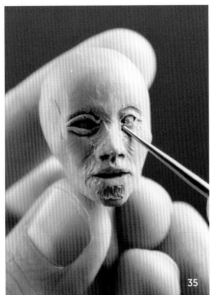
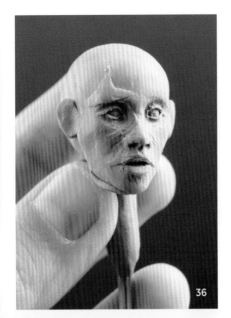

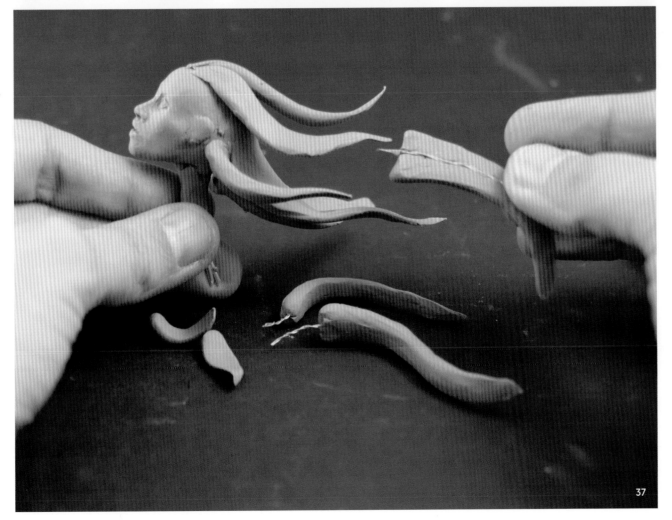

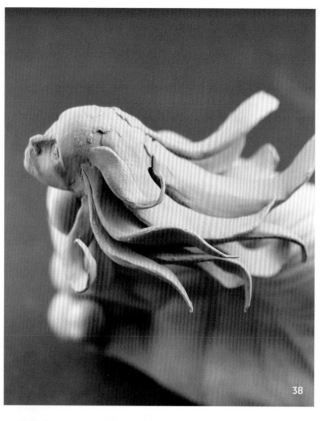

38

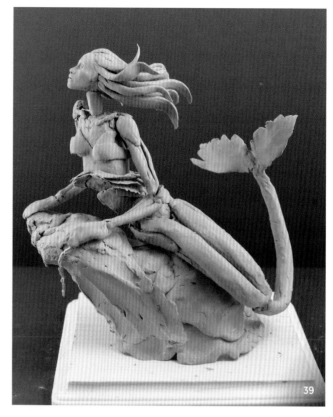

39

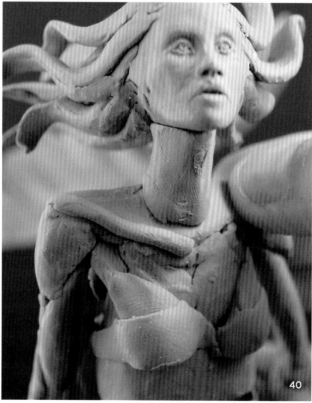

40

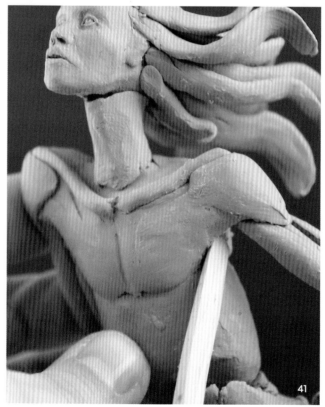

41

38 As you add the locks, work on the flow of the hair; keep in mind that there is a strong breeze and the head of the figure is facing it. You can curve the locks in slightly different directions but they should all flow in the same general direction. Add larger, thicker locks for the inner, thicker parts of the hair. These make up the bulk of the hair. Then add thinner and thinner tubes as you get to the outer part of the hair. These need to have more of a curve than the inner locks to show that they are more affected by the breeze. Finally, add very thin hairs that act as strays and curve even more as if they are being whipped in the wind.

39 Once you are happy with the look of the hair, blend the tubes into the head with your fingers. You can then place the head back on the figure. I tilt the head to make the mermaid look up. I also adjust the hair so that it fits into the composition while appearing to flow with the wind realistically. Check the hair from all angles to make sure the strands are flowing the way you want. You can still keep the hair very rough at this point.

ADDING DEFINITION TO THE BODY

40 Keep the head connected to the body to fill in the shoulders. Add clay to thicken the neck to match the size of the head. Fill in the space on the shoulders in between the clavicle and scapula, using your finger to push the clay in. If the clavicle bones were damaged during posing, you can fix them by rolling them up again into tubes. I make them a little bigger than they were before so that they stand out more. Do not blend this area yet because we need to be able to remove the head and neck again later.

41 Returning to the muscles on the front of the upper torso, remove the temporary breasts, bikini top, and gills. The posing will probably have damaged the appearance of the pectoral muscles, so reconnect those to the upper arms. Sculpt them more realistically now by referring to anatomical references and press them on with a wooden sculpting tool. Fix the deltoid muscles, since they will also have been damaged during posing, and give them a more realistic connection to the chest. Then add in small bits of clay to fill in the armpit region.

42 Moving down to the lower torso where the abdominal muscles are, first lift the arms slightly to make it easier to access this area. Posing the character will have loosened the abdominal muscles from the lower ribcage so press them back on. The torso will have twisted, so twist the abdominal muscles across the lower torso down to where they originally connected to the pelvis bone, smoothing them out using your thumb.

43 Turn the figure around to work on the back muscles. The hair can get in the way of working on this area so you may want to remove the head and neck temporarily. Reposition the scapula muscles, tilting the right clavicle up with the shoulder. With your thumb, add a slight ridge to them at the top. Wrap the back of the deltoid muscles over them. Turn the sculpture around and check the figure from the side to make sure that there is enough mass in the upper torso and that nothing is caving in or malformed.

44 Next we will work on the lower back muscles, filling in any spaces between the lower back and the ribcage or pelvis. First, draw a reference line from the base of the neck down to the pelvis to get a better idea of where the spine is (you can see I started this in step 43). Roll two thick tubes of clay and flatten them. Put these on the sides of the lower torso where the bulk of the side abdominals are, making sure they twist naturally with the torso. Turn the figure around as you add these to check their position from different angles.

45 Using the spine line as a guide, you can now add on the groups of muscles that run down the back of the torso on either side of the spine. Raise the arms to make it easier to get to the armpits. Roll out two tubes of clay, wider at the top and thinner at the bottom, then flatten them so that they are a thin shell. Wrap them around the back, connecting at the armpit, down along the spine, and finally connecting to the middle of the pelvis. Rotate the figure slightly as you do this. Leave a gap where the spine is as we will fill this in later.

46 Turning the figure around, redefine the ribcage to make it look more realistic; I would recommend using a rake tool made from guitar string at this point because this sort of tool is great for blending edges of clay and drawing the direction of muscles or bones. First blend the upper abdominals into the ribcage. With the rake tool, you can then define the dip between the ribcage and the abdominals. Next, along the curvature of the ribcage, draw the dip between each rib all the way back to the back muscles and up to the pectoral muscles.

47 Moving on to the abdomen area, use a loop tool to draw a line down the center of the lower torso, from the ribcage down to the split between the legs. Fill in the space between the leg muscles with a bit of clay. For the two bones on the side of the pelvis that protrude, add two tubes of clay, blending them into the abdomen with a guitar-string rake tool. I feel the abdominal muscles are too sunken here, so I lay two flat tubes of clay along the middle line and blend them in. I draw a line with a loop tool to indicate where the belly button will be.

SUPPORTING PARTS

It can be good practice to have supports for parts of the body that you have set aside when you are not working on them instead of laying them down. I usually have a piece of clay or a small wooden support with holes for wires in it to secure the body part. For example, I tend to remove the head a lot while working on a figure, so I keep a ball of clay stuck to the table and stick the wires of the head into it. This prevents the head from resting on hard surfaces and possibly becoming damaged or flattened in some areas.

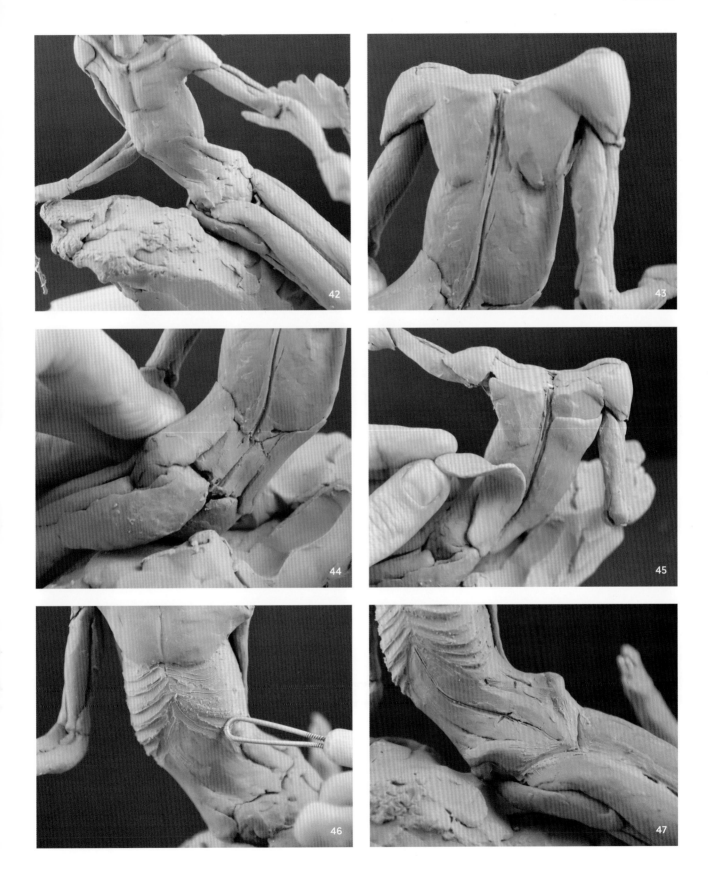

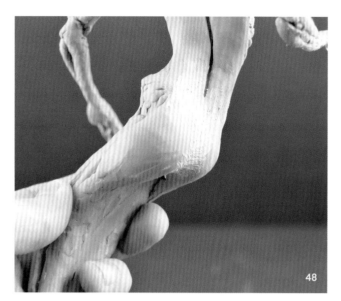

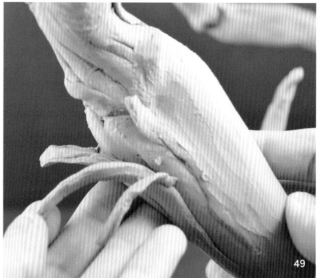

48 Turning the figure around, pick her up from the base to work on the gluteal muscles. I feel the gluteals are too flat now that the tail has been bent during posing and that they need more definition. Roll two thick tubes of clay, placing them over the old clay we put there before. Shape the gluteals to support her body more. Where they meet the rock, they should flatten a little. Since this is a fish tail, use the guitar string rake tool to blend them together while maintaining a pleasing shape. Blend them into the lower back muscles.

WORKING ON THE TAIL

49 Now you can work on the tail, starting with the hips. There are gaps in the hips below the pelvis so roll out some tubes of clay and fill in that area, tapering the tubes down the length of the hip. Also lay a tube of clay down the middle of the tail to fill in between the two legs. Use a guitar-string rake tool to blend the clay tubes together, then use your finger to smooth out the surface and the shape to remove any bumps or gaps. I make an exaggerated feminine hip shape.

50 Turning the figure around, take some chunks of clay and fill in the gaps in the back of the hips, below the gluteus on each side. Once again blend them in with the guitar-string rake tool and your fingers. Place the figure down and study the hips from the side to make sure they work with the rest of the figure's proportions; they should not be too thick or thin. Give them a soft curve into the rest of the tail. Make sure you rotate the figure and check that the hips work from all angles; adjust where necessary, filling in any gaps or valleys and raking down any lumps or bumps.

51 Work your way down to the lower tail. Wrap clay around it making a soft and smooth transition from the hips down to the end. I taper the thickness of the tail from thick to very thin, however I feel that the lower end of the tail is much thicker than I want it to be and that the wires are too thick together. To resolve this, remove clay from the lower tail, cut out one of the twisted wires, and straighten out the remaining wire with the pliers. You can leave the wire exposed because we will wrap the tail fin wires around it. ✂

52

"AT THIS POINT WE ARE EXAMINING THE COMPOSITION WITH ALL OF THE ALTERATIONS WE HAVE MADE"

52 Use the temporary fins as a base for the tail fins. First measure out a piece of 30-gauge florist wire that is four times the span of the fins on both sides. Cut the wire in half, then bend each half and twist them on themselves. Shape them and lay them along the top of the tail, spanning the fins. Next roll two long tubes of clay and place them along the length of each twisted wire. Press the wire into the tube and then blend the tube into the fins. Stick the exposed wire ends into the tip of the tail.

53 Attach the head back onto the figure and place her back on the rock. Turn the sculpture around and look at it from all angles. At this point we are examining the composition with all of the alterations we have made because a lot of the volume has changed. I adjust the angle of the tail and tail fins and experiment with adding more fins to the sides of the tail to see if they fit into the composition. I also adjust the pose of the torso and arms, in addition to the angle of the head.

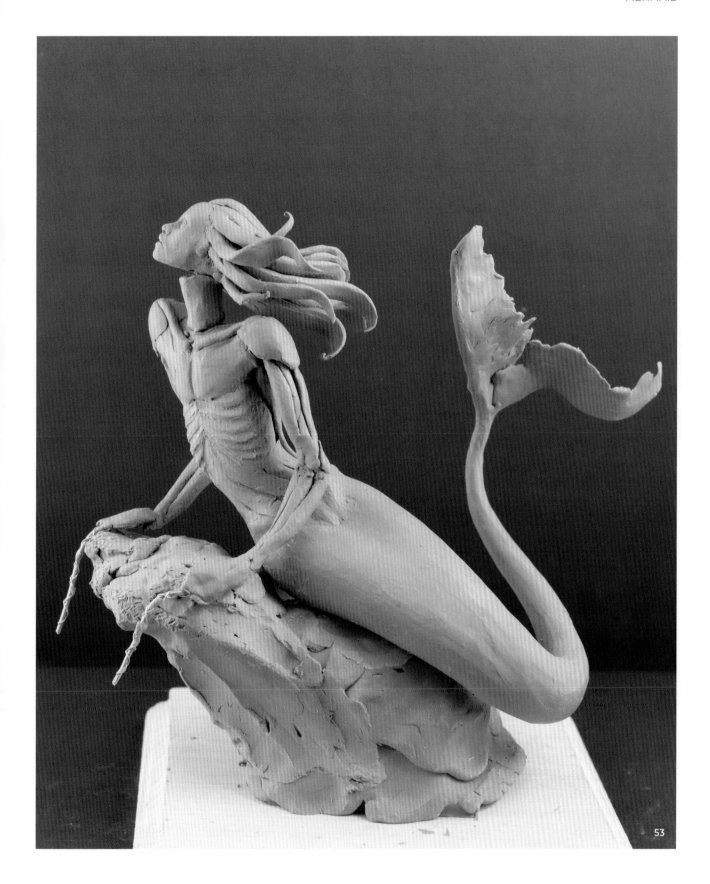

53

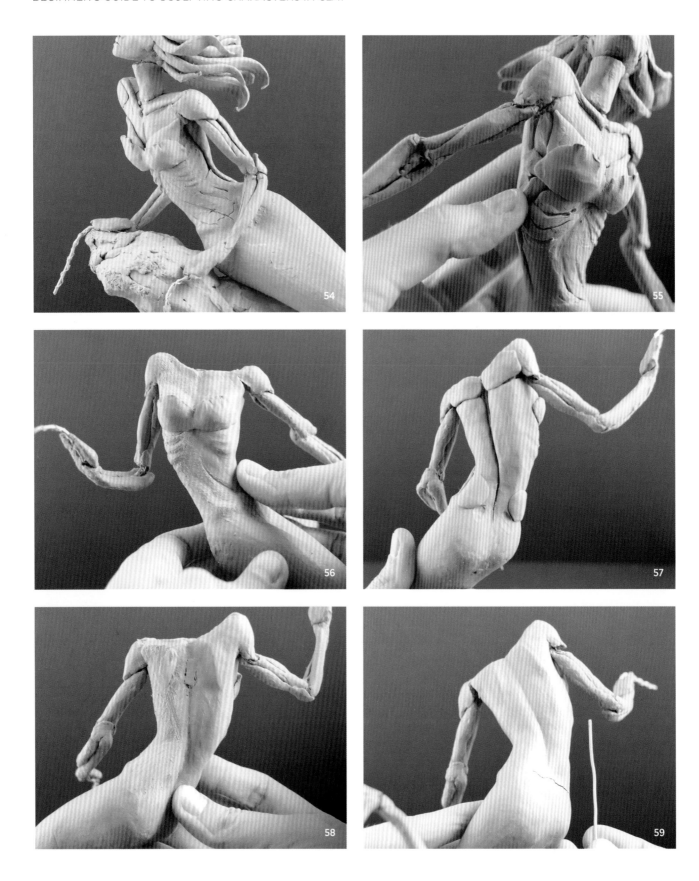

REVISITING THE UPPER BODY

54 When you are happy with the figure you can revisit the chest. Roll out a ball of clay and pinch it into a teardrop shape. Use a hobby knife to cut the teardrop down the middle to make two half-teardrop shapes, which will be the breasts. Position them on the chest. Next take a tube of clay and flatten it out. Use a hobby knife again to cut the clay into the shape of a bikini top. Shape it around the breast to get an idea of what her chest will look like and to check that it will work with the rest of the figure. If you removed her head, place it back on and take a look at the figure. ✂

55 Once you are satisfied with the breasts and their placement you can begin to work on the surrounding area. Once again, lift the arms for better access. Having added the breasts, I feel like the ribcage is too sunken, so I add clay to bring that out. Her upper torso is looking a bit too narrow, so I add some patches of clay to widen it slightly.

Add some fat deposits on the side of her chest under her armpits, and make sure the right side is stretched more than the left because the shoulder is raised. Turn the figure around to make sure that any patches of clay you have added fit in.

56 Using a guitar-string rake tool, blend the breast into the pectoral muscles. Make the transition very smooth with a soft bulge on top of the breast. Then blend the fat deposits in with the armpits and back muscles. Also blend in the clavicle bones and deltoid muscles; then blend in the ribcage and abdominal areas as well. Smooth all areas with your thumb and finger, making the transition between muscles and bone soft and subtle.

57 Turn the figure around to the back. I find a gap I left in the back of the shoulders, so I roll out two tubes of clay, flatten them, and place them across the top half of the scapulae. Add bits of clay for the fat deposits on the sides of her waist and indicate bulging and twisting in that area with subtle creases. Using a loop tool, gouge out dimples in her lower back.

58 With the guitar-string rake tool, blend the back anatomy. Blend the scapulae in with the back muscles, being sure to keep their definition and adding two bits of clay for the part of the scapulae that protrudes. Blend the back muscles into the spine, keeping the spine in a valley; I find a gap in the spine so I fill it in with a bit of clay. Blend the fat deposits into the side of the figure, the back muscles, and the dimples on the lower back. Then smooth everything out with your finger, keeping everything looking soft and subtle.

59 Having worked on her torso front and back, you may find that the extra clay you have added has weighted the armature down. You may see cracks in the figure's waist as the armature wire in her spine bends under the weight. To resolve this, cut some aluminum wire about the same length as her spine. Holding it straight, insert it through her gluteals and use a wire tool to push the wire up through her torso. Dig into where you inserted the wire and clip off the end of the wire, covering it up with a bit of clay. Add thin tubes of clay to fill in the cracks that formed on her waist and smooth them out.

60 We had removed the gills to make sculpting the body easier, but we are ready to add them back on now. Put the six temporary gills you created previously back on the lower three ribs of the ribcage. Trim them down a bit so that they do not protrude too much. Add thin tubes of clay to the cracks where the gills are attached to the body and then, using a ball tool, blend the gills into the body.

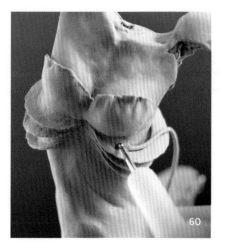
60

REVISITING THE ARMS

61 Returning to the arms, I find that they are looking very thin. If you lift them away from the body you can get better access to add pieces of clay as flesh in a few areas that have gaps. Add a bit of clay on the inner arm from the side of the elbow up to the armpit, in addition to a bit on the outer side of the upper arm between the bicep and tricep muscles. Also add a bit of clay to the back of the upper arm just above the elbow. Blend the new pieces in and smooth them out.

62 Since we have been adjusting the arms a lot, you may find the armature wire has broken. In a case like this, you need to reinforce the arm with another wire. Unlike the spine, the clay on the arm is very narrow, so we need to attach the new wire differently. Cut a new wire for the arm that is long enough to run from upper arm to lower arm. Bend it to match the bend in the arm. With a hobby knife, make a cut down the inner arm through the clay to the broken wire inside. Open the cut just enough to lay the new wire inside, then close it up and smooth it over. ✂

63 Now work on the connective tissue on the upper arms. Set the arms back down to the sides of the body and pose them. Add some small bits of clay to the front and back of the deltoid as the tissue and flesh connecting the arms to the shoulders. The tissue runs across the front of the deltoid to the side of the breast. The back tissue runs across the back of the deltoid over to the scapula. The right arm has a crease between the arm and the scapula since they are pushed up against each other. Blend the new pieces in and smooth them out.

64 Remove the temporary clay hands from the figure. To create new, defined hands roll two balls of clay and flatten them into the shape of the palm of a hand, making enough room for fingers and a thumb. Make small tubes of clay the size of her fingers. With your thumb, smooth these onto the new hand where each of the knuckles is. Using

a ball tool, blend them into the top of the hand and the underside of the fingers. Squeeze the tubes to look more like fingers and bend them slightly at each joint. Use the loop tool to add little marks at the knuckles and fingernails.

65 Once the new hands have been created you can then attach them onto the figure. Hold a wire up to each hand, bending the wires down the center of each palm. Press the hands onto the wires, blending them into the wrist with your fingers. Add small pieces of clay to cover up the wires under the palms. Cut the excess wire, leaving just enough to stick into the rock. Add a bit more clay to the rock, then stick the hands onto the rock.

ADDING DETAILS

66 Next we can add details to the face and finalize it. Add some clay to give the character higher cheekbones, a more defined jawbone, and to raise the forehead. Add small pieces of clay to the eyelids to make them appear larger and add eyelashes by laying thin pieces of clay along the tips of the eyelids. Use the ball tool to blend them into the outer eyelids.

Next add bits of clay to the lips and define them with a ball tool; you can define lip lines with a loop tool. Using the ball tool, sculpt the ears (you can find out more about sculpting ears on page 153). Finally, smooth out the skin with your fingers.

67 To detail the hair, roll thin tubes and smooth them out, adding them to the hairline to frame the face. Draw some hair lines at the base of the locks lining the forehead to give the appearance of hair coming out of the head. Add thinner locks of hair, blending with the larger chunks at the back. Adding thin locks to the thicker locks at the back of the hair will make the hair a bit more chaotic, creating a sense of movement. Smooth them onto the thicker locks to give the hair dimension.

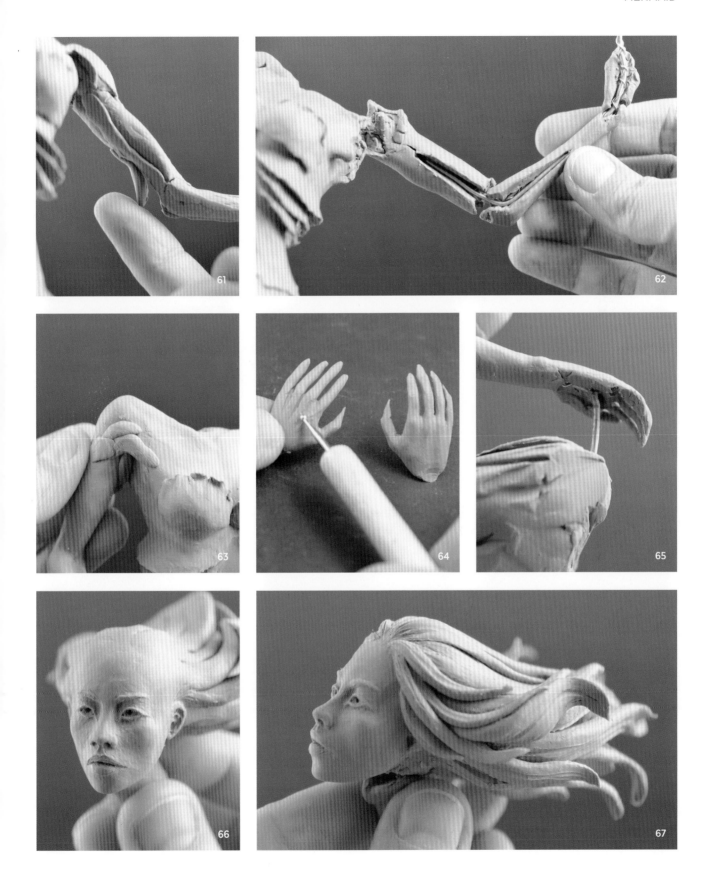

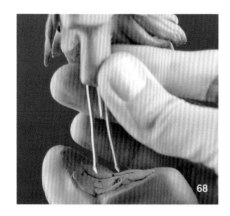

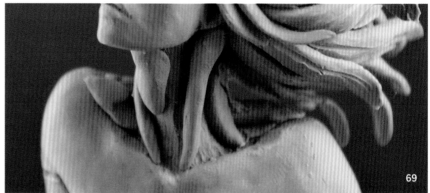

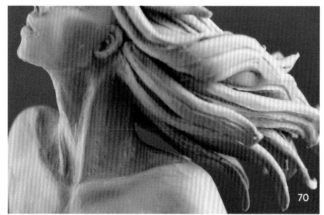

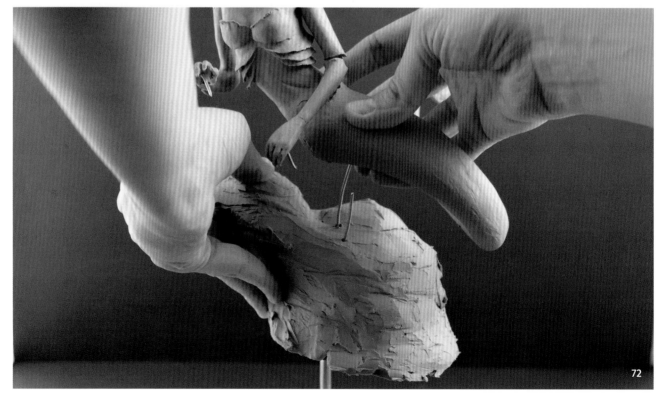

"SINCE HER RIGHT SHOULDER IS BENT UPWARDS, THE MUSCLES AND FLESH IN THIS AREA WILL BULGE MORE THAN THE LEFT"

68 Now you are ready to secure the head and neck to the body. First blend the neck into the bottom of the head. Then add a few additional wires to make sure that it will be stable. Cut the ends on an angle to form a point so that it is easier to push them into the body. Grabbing the wires with pliers, insert them, with the head, into the body. ✂

69 With thin tubes of clay, add the front neck muscles. These connect from the back of the ear and jaw down to the inner tip of the clavicles. Add a piece of clay for the fleshy area under the chin. Then add a tube of clay for each of the muscles on the back of the neck. They run from the back of the skull down to the outer tip of the clavicle while connecting to the top of the scapula.

70 Now blend the neck muscles using the guitar-string rake tool. Make a smooth S-curve from under her chin down to the bottom of her throat. Blend in the trapezius muscles, which are the muscles on the back of the neck and tie in the scapula area. Blend in the thin muscles on the side of her neck and add bits of clay to fill in any gaps. Since her right shoulder is bent upwards, the muscles and flesh in this area will bulge more than the left and will fill in more of the shoulder than the left side.

71 Now smooth out the surface of the rock, referring to a rock reference. Put the clay rock in the oven to soften it, then use a kidney shape to abstractly smooth flat sides along the surfaces of the rock. Work out the planes of the rock, such as the plane the figure is sitting on and the surface that the hands will lay on. Scratch in cracks and crevices with the kidney tool, and draw smaller cracks along the rock surface with a loop tool. ●

72 Before you get to the final details, you need to secure the sculpture while keeping it removable. First you need to prevent the rock from sliding off the wooden base. Drill a hole in the underside of the base about the same diameter as 4-gauge wire and cut a piece of 4 gauge wire a few inches long. Next you need to secure the figure to the rock to prevent it from falling off. Cut two short 14-gauge aluminum wires. Insert one into the rock where her gluteals will rest and the other a little further down where the tail will be. Gently place the rock on the base, and then the figure on the wires in the rock. ⚙

TEXTURES AND FINISHING TOUCHES

73 Start to texture the gills by using a tiny ball tool to draw curved lines on them. These should sweep out with the curve of the gills and disappear once they meet the body. Make the gills look soft and wavy with a wooden tool, lifting them up in some spots. Lightly smooth the surface with your finger. Clean them up with rubbing alcohol and a brush, brushing lightly down the lines to clean up any small balls of clay. ❶

74 Move on to the tail fins to add texture. You may find that further extending and thickening the tail fins slightly first works better with the figure. Smooth the fins as much as you can with your fingers and remove any lumps. With a tiny loop tool, draw soft lines dividing the fins into quarters to indicate the direction of the texture. Then draw lines dividing the fins into eighths. Start adding strokes on the fins with a small ball tool, making them look similar to a betta fish's fins, very soft with a fabric-like appearance. Then clean up the little balls of clay from the tail fins with rubbing alcohol and a brush again.

75 To work on the tail texture, you can modify a loop tool using pliers. Bend the loop tool so that you can use it as a stamp. Refer to a fish scale reference and start stamping down the middle of the tail. Run the pattern evenly straight down the tail, then start spreading it out around the tail, covering it completely. For areas that you find it difficult to get your stamp tool into, use a tiny ball tool to draw the scales on. Again use rubbing alcohol and a brush to clean up the pattern and soften it slightly. ❶

76 The final element left to detail on the mermaid is the bikini top. Roll out a thick tube of clay long enough to cover the figure's breasts and flatten it in your hands to the thickness of the temporary bikini top you made previously, like fabric. Use the temporary bikini top as a template to cut the new one out of the flattened clay. Prepare the new bikini top to fit the breasts by pinching at six different spots. This makes a nice folded fabric pattern. Then roll a very thin, long tube of clay. Flatten that by pinching it with your fingers. Lay that along the bottom of the bikini top. Finally place the bikini on the figure, securing it at the back.

77 We will now make finishing touches to the rock. I notice a gap under the mermaid tail where the figure is floating a bit, so I fill that in as rock with a piece of gray clay. Carve random cracks and wipe any fingerprints out. Smooth the edges to make it look weathered. Next add little shells coating the underside of the rock by making small egg-shaped balls of clay and cutting them part way through. Draw thin lines on them, then stick them on the rock with a little ball of clay.

78 To finish off the sculpture, add some waves brushing up against the rock. Start them off with messy clumps of clay, laying them against the rock. Use your thumb to push the outer side of the clumps down in a curve and drag the clay across the base. Add strokes from your tools to create some texture. Finally smooth on a thin layer of clay on the base as water.

FINDING INSPIRATION

Whether you are in an artistic slump or looking for something to excite you about your next masterpiece, a lot of inspiration can be found in the natural world. I get a lot of inspiration from watching animals and people, from studying plants, trees, and rock formations. It can come from a book I read or a film I watched. I get excited by going to museums and looking at the sculptures and other works that old masters from the past have created. Experimenting with different techniques by the old masters can inspire work as well. Every day there are opportunities to be inspired.

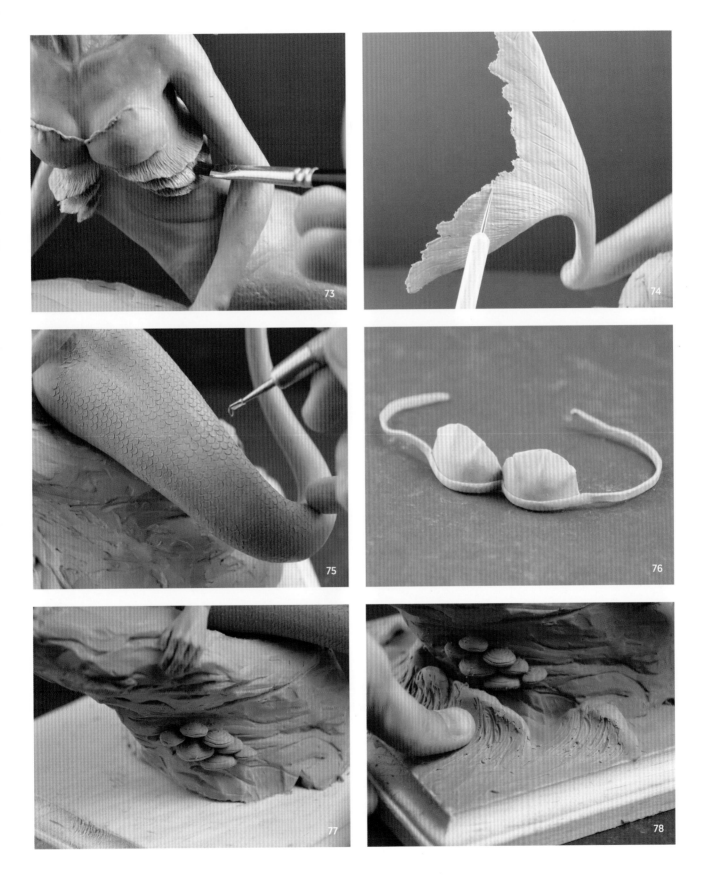

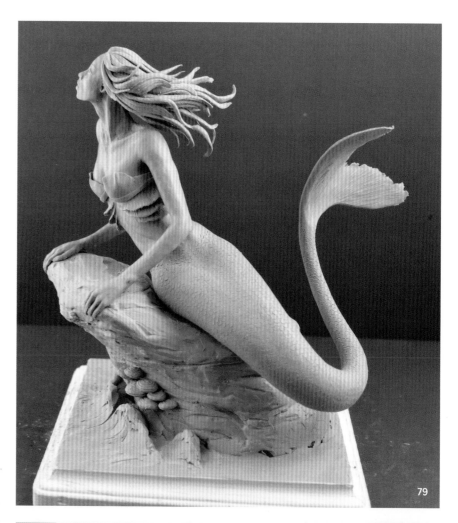

79

79 At this point everything has been sculpted. Take a look at the full sculpture, turning it around. Fix cracks in the arms and tail by filling in the gaps. If some of the tips of the hair and fins have been flattened a bit smooth them back out. Clean up any messiness in the hair and smooth locks out where needed. Study the composition of the sculpture to make sure that everything still works together.

80 Finally, clean up clay crumbs and scratches in the surface with rubbing alcohol and a brush. Oil-based clay is fairly stable so you can leave the sculpture on a shelf; it should be fine as long as it does not become hot. You may want to put it in a display case so that it does not collect dust. To make a more permanent version of the sculpture and make multiple copies, it has to be molded and cast. This can be done by a professional studio that does molding and casting.

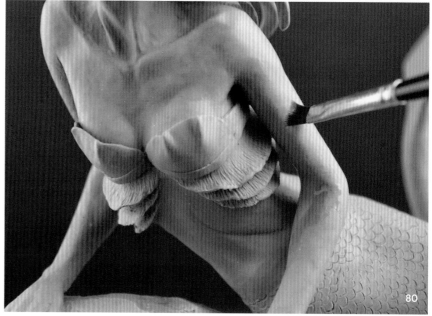

80

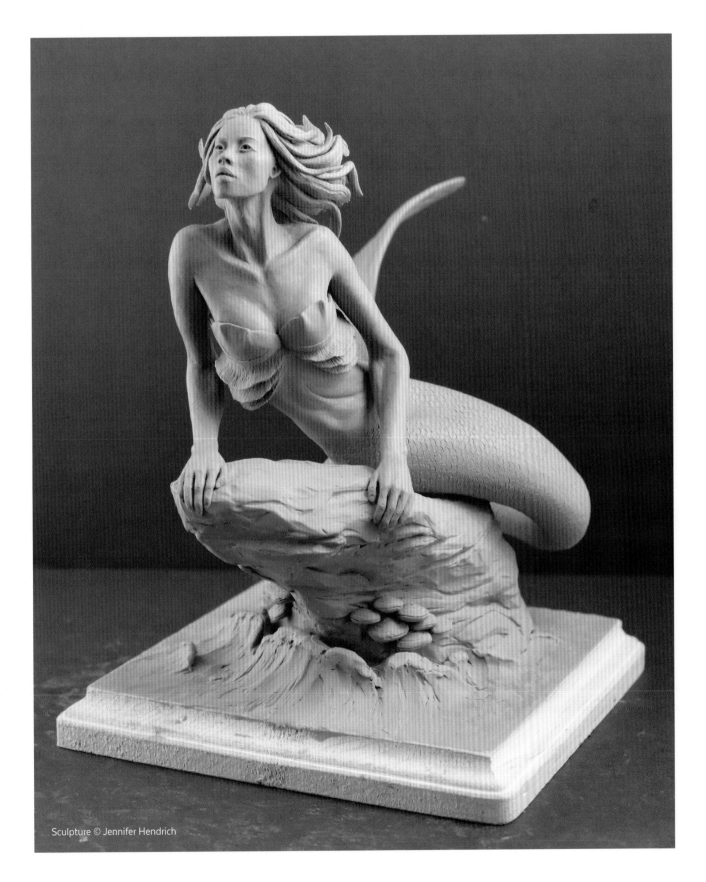

Sculpture © Jennifer Hendrich

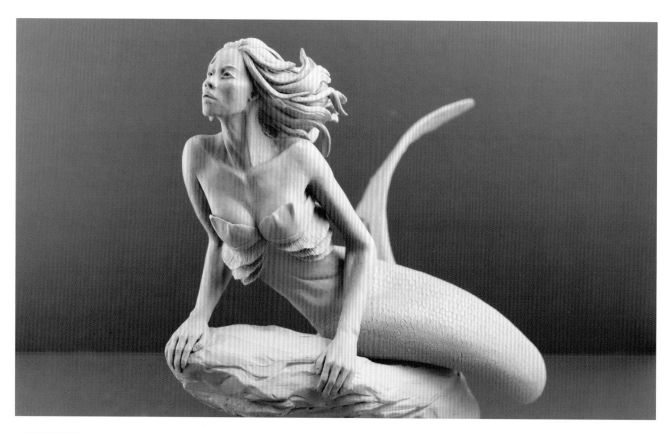

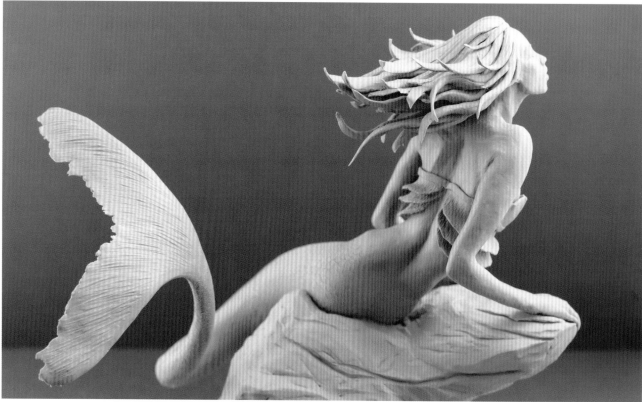

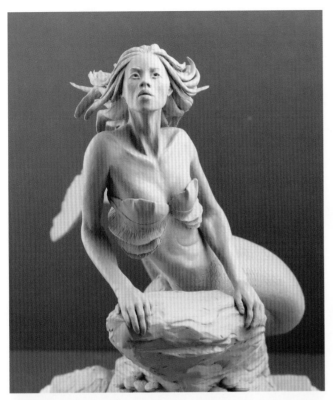

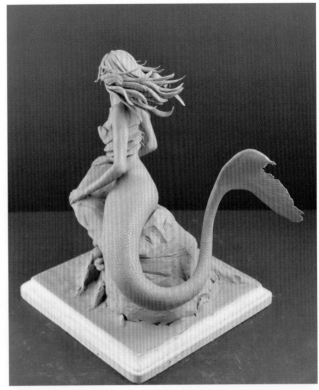

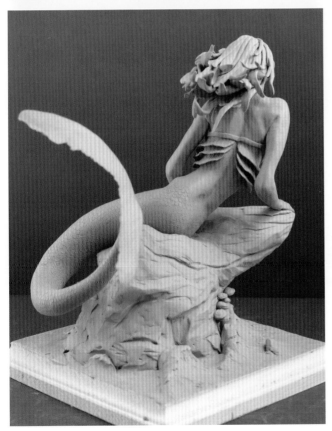

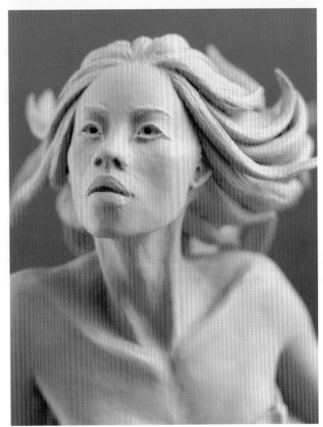

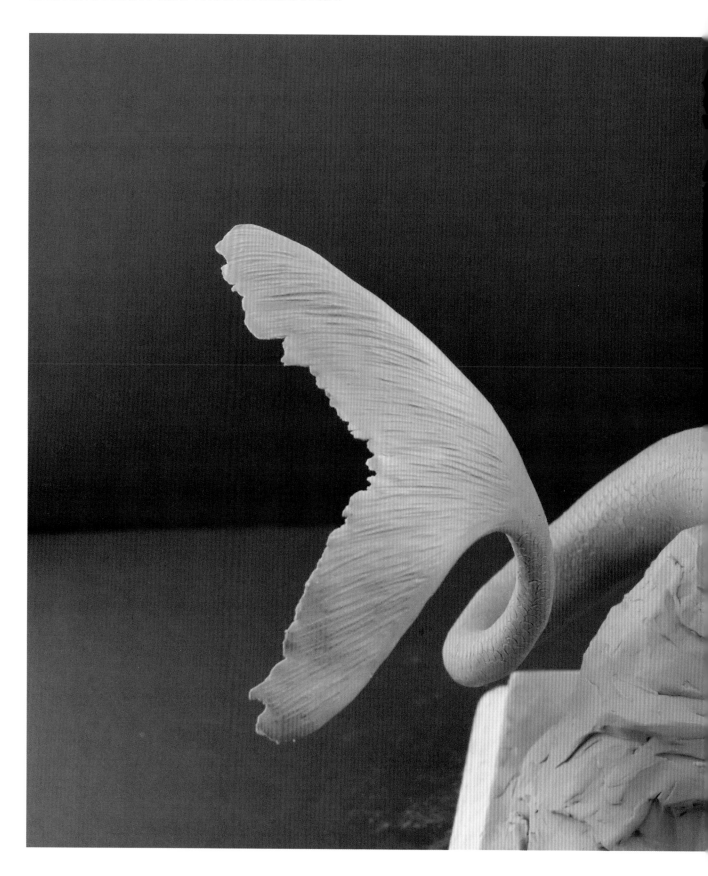

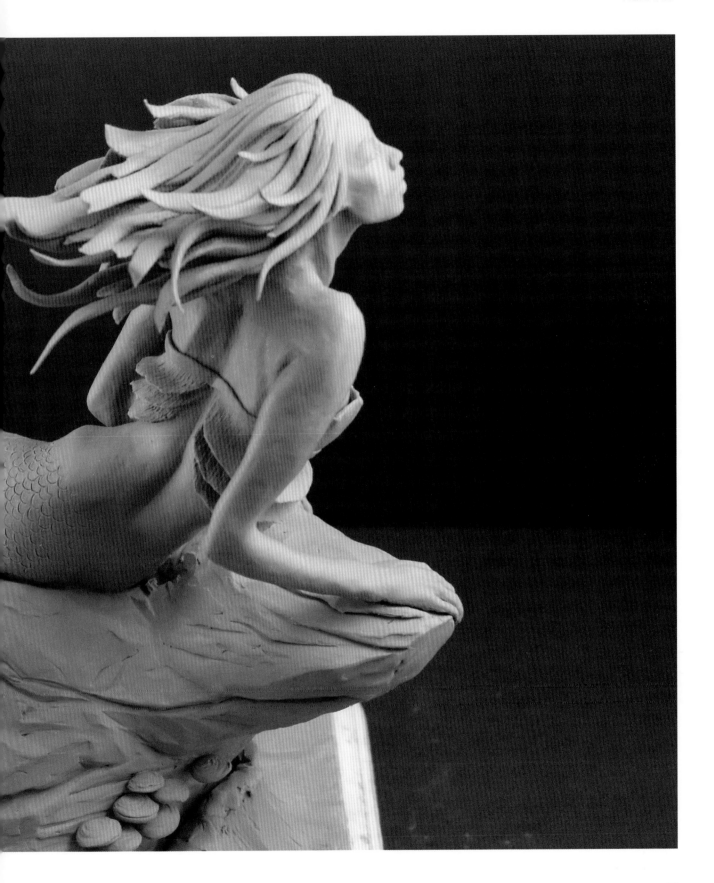

Severed | Chavant NSP | © Jennifer Hendrich

Bas-relief | Chavant NSP | © Jennifer Hendrich

Cat with Cephalopod | Chavant NSP | © Jennifer Hendrich

Fox with Rabbit | Chavant NSP | © Jennifer Hendrich

DWARF BUST

BY GLAUCO LONGHI

MATERIALS

Aluminum foil

Isopropyl alcohol

Metal flange

Metal pipe

Oil-based clay (medium density)

Turpenoid (optional)

Wooden base

TOOLS

Brush

Camera (optional)

Cutting wire

Loop tools

Mini blow torch (optional)

Rake tools

Spatulas

Turntable (optional)

In this tutorial I will walk through the same sculpting process I use professionally. I will use medium-grade Monster Clay for this bust (Monster Clay is available in soft, medium, and hard grades). However, you can use any oil-based clay you want. If you plan to use water-based clay, you will need to build up a base with old newspaper, or even plaster, instead of the aluminum foil base I will show you. The newspaper or plaster will help retain some of the moisture of the water-based clay and also make it stick better to the structure.

I recommend medium-density clays because they are hard enough to hold details but soft enough to tweak small shapes without using wax pens or any extra heat. The reason I like Monster Clay so much is that I can warm it up in the microwave without the need for a special oven or kiln. I also enjoy working with water-based clays, but they dry out and are very soft, so they require special care and need to be constantly sprayed with water to slow the drying process.

The goal in this tutorial is to sculpt a scaled bust of a dwarf based on Even Mehl Amundsen's character concept, *Birker*. We will cover the entire process, from armature making, blocking in the base shapes, refining shapes, and adding secondary forms, to finally texturing and adding finishing touches.

This bust will be to a scale of about 1:2 to 1:3. You do not need to take any measurements, or even think about scale during the process; you can just work in a size that feels comfortable. This can vary from person to person, so make sure you are happy with the size you are working at.

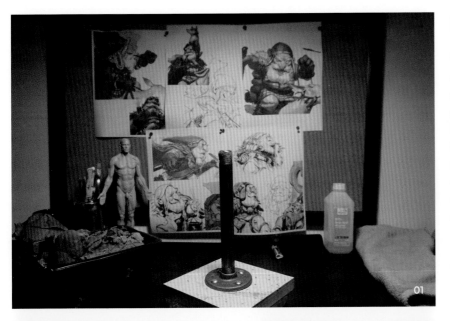

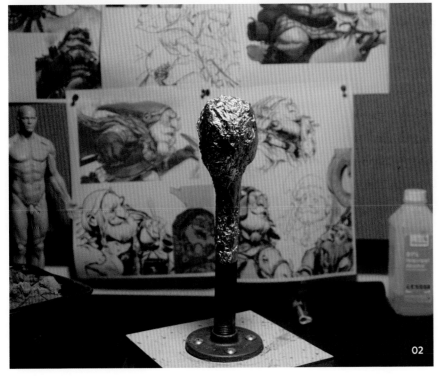

PREPARING TO SCULPT

01 Before starting on the sculpture you will need to set up your workspace. I keep mine very simple. I have the clay, tools such as loop tools, rake tools, spatulas, and brushes, and a reference board of the character concept. I also have a mini blow torch, which can be used to melt down the rigid clay to give a smooth look, some isopropyl alcohol that we will use for smoothing out the clay with a brush, and a base structure sitting on a small turntable.

For a bust sculpture of this size you will need to use about 4 lbs of clay in total. To make an armature for the bust use a metal flange screwed onto a piece of board. Screw a metal pipe into the flange to make a base on which you can start building up the bust.

02 Start building volume for the head with aluminum foil (or newspaper if you are using water-based clay). This will save clay, make the piece lighter, and also provide some grip for the clay. Tightly wrap sheets of foil around the piece, pressing it into shape with your fingers. As you can see in image 02 this will create the basic shape of a sphere. Imagine that this will be the center of the skull, although it does not have any features yet.

Remember to keep the armature smaller than the desired head, otherwise the foil will poke through when you carve out features like the eyes. I do not measure the foil since I am not working with a specific scale, but I use roughly four to six sheets. Make sure they are packed tightly together and that some of the foil extends down the pipe to give the clay something to hold onto.

03

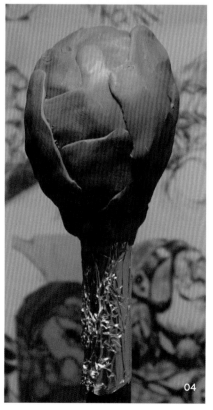

04

05

06

"WORKING WITH A TURNTABLE IS USEFUL BECAUSE IT ALLOWS YOU TO CONSTANTLY CHECK YOUR SCULPTURE FROM ALL ANGLES"

03 As mentioned, what I like about Monster Clay is that you can microwave it to warm it up and make it softer, which allows you to mold the clay with your fingers and create the initial shape quickly. Microwave a tub of clay for two or three minutes with increments of thirty seconds if needed. Be careful when heating the clay as the bottom will usually melt down and become hot while the top stays harder and cooler. Have this in mind when putting your hand into a tub of newly heated clay and do not put your bare hand into the tub if the top of the clay is too hot to touch. 🔥

BLOCKING IN FORMS

04 Start blocking in the basic head shape, without focusing on smoothing the clay or even getting the forms one-hundred percent correct. You only need to establish the overall form and size of the head at this stage. Using your fingers, press small amounts of the softened clay firmly against the foil, making sure you cover the foil completely.

05 Slowly add more clay, forming the shape of the head. At this stage, it is better to add more clay and then remove it if necessary. Take advantage of the softness of the warm clay and keep adding to the shape. Again, do not think too much about smoothing the clay at this point; just keep adding to the basic form until you are satisfied with the proportions.

06 Make sure you view the head from different perspectives as you apply the clay. I have chosen to mount the base onto a turntable. Working with a turntable is useful because it allows you to constantly check your sculpture from all angles. You can find cheap wooden turntables in your local pottery or artist supply store or online. It is definitely worth acquiring one if you plan to sculpt regularly.

07 There are multiple ways to structure the head. The way I sculpt is a mix between the drawing concepts taught by Andrew Loomis and my own style developed over the years. I recommend that you refer to a real skull or at least have some anatomy books near you throughout the entire sculpting process. Find faceted shapes like you would find on a front planar face and take it from there. Then compare this head structure to the rest of the bust's proportions.

Now that the base of the head is in place, repeat the same foil base-building process for the body of the bust. First you need to bulk it up with aluminum foil and then you can add clay on top, making sure you simplify every form first.

08 Using your fingers again, add clay to shape the bust. In image 08 you can see that I apply clay to the neck in a way that already follows the muscle structure, which goes from the back of the ear to the clavicle at the pit of the neck. This creates a good starting point as the bust already has the proper shape; this is why studying anatomy is so important.

I also cut and block in the rest of the bust, simulating the final sculpture so that there is already a sense of the piece.

09 So far I have spent about ten minutes on this process, but do not worry if you cannot work at this speed. Take your time, make sure the proportions are correct, and enjoy the process. At this stage, it does not matter if you have to stop and continue on another day. Just reheat the unused clay then add it on top of the cold clay of the bust; it will stick without issue.

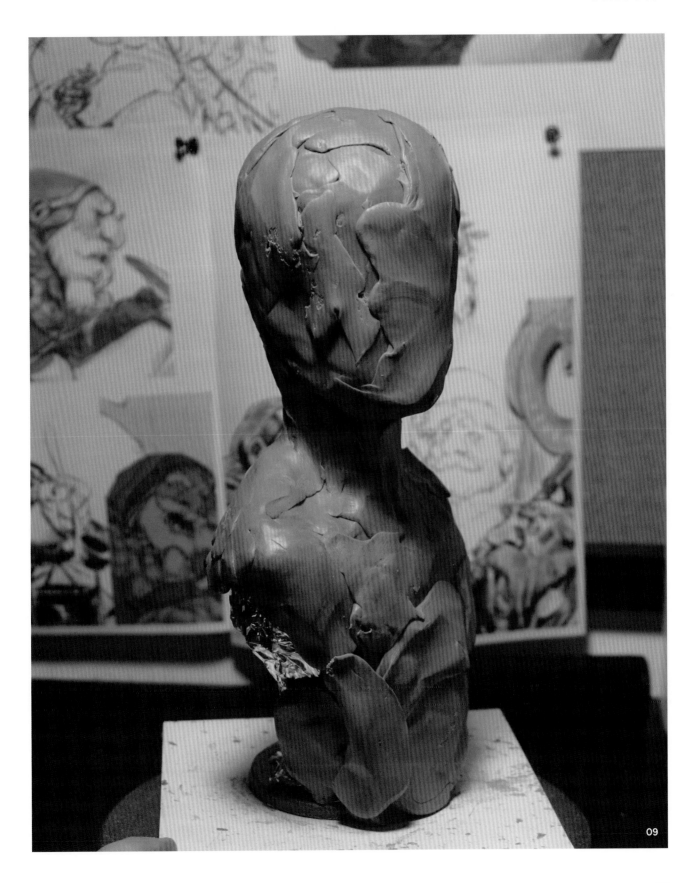

09

BASIC FACIAL FEATURES

10 With the main shape of the bust formed you can now work on defining the basic facial features of the character. Using both thumbs at the same time, shape the eye sockets making sure you carve out the clay to the sides. The depth of the eye sockets should be checked by assessing the sculpture in profile and imagining that there are eyeballs inside them. Do not carve them too deep, otherwise you will have to fill them up with clay later. Make sure that you constantly refer to anatomical references; although you are sculpting a stylized character, you are building a base structure that follows real proportions.

11 Continue to add depth to the structure of the bust, again using only your fingers. In this case we want the forehead to stick out. You can reshape the forehead by adding more clay and pushing parts of it around.

Bring the side of the zygomatic arch (the widest measurement in the face, found just below the temples) closer to the back of the head. Turn the bust to see the zygomatic arch from the side as this will act as a landmark which will be covered with clay later on. You can also carve out the cheeks, using the motion of your thumbs in the same way as when you carved out the eye sockets.

12 Block in some of the key facial features such as the nose, cheekbones, and ears very loosely. There are multiple ways of doing this, such as sculpting the features and then attaching them, but I generally build these volumes by adding bits of clay directly to the head structure. Ensure your clay is firmly attached to the head by pushing on smaller bits of clay first, even if they look smudged at the sides.

Make sure you check the overall proportions and the feeling of the character as you work. We will carve these added features out later to refine them.

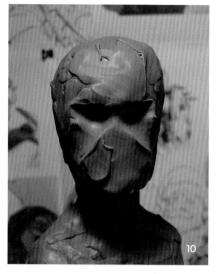

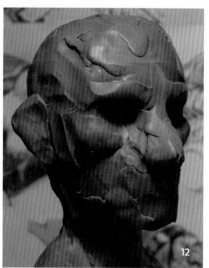

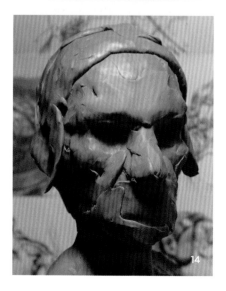

13 The profile view is probably one of the easiest perspectives with which to check whether you are on the right path because all the features tend to be more distinguishable from this angle. The three-quarter view is also very important and can be used to check jaw lines and the silhouettes of the cheeks, forehead, and nose. If you have only one piece of concept art to reference, it will definitely be harder to match; try to remember that you are sculpting a 3D character when checking from the angle that matches your reference.

You can see that my bust is missing some form at the back of the skull but we will add the character's hat later so we do not need to refine that area for now. As you can see, I have all my references nearby, and I constantly analyze them to understand and capture the feeling of the character.

14 Start to add some of the hat shape in order to give yourself a better idea of how the character is progressing. I add the side flaps for this but they are just placeholders that are attached loosely.

Add more clay to the jaw, working from the profile and front view. This is to make sure the bust gets the more masculine, squared look and the defined lines of the original concept.

15 Continue blocking in the main facial forms and characteristics of the character. I work on a rough beard and mustache for my bust, in addition to blocking in the cloak. Check if you are on the right path again by comparing your piece to the concept and your references. It can be a good idea to take photographs because they will flatten the look of the sculpture, which will help you to compare it to references.

Everything you add now should be very lightly placed so that you can easily remove new additions if you need to refine the forms underneath.

As you may be able to see in image 15, some of the features are not quite right, such as the cheeks and the height of the hat, so I use my fingers to keep adding small bits of clay. If you add too much, you can always remove it with your fingers or with tools like a spatula or loop tool.

16 If you feel like you are becoming tired, this is a good point at which to stop and take a break. Then come back to the sculpture with fresh eyes to check everything one more time before moving on.

Do not be afraid of the fragile elements we have added, like the hat flaps and mustache. They are just placeholders so if they get damaged it is not a big problem. We will remove and resculpt them later on.

TAKE YOUR TIME

Do not worry about how long it takes you to sculpt. At step 16 I was almost two hours into the process. This is just for your reference; all you need to do is make sure you are progressing with the piece. Most importantly when you are starting out, make sure that you are having fun with the process.

16

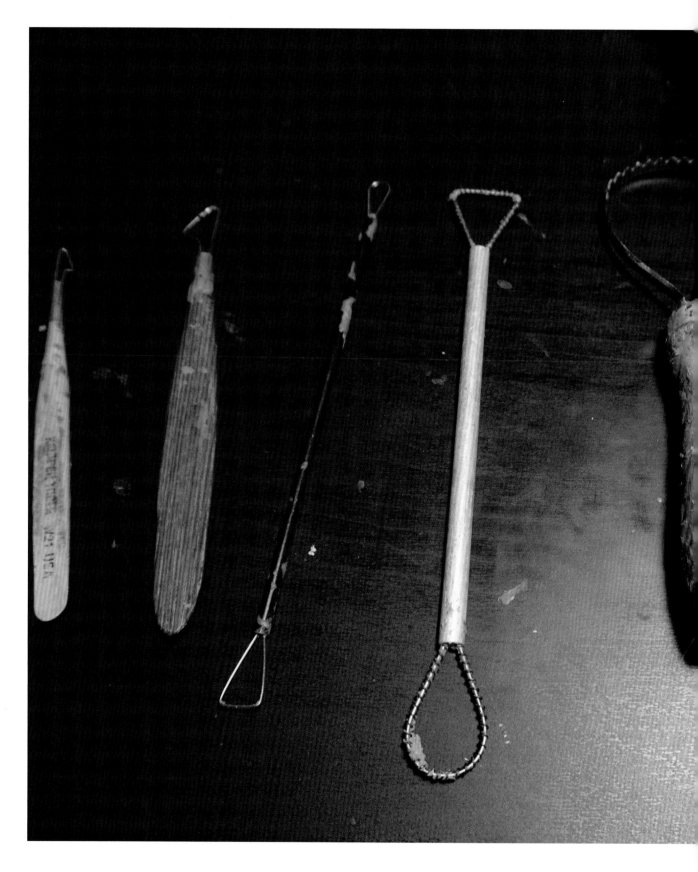

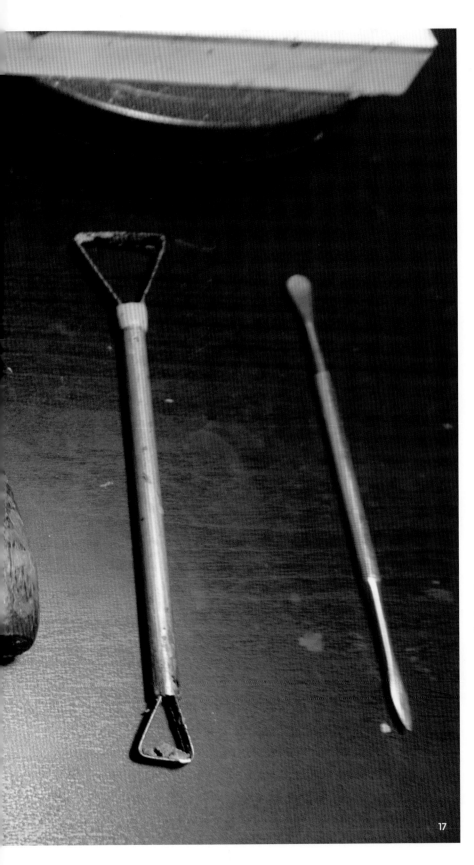

REFINING THE BASIC FORMS

17 Image 17 shows the main tools I use to sculpt. I try to use my hands as much as I can, but there comes a point where you have to use tools. I like to think of the tools as an extension of my hands, so they move and flow from my shoulder, through the elbow, and down the wrist.

My basic set consists of a few loop tools, metal and wooden spatulas, and rakes in different sizes and shapes. They are easily available online and in local craft supply shops. I like Kemper tools, which are fairly inexpensive. You can also make your own tools with wires and small aluminum or brass tubes (see page 56). Some people like to use guitar strings bent into tubes for loop tools.

18 On your bust, remove the hat placeholders to reveal the forms underneath. Then, using a large rake tool, refine all the basic forms so that you have a more solid mass to work with. Hold the tool so that the rake is flat against the clay, making downward movements and applying only light pressure. It is usually easier to refine round shapes with circular movements because they will interlace, creating a flatter surface. The rake is mainly used to leverage the height of the shape, creating refined forms.

I like using bigger rakes for bigger forms, but it is up to you. I know people who prefer the opposite so make sure you try different things to find what works best for you. You are slowly moving forward and although there are no Undo or Save options in clay sculpting, you can always revert and redo any of the steps, so take your time.

19 Block in the mouth line using the corner of a spatula to draw a line, creating depth. Add small pieces of clay to either side of the mouth to form the nasolabial folds (the creases that separate the cheeks and mouth). You can also start to add more shape to the forehead, nose, and body, always referring to the concept to match the roundness, size, and shape of the character.

20 By adding more clay and smudging it around with your fingers, you can create a softer looking piece. This is the workflow I use throughout my sculpting process: refining forms with a rake, adding shapes with bits of clay using my fingers and sometimes a spatula, and then blending the shapes with a spatula or loop tool. I like to work in this way because it gives me the freedom to resculpt and alter shapes at any time.

21 With the spatula again, refine the nasolabial folds and the corners of the mouth. Use the flat side of the spatula to press the clay firmly upwards, forming the corners, and then add pieces of clay to the nasolabial folds, pressing against them to give a flatter look.

Adding secondary shapes to the nose with more fresh clay will also start to give the sculpture more form. Secondary shapes are transitional forms; smaller shapes within the bigger forms. The nose, for example, can be represented by many small shapes and facets. I recommend Burne Hogarth's drawings to help you understand these shapes, since he is known for exaggerating them. George Bridgman's books are also amazing for these concepts.

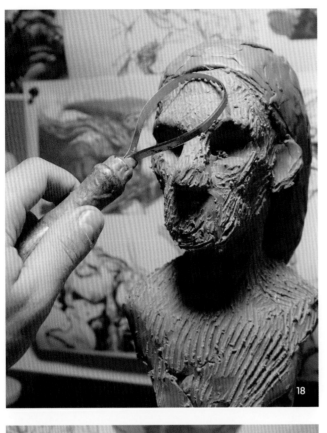

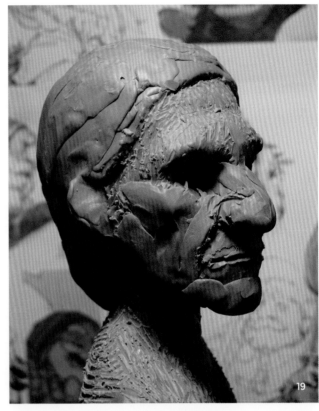

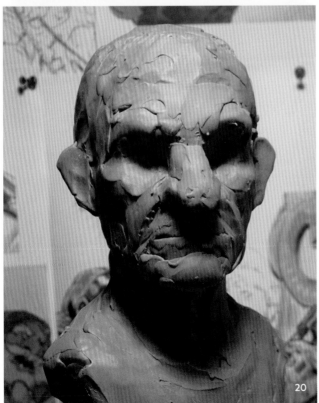

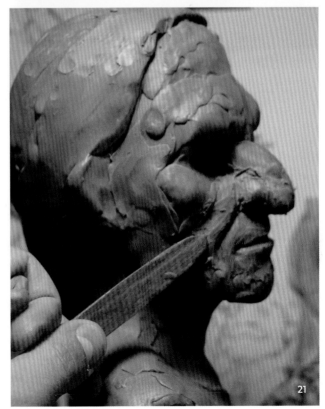

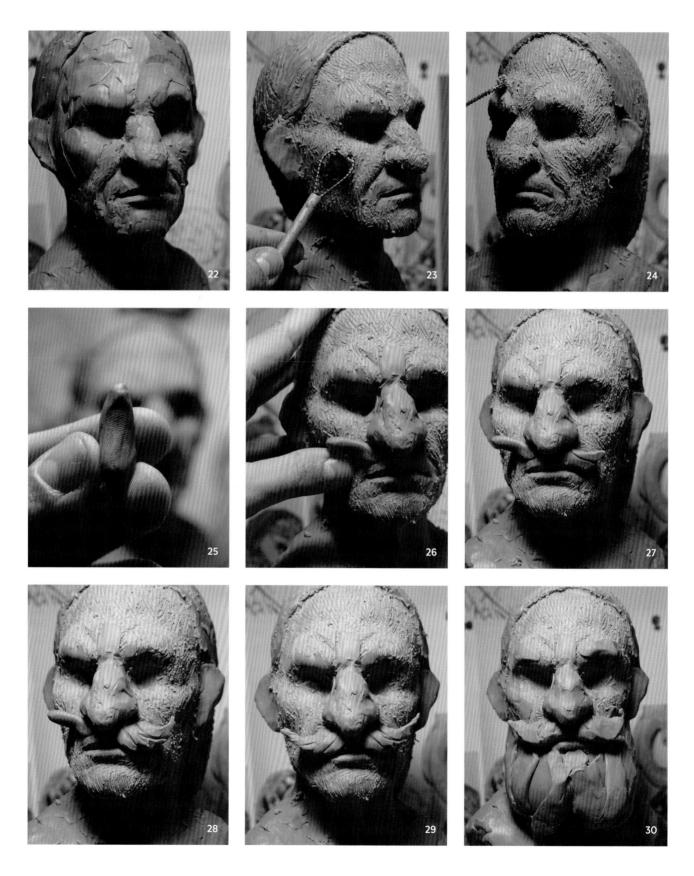

22 Review the sculpture so far. You can refer to anatomy charts to make sure the shapes and simplified forms are correct, or compare your work against image 22 as a guideline for these forms. You should also check the bust against your concept to see if the feel of the character is forming in the sculpture. Even though everything is still very rough and blocked out, you should be able to recognize the character.

23 Use a small rake tool all over the face to refine the forms and give you a "fresh" start. This will make the forms easier to read from a distance and partially smooth out all the previously added shapes. Only use the rake lightly so that the forms of the face that we added with the spatula earlier are maintained.

24 While doing this, I use the rake tool in a motion that flows with the shapes of each form. In the eyebrow area for instance, move the rake around the form creating a pattern and flow with the roundness of the simplified shape; on the forehead go in a different direction, creating flatter, more angular patterns to give a different interpretation of the forms.

BLOCKING IN THE FACIAL HAIR

25 It is time to block in the mustache and beard. To make the mustache, take a small piece of heated clay and mold it with the tips of your fingers into a curved oblong shape. We will add it to the sculpture, and then repeat the process to build the hair up piece by piece. This is the same procedure we will use for all the hair forms on this bust. Always think about the flow and movement of the sculpture, adding form to the bust instead of carving lines into a flat surface.

26 Lightly press the base of each oblong piece against the upper lip of the bust with your thumb.

Build the block of mustache hair up gradually, working from the corner where the nasolabial fold meets the nose down towards the mouth. Remember to think about the silhouette, forms, and shapes you are creating.

27 With the separate oblong forms in place use your fingers to shape the clay and give it some hard edges. This will create planes, which are stronger than rounded forms. We will sculpt and carve these out later. I like to work on both sides of the mustache simultaneously, so add a bit on the right side, and then a little on the left, and vice and versa. This will allow you to observe how it develops as a whole.

28 By gradually adding smaller bits of clay, you can easily shape and add more forms to the hair to match your references. For example, you can see in image 28 that the tip of the mustache is outside the silhouette of the head in the three-quarter view, which fits the concept. This is how I compare and check proportions at this stage: by making sure the mustache is longer than the eyes and mouth, and so on.

Drawing imaginary lines between your forms makes these proportions easier to check. You could also take photographs and then draw the lines on top of them.

29 Your fingers are probably the most versatile tool you have. You can easily pinch and twist the end of the mustache and also entirely reshape it just by pushing the clay around. Use your thumb and index finger together to shape the tips of the mustache.

30 Repeat the process of steps 25-29 for the beard, but use bigger forms since you are creating a bigger volume. At this point I also change the overall shape of the mustache so that it matches the concept better. Again, this is achieved by using bits of clay and my fingers to reshape the forms.

CHARACTER ADJUSTMENTS

31 Add more mass to the zygomatic arch and cheekbone by adding pieces of clay with your fingers. You can also check the supraorbital margin (the rim of the bone arching above the eye socket) for accuracy against the concept art. There is a very prominent corner on the supraorbital margin of this character, which adds strength and age to him.

I also refine the shape of the beard by adding two twisted ends. To do this use the same technique of blocking in that you used for the mustache.

32 Using a piece of cloth or towel as a reference, start blocking in the forms of the character's hat. A rag is a suitable reference because the material matches the softness and flexibility of the hat and has a similar density, so you can accurately replicate the folds.

33 To create the forms of the hat, use a mixture of adding clay with your fingers and carving out lines with the loop tool. Then smooth the shapes out with your fingers.

When sculpting cloth or any sort of material think about the material folds and how it hangs or twists, instead of focusing on the final shape or lines. You also need to think about how different densities of materials create bigger or smaller folds, so always use real-life references to check and understand the material forms you are recreating.

SCULPTING THE EYES

34 They eyes are where people usually make mistakes with their portraits and sculptures. Because the eyes are the focal point of the face and most important to the character they can either enhance or destroy your piece. Remember though that the eyes are forms just like everything else you sculpt, so do not be intimidated by their importance. Keep in mind that they will look rough when blocked in, but as you refine and add more form to them, they will eventually look better.

I like to sculpt both eyes simultaneously, which helps me to avoid errors such as accidentally sculpting one eye bigger than the other. Take the following steps one at a time and duplicate each step on the second side. As I am right-handed I find it easier to sculpt the left side, so I usually start with the right eye then replicate the step on the left side. This makes the tricky task of duplication easier.

35 Take a small portion of warm clay and rub it between your thumb and finger to form a smooth oblong. Then press the oblong into the top portion of the eye socket to form the upper eyelid. You could also use the flat part of a spatula to help you place this portion into the eye socket. Repeat this for the second eye.

36 Using the same procedure as in the previous step, add small round pieces to each eye socket form the eyeballs. Make sure you are firmly pressing all these parts into the sockets, but not so hard that they become deformed.

WORK OUT PROPORTIONS

A rule of thumb for eyes is that the width of the head in front view should be equal to the width of four eyes in a row. The distance between the eyes should be the width of one eye and, generally speaking, there should be a distance of half an eye between the outer corner of each eye and the side of the head. This rule can change from character to character however and also differs depending on the field of the view caused by the perspective.

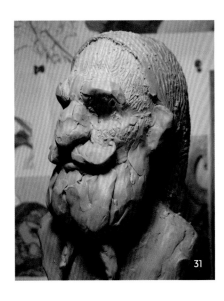

31

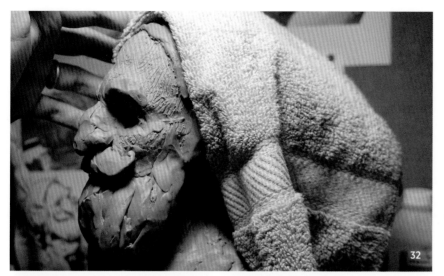

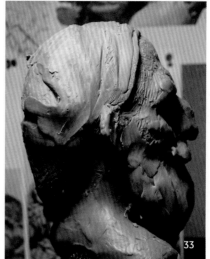

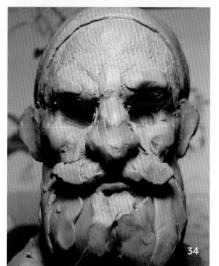

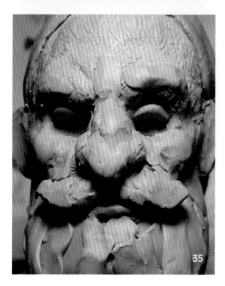

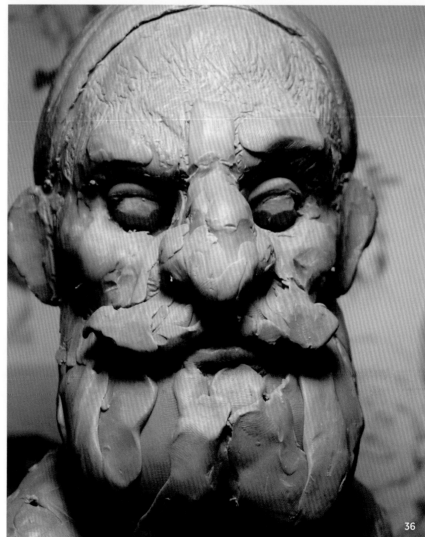

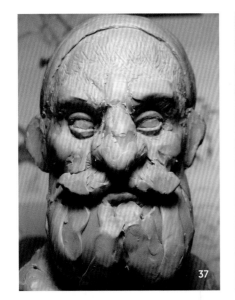

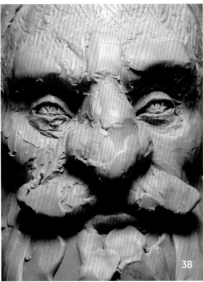

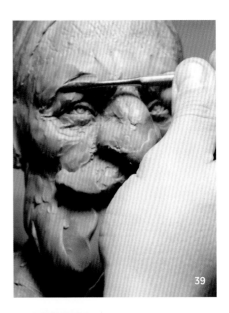

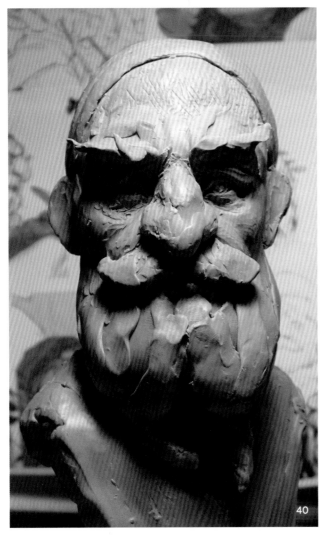

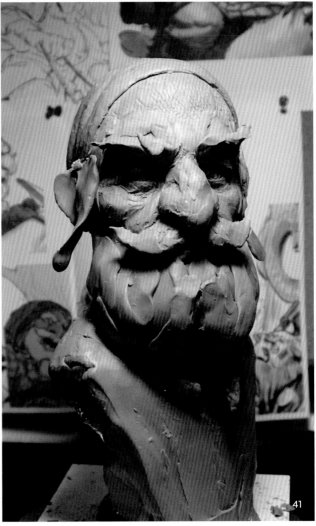

37 To form the lower lids, make two long tubes or strips of clay. Place each one over the lower section of the eyeballs, covering the space between the eyeball and the socket. Do not worry if the shapes of the eyes are not quite correct as you can resculpt them if necessary. If your proportions are wrong though, I recommend restarting the eyes from scratch.

You can blend the lids after by smudging the top portion with a spatula and then adding bits of clay to fill up the empty space and create the upper eyelid surface. Follow the same procedure for the lower eyelid, but be careful to not fill it up too much to avoid erasing the eye socket shape. You should maintain the socket roundness even after placing the eye bags.

38 Using a small loop tool, indicate the pupils and irises with simple lines. You can also add secondary forms to the cheekbones with a spatula at this stage, to find smaller planes and transitions between the forms. I usually try to indicate solid structures like bones on a face in order to give the character a stronger, harder look.

SHAPING THE EYEBROWS

39 This character has prominent eyebrows so first use a spatula to shape the underlying forms, referencing the original concept. Nothing we do here is set in stone so explore different shapes and forms to find the best effect.

40 To make the eyebrows, repeat the same steps as for the mustache (steps 25-29), but this time use more delicate forms. If your character has very thin eyebrows, you can still repeat this process but with very thin pieces of clay.

It is important to avoid "drawing" the eyebrows by carving into a flat surface.

ALTERING THE CHARACTER'S EXPRESSION

41 I press the hat flaps back on now to check the sculpture against the concept and see how the work is progressing. You need to review your sculpture regularly to ensure you are capturing the expression and feeling of the piece.

42 I am not happy with the character's expression, so I decide to rework it to make him smile more. To change the facial expression, remove the mustache and start adding forms using new bits of clay. Refine the new forms with a loop tool, making sure they blend with the rest of the bust.

Carve out clay under the nasolabial fold to create more depth and then add more clay with your fingers. Use a spatula to reshape the fold and corner of the mouth. Again, checking the sculpture from profile and three-quarter views will help you capture the forms and avoid beginners' mistakes such as creating flat sculptures. Note that I have removed the hat flaps again here to make the adjustment easier.

43 Focusing only on one side of the face, lift the nasolabial folds and pull up the corners of the mouth. You can also add wrinkles to the cheeks to make the character smile more. To do this, add flat lengths of clay in a fan shape to form creases around the eye, again thinking about the forms and not the lines. The forms will automatically create lines and shadow; once these are established you can use a loop tool or the end of a spatula to mark down some thin lines and wrinkles.

44 Continue to adjust the expression by reshaping the brow with a small loop tool. Add more small flat lengths then move the tool around the form in order to blend all of the shapes together.

Facial expressions are a combination of many muscles of the face. There are many useful anatomy and expression resources out there for you to study. I recommend researching FACS (Facial Action Coding System) developed by Paul Ekman if you want to know more about the subject.

45 Repeat steps 43 and 44 on the other side of the character's face, turning the bust. Refer to the concept as you work, although you should use as many references as you can. Even when creating a stylized character try to find real-life references that can serve you as a guide. Beginners often focus too much on their concept art and forget to study the basic proportions of the figure they are creating. It is important to take your time and not rush in these steps.

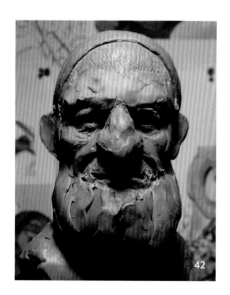

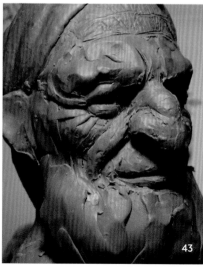

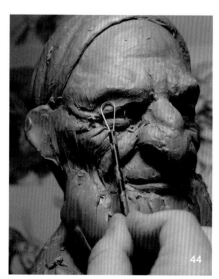

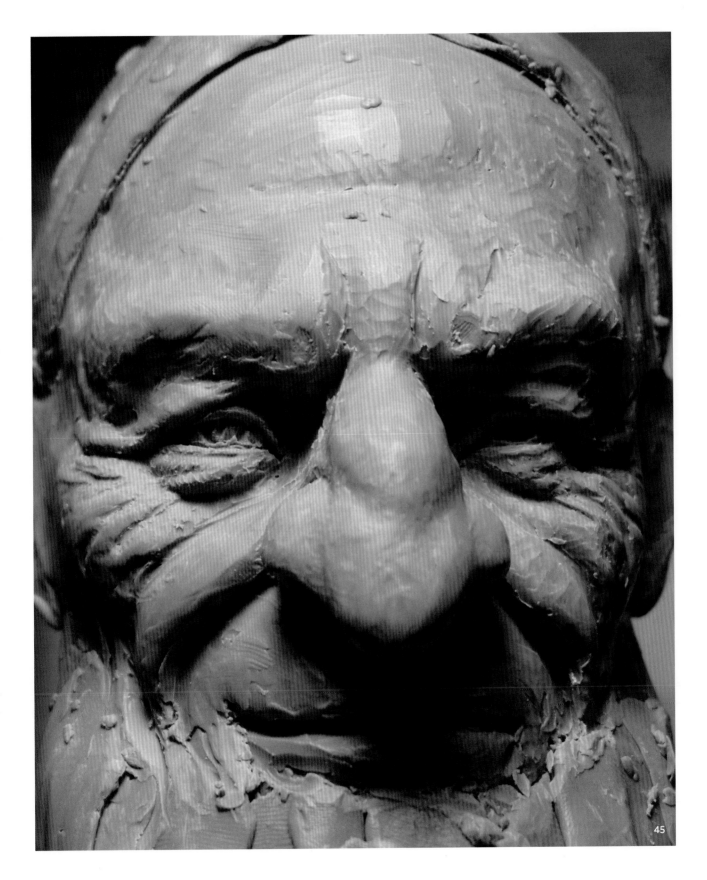

45

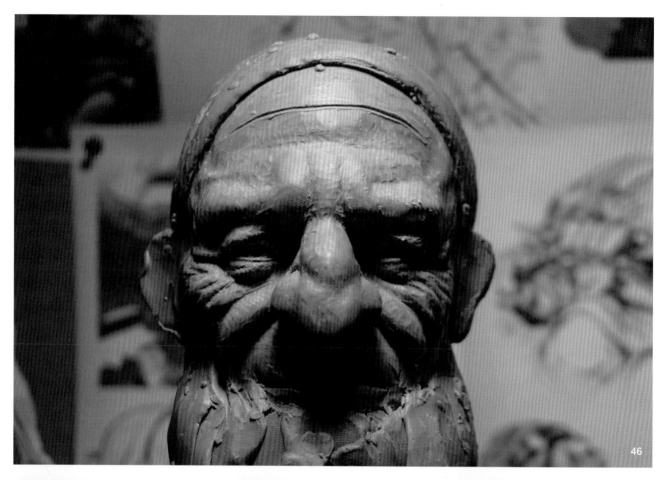

46 The forehead needs to be refined further because it looks a bit flat, although we will tweak this and the hat a lot more later on. Use a loop tool and spatula to create a few creases and lines in the forehead, then smooth them out with a rake tool. The important thing is to work on the transitions between the wrinkles, so that they look natural. The wrinkles should look like soft tissue being pressed against itself rather than simple lines on a flat surface. Use references to check how much they should protrude and how much fat and skin they consist of.

Wrinkles are created by muscles pulling generally in transversal directions, and combine to create expressions. Take advantage of the soft clay and play around with this. Push the eyebrows up or down and see what happens!

SCULPTING THE EARS

47 Now move on to developing the ears, which are still only simple blocks. Although ears look intricate, this process is very simple and in a few steps you will see the main forms of the ear. You will however need to refine and tweak the secondary forms later. Use small loop tools for this task.

48 Start by carving out a hole in the blocked-out ear, parallel to the character's cheekbone, with a loop tool. This will form the concha of the ear and create a simplified ear shape similar to a letter C.

49 Add more clay to form the curved tragus of the ear and then cut out a line to be a guide as you shape the helix. I only use one small loop tool to do this but feel free to try different tools for these steps. The specific tool does not matter too much, as long as you feel comfortable working with it.

50 Still using a small loop tool, refine the forms, blending the shapes to create a softer look. Add small pieces of clay to create the indent for the fossa triangularis at the top of the ear and ear hole, and then round the helix and antihelix.

REFINING THE FACIAL HAIR

51 Once you are happy with the main forms and the character's facial expression, put the mustache back in place to add more form to the beard and mustache. Repeat the same process as in steps 25–29 to resculpt the mustache and beard forms from scratch to match the new expression developed in steps 42–46.

52 To give the updated facial hair definition, carve out some lines and add new bits of clay to create overlapping clusters. This adds more form and shape to the beard, and also makes it more interesting. I have a few Renaissance-style sculptures beside me to use as a reference. You can easily find amazing classical sculpture references online. Bernini and Michelangelo are my favorite sculptors from that era.

53 Using a mini blow torch, melt down the superficial surface of the beard. This will blend and add texture to the beard while allowing it to keep its shape. Practice on a piece of clay first to avoid melting down or burning the piece before working on your sculpture.

Make sure you are in a well-ventilated area when using the blow torch and be careful not to burn yourself as it will become hot very quickly. You should hold it a few inches away from the sculpture for one to two seconds at a time. There are clays which cannot be used with fire, so check with the seller before you try this out. 🔥

This is not a required step; you can instead keep sculpting, refining, and rounding the forms until they look soft. You could also use a solvent like turpenoid to melt down the clay with a brush. I prefer the blow torch because it does not leave any residue or oils on the clay. If you choose to use a solvent, make sure you use it in a well-ventilated area to avoid breathing in solvent fumes. ❗

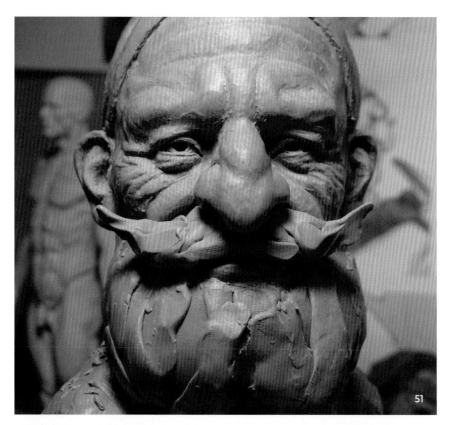

51

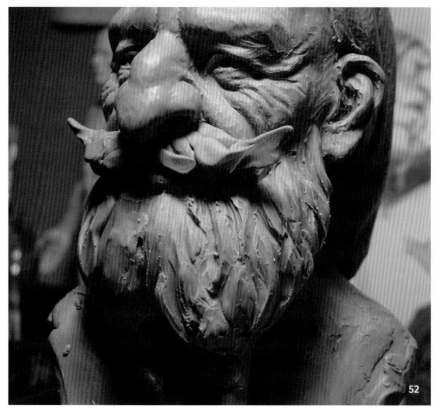

52

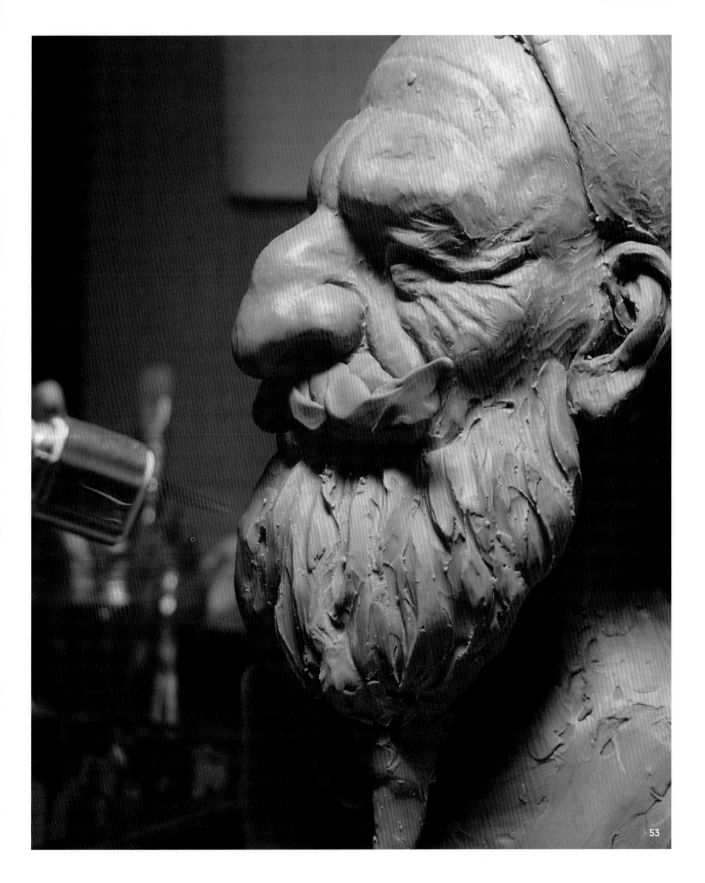

53

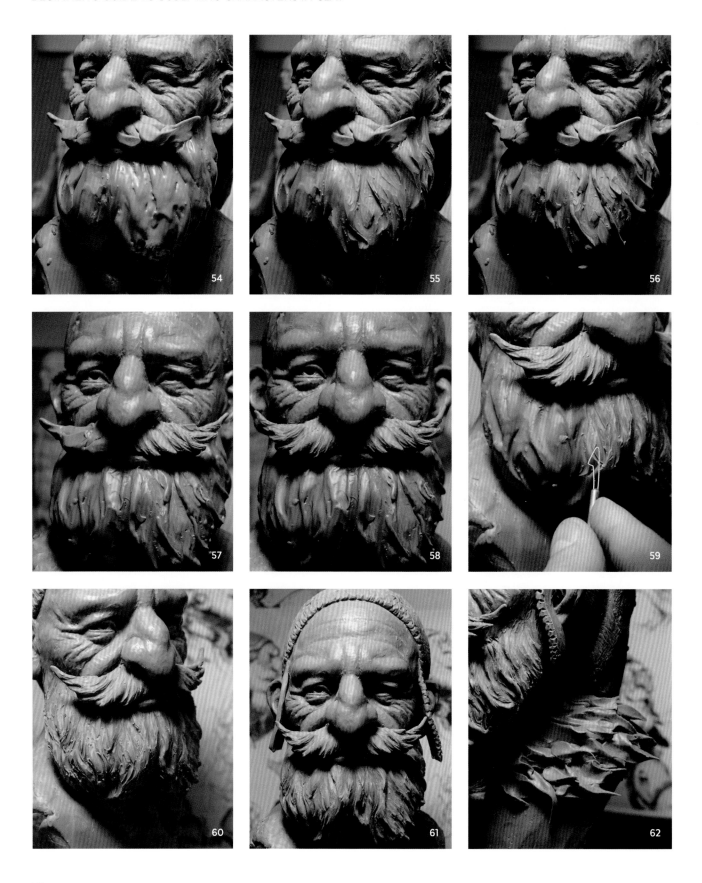

54 You could take an opportunity to have a break here before starting on this step, but as your clay should not be melted to the point that it is liquid you should be able to sculpt right away if you want to. Make sure the clay is not too hot to touch in order to avoid burning yourself. With the surface of the beard melted together or rounded out you can refine the forms again with a small loop tool.

55 Using firm flowing strokes, carve out the shapes of the beard using a loop tool with a pointed end. Think about building up the forms similar to the Renaissance style, and do not focus on the lines.

56 To build up the beard forms, roll strands of clay with your fingers on the work surface and then press them into the beard to give it texture and build up the silhouette. You can then repeat the blow torch process here to smooth it out and blend it together. Remember to follow the safety advice given in step 53. 🔥

57 Repeat the process of melting then refining the beard surface until you are satisfied with the result. Remember to look at forms rather than lines, so every time you repeat this process you are adding information and more shape to the beard. Beginners usually create very flat shapes with lines just drawn on top, so this method is a way to avoid that issue.

58 The same process can be repeated to create the mustache, but avoid using the blow torch to melt it down. This is because the clay of the mustache is so thin you could run into problems by melting it too much, destroying the overall shape of it. Instead, keep carving the mustache with small loop tools to get the desired look.

59 Hold the pointed loop tool close to the loop to give yourself more stability and precision while carving. I find that using small loop tools for this task takes longer but it is an easier method for refining forms.

60 It has taken me about thirty minutes to refine the mustache and beard, but again, do not worry too much about how long it is taking you. These timings are just for your reference and you should probably take longer than this if you are a beginner.

At this point, you should stand back and analyze the piece, referencing the concept again to check the proportions and overall look. Whenever you feel tired, make sure you rest and come back to the sculpture with fresh eyes.

CREATING THE COSTUME

61 Focusing on the costume now, reattach the hat flaps onto the sculpture. Use a loop tool to start creating some texture on them and do the same with a rake tool for the hat. We will go into more detail on texturing the hat in steps 72-78.

62 The cloak the character is wearing has a fur texture, although It Is more styllzed than actual fur. Try several different looks for this texture by adding a cloth-shaped surface and sculpting thin fur, or by adding balls of clay. I go with a simple "stretched" clay look, pulling the clay apart to allow the natural shape of the stretched clay to form the irregular shape of the stylized fur.

REFINING DETAILS

63 Using your fingers, press some warm bits of clay onto the bust's shoulders then pinch the end, pulling it apart from the rest of the clay. You can then shape it more once the clay is harder.

Keep adding to the cloak and increasing the shoulder size. It is very important to build the body of the character slowly to have the perfect balance of head and shoulder for the final piece.

64 For the brooch on the character's cloak, press a clay sphere into the torso. Then use the loop tool to carve some lines onto it, just to give the broach some simple detail.

I recommend taking photographs at this stage because it can be hard to see what is going on since your eyes are used to looking at the sculpture up-close and there will be some perspective distortion. Taking a few steps back will help you see the piece as a whole. There are no fixed rules for checking proportions here so you just have to follow what feels right. Checking the work of your favorite artists will help you understand design and angles better.

65 Continue to refine the sculpture as a whole, adding small bits of clay inside the eye to give the effect of reflection. This is just something to catch the light inside the dark pupil, to give an illusion of roundness and depth. I have learned this trick from admiring and studying all the great masters of the past. Use a spatula to help you position the clay inside the iris.

You can see that I also add a few hair strands peeking out from underneath the rim of the hat. Create these the same way you made the mustache and beard by adding small pieces of heated clay and using your fingers to shape them.

66 At this point, I stop to take several pictures of my sculpture and play with them in Adobe Photoshop. You may find it useful to use a black cloth to eliminate the background and focus on the final sculpture. I am unhappy with the overall shape of the head and expression, so we will change this in the following steps.

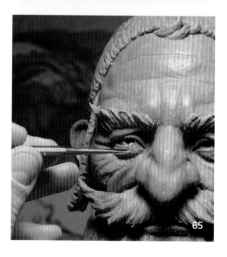

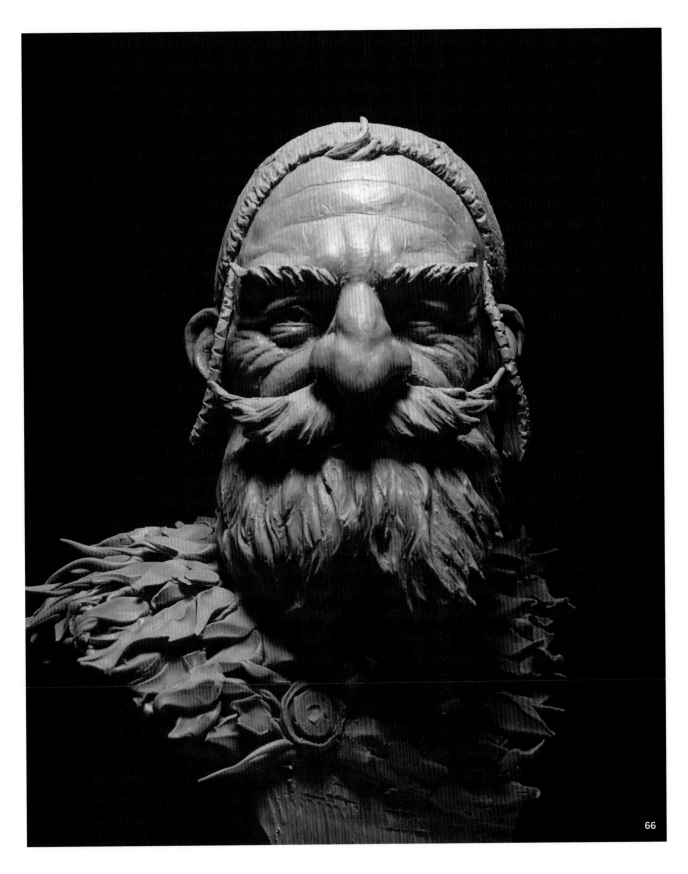

66

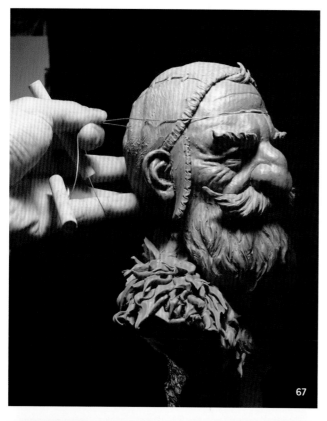

67

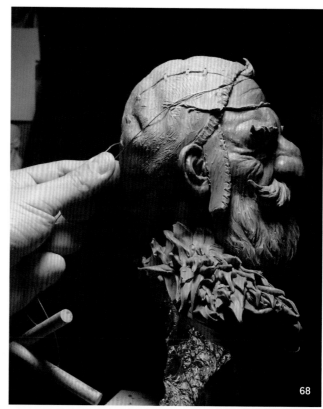

68

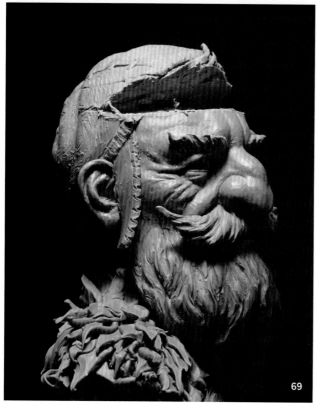

69

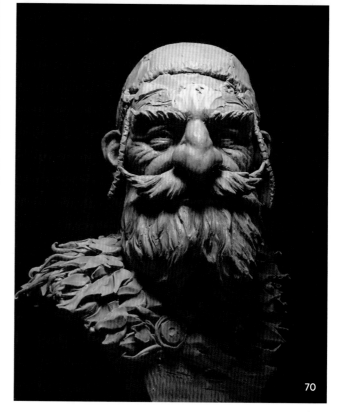

70

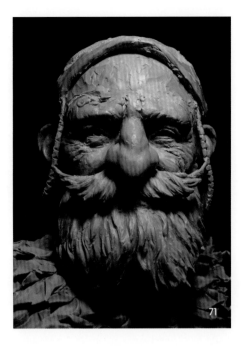

71

RESHAPING THE FOREHEAD

67 Use a cutting wire to remove a slice of the forehead to make it shorter (see page 33 for advice on using this tool). To make the first cut, loop the wire loosely around the sculpture then pull the wire towards you in a firm, smooth motion. This procedure can be done without damaging the sculpture too much, but you have to work very slowly. We are going to resculpt everything around the cut again so do not be too concerned about any damage. Make sure you use the wooden grips on either end of the cutting wire to avoid cutting your fingers.

68 For the second incision, repeat the previous step, this time creating a slice on an angle. Remove a bit more clay than you think you will need because it is easier to put clay back than to redo all the cutting steps. As we are not using specific measurements for any of these procedures you will need to use your judgement. This may seem tricky at first but as you become more practiced you will find it easier.

69 Use a spatula to gently remove the slice of clay from the head. It may come out in several pieces if the two wire cuts did not connect properly at the end. As you can see in image 68 this is not a big problem.

70 Push the top of the head down with your hands and fill in the gap with fresh, warm clay. Do this carefully to match the new head proportions. Do not be concerned about losing the details of the hat as we will have to resculpt these details again anyway.

71 Add clay to the side of the head as well, changing the shape of the hat. Remove the eyebrows so you can check the proportions better. What we are trying to achieve here is a major change in shape and proportion, so you need to enlarge the head to the sides and round the forehead. This will give the bust stronger forms, matching the concept more accurately.

Resculpt the brim of the hat, using references to make sure it has the appearance of cloth draped over the skull.

FINISHING TOUCHES

72 Tweak the character's expression to make him happier by exaggerating the wrinkles and the volume of the cheek area. Make the cheeks rounder and more compressed, and then blend the wrinkles a little more using a loop tool.

The lesson here is to not be afraid of changing your sculpture even if you have everything laid out. Keep sculpting until you are completely happy with it!

73 Follow the same general workflow we have been using to resculpt the hat, again referring to the concept and references. Block in the forms by adding clay and carving out some wrinkles in the soft material. Use a larger, flat-edged loop tool held at an angle to the clay to carve a clear cut line. Then add more pieces of clay and blend them with your fingers and the loop tools.

74 Rake over the whole hat to add some texture. This will ensure the texture of the hat reads differently from the material of the skin, beard, and mustache. You need to consider how these materials will read in the finished sculpture. It is all about adding interest and making it looking attractive and, in a way, realistic.

75 Create seam stitching on the hat by carving out a line with a pointed loop tool to make the seam. We will then add bits of clay to make thick stitches. Carve the cut deep enough to catch shadows. Of course seams are not even close to this depth in real life, but this is a more stylized way of achieving the look.

76 For the stylized stitches, add small pieces of clay which you can shape with your finger tips. Press each stitch gently across the seam line, creating an illusion of thick, rustic stitching.

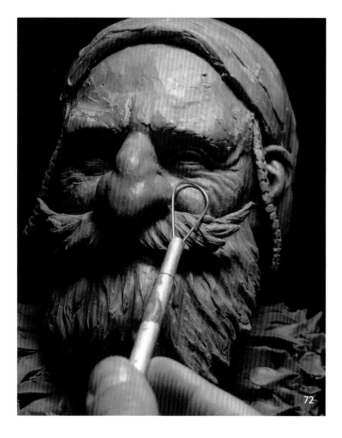

72

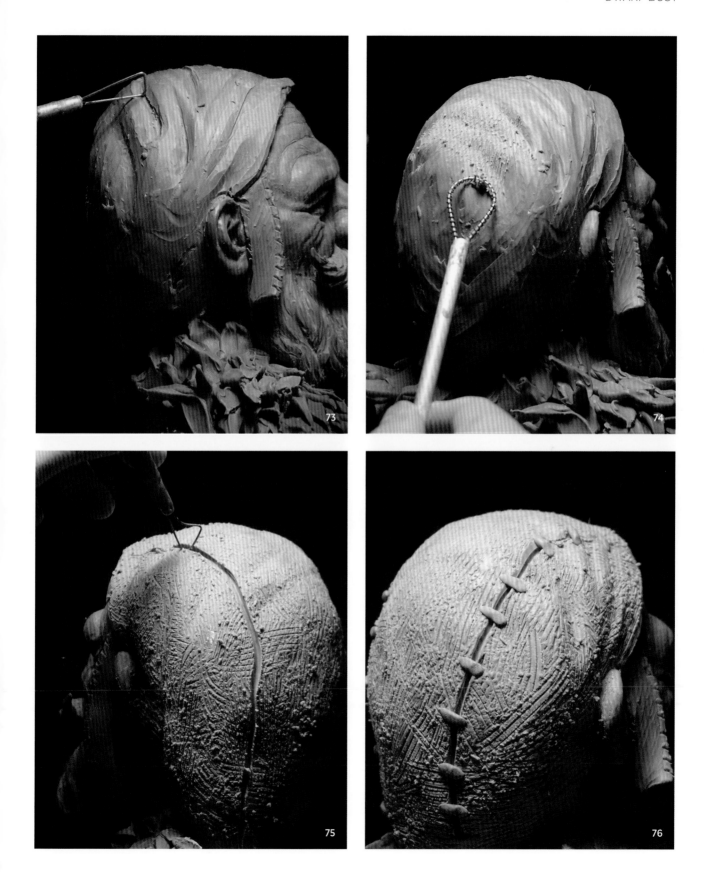

77 Using a spatula, shape stitch hole details by simply punching in the pointed end of this tool. You can also press the flat side of it gently against the stitch to help blend the clay together.

78 The rake tool has left strong marks on the hat, which does not look very attractive, so we need to soften them. Isopropyl alcohol is a very light solvent for Monster Clay and dries out very quickly, so it does not leave any residue or change the composition of the clay.

Gently apply the alcohol with a soft brush in a circular motion to smooth out the surface. Depending on where you live, it can be harder to find ninety-nine percent isopropyl alcohol, but you should be able to find some percentage of alcohol. Do not worry about the percentage too much as you can achieve the same results with any sort of alcohol. If you are not using Monster Clay, check with your supplier which is the best solvent to use.

As before, make sure you use the solvent in a well-ventilated area to avoid breathing the fumes. ❗

79 Add different details to the sides and the edges of the hat to create another texture. Use different sized loop tools and interlacing strokes to carve deep shapes and wrinkles. For this stylized sculpture, do not worry about sculpting a realistic hat; a more sculptural, stylized approach is needed for this piece.

80 The sculpture is complete! You can now spend time taking photographs and properly presenting your work. I use two light sources: one yellow spot on top of the piece and a softbox for the rim light.

TAKE PHOTOGRAPHS

As mentioned, you should take photographs of the process throughout to check the proportions of your sculpture. However, you should also study the essentials of photography and post-production, because generally people will see the picture of your sculpture rather than the piece itself. A bad photograph can ruin a good sculpture. Keep your photographs simple with only one, two, or three lights to avoid flattening the piece.

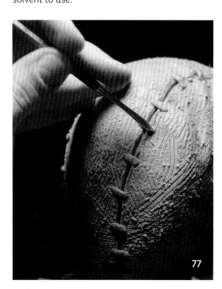

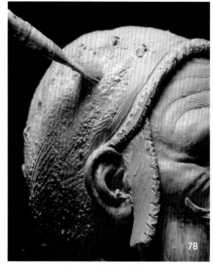

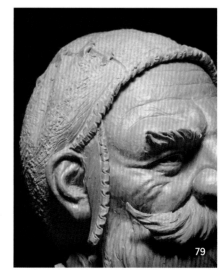

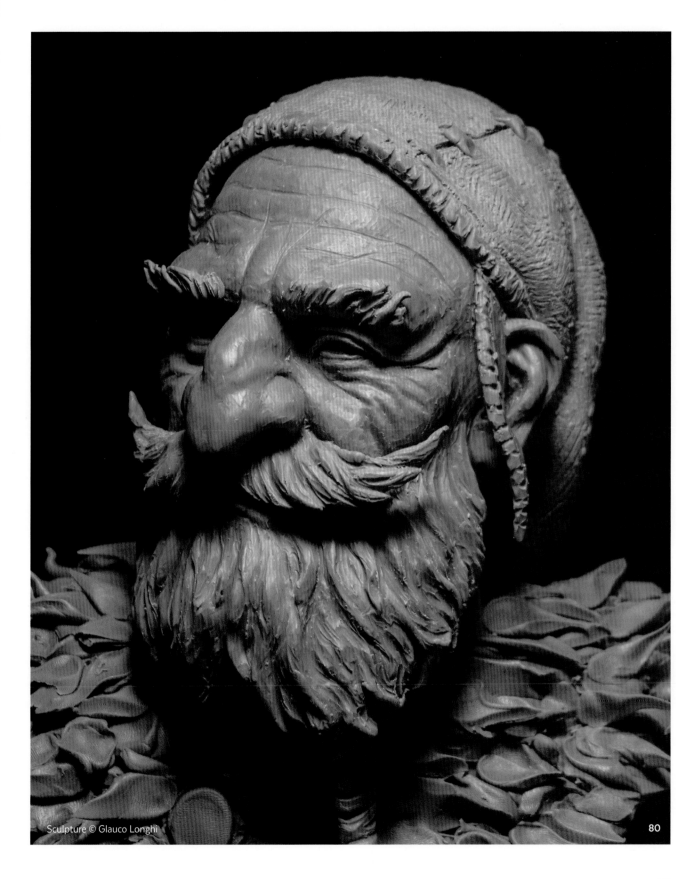

Sculpture © Glauco Longhi

80

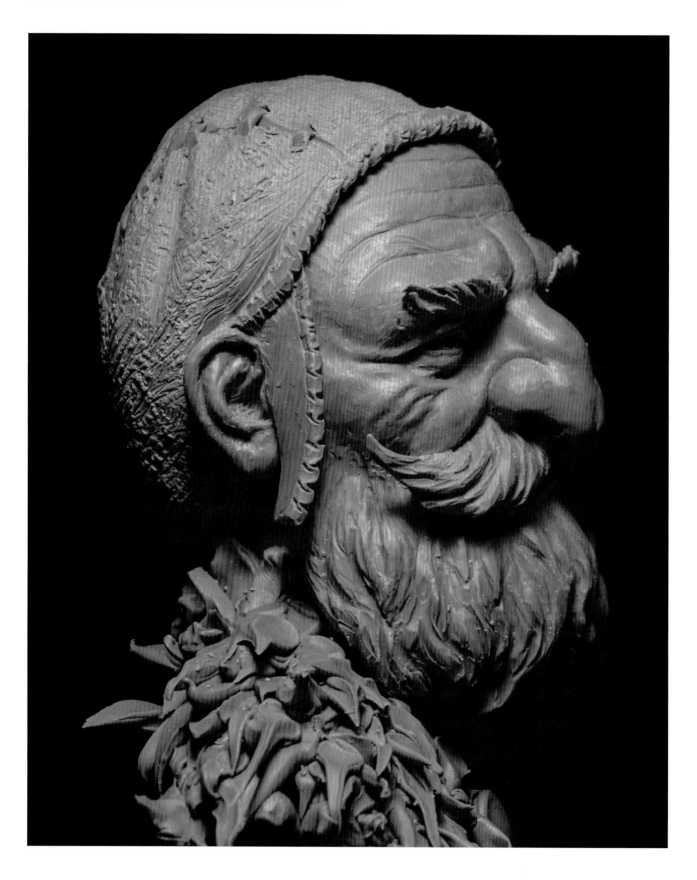

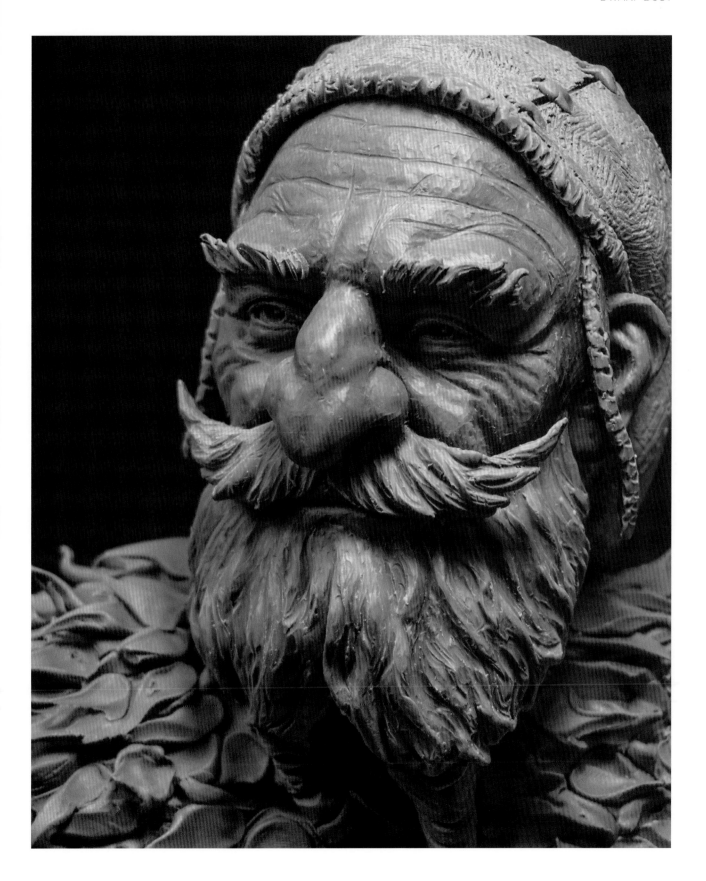

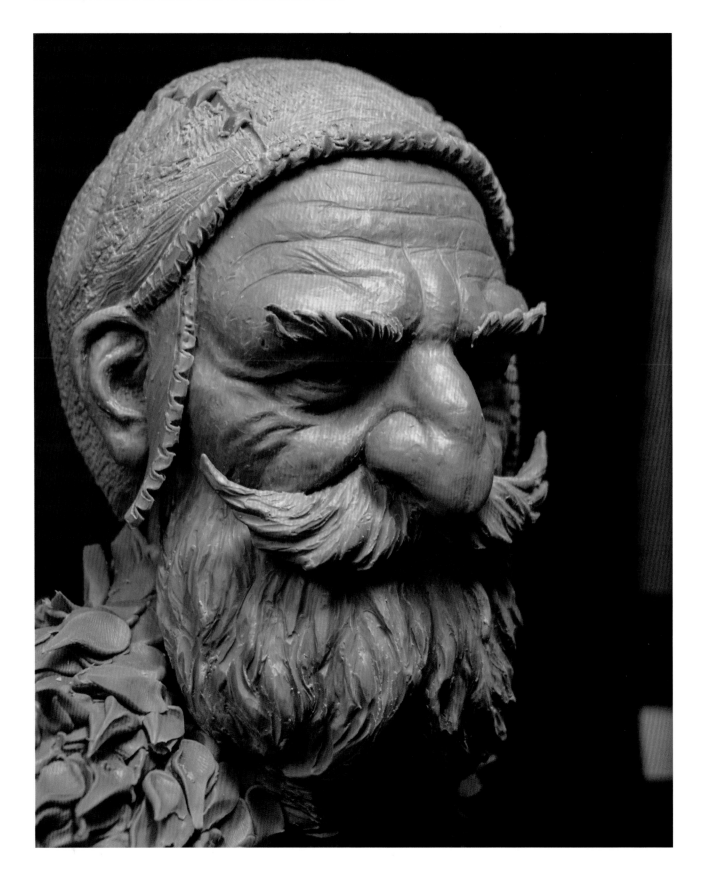

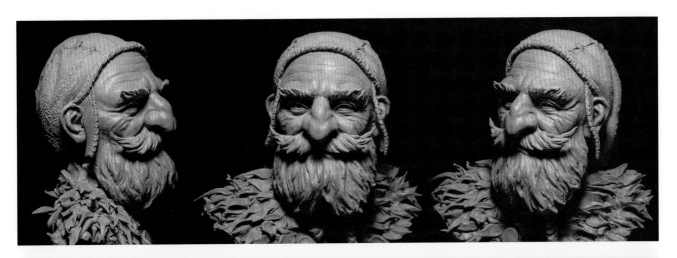

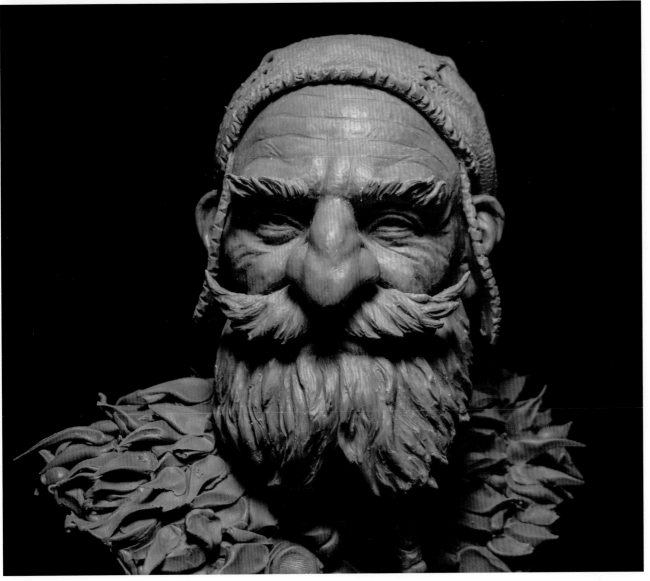

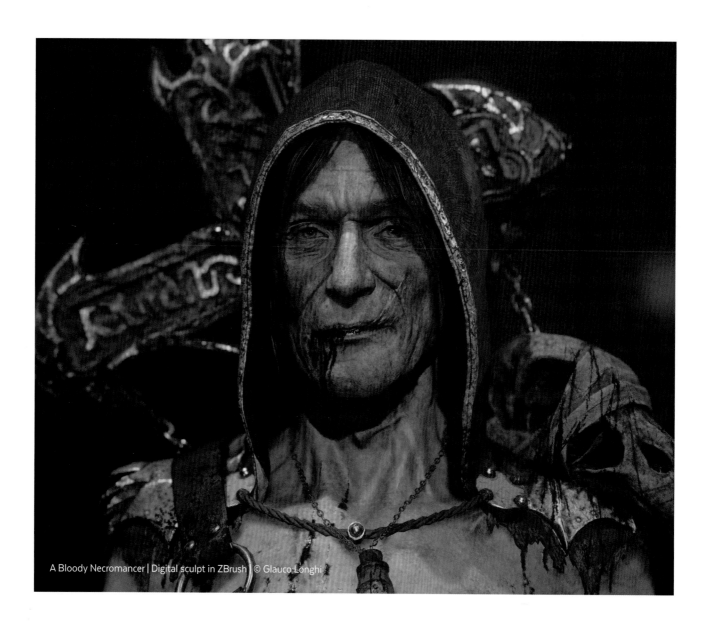

A Bloody Necromancer | Digital sculpt in ZBrush | © Glauco Longhi

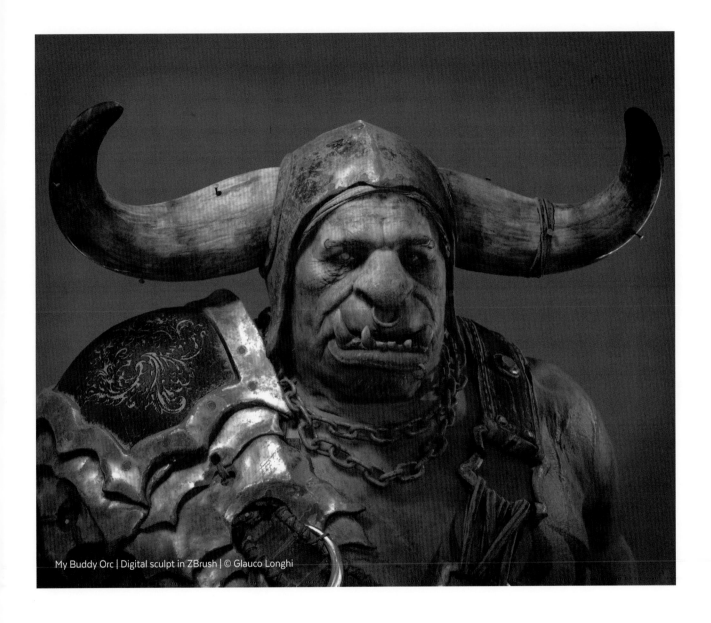

My Buddy Orc | Digital sculpt in ZBrush | © Glauco Longhi

CYBORG

BY ALFRED PAREDES

MATERIALS

Aluminum foil

Armature wire (1/8-inch aluminum)

Board

Sulfur-free plasteline (medium)

Florist wire

91% isopropyl alcohol (rubbing alcohol)

Superglue

Two-part epoxy putty

TOOLS

Alcohol torch (optional)

Ball tools

Brass tubes of different sizes

Compressed air

Drill & bit

Electric food pan (optional)

Kidney shapes

Loop tools

Micro-butane torch (optional)

Needle-nose pliers

Sanded tooth pick

Sanding screens (medium & fine)

Sharp knife

Small torch (optional)

Soft brush

Spatulas (large & small)

Spinning platform

Before we begin our journey together in this tutorial, I want to state that the methods and techniques I will show you here are not the only way to achieve these results; they are not even the only way that I achieve these results. There are many methods you can use and I suggest trying them all to find what works best for you and the project you are working on.

In this tutorial I will show you how to sculpt a mech-type character using Chavant sulfur-free plasteline (NSP), which is an oil-based clay. I will not use a specific scale for this piece, although it is important to be aware of time and scale when you are sculpting professionally as both will affect the amount of work you can accomplish and the level of detail your piece can have. I find medium Chavant NSP to be the most versatile clay for these purposes. If you go for a harder density you can achieve tighter detail but it takes longer to work and it is harder to make changes; softer clay is faster to sculpt, but it is too soft to hold a crisp edge. I will walk you through all the sculpting steps I carry out, from building an armature, posing, and adding the clay to the piece, to sculpting details.

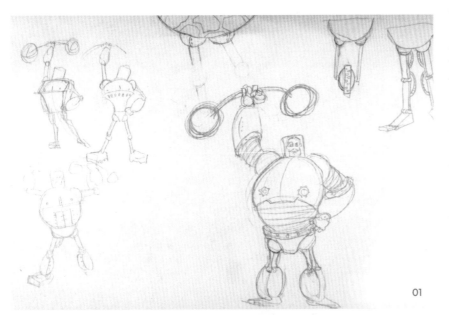

01

PREPARATION

01 Any good sculpture is about character and story. Whether it is a polished final piece or a roughly sculpted maquette, if it does not have character and a story to tell, it will not be interesting. To start a sculpture then, it is always useful to begin with some designs. I like to put pencil to paper to work out ideas and lose the bad and redundant concepts along the way. There are times when I will explore straight in clay but, for the most part, I like to have a bit of a road map before I start.

This mech character needs to have hard surfaces and an appropriate expression. Begin by doodling to come up with ideas. I have always been a fan of retro-future designs and I think this would be a great fit. After coming up with an idea, it is time to work out the design. This takes some playing around. Sometimes you will find a good idea straight away and sometimes it takes dozens of designs to get it right. I know I want my design to be whimsical as that tends to be a motif in my work, and I want there to be a human element as that is also a significant part of what I sculpt. The idea comes together in a retro-futuristic, old-timey, strongman cyborg. To add to the effect I decide I would like to place a glass dome on his head as a sort of helmet.

02 To start a sculpture you must first gather your materials. In this case you need: a board to mount the sculpture (I use a scrap piece of shelving as I like the melamine surface); armature wire (1/8-inch aluminum wire works well for this); florist wire for wrapping around the armature wire; aluminum foil to bulk out the sculpture and cut down on weight; epoxy putty for holding the armature together firmly; and finally, clay.

02

03

04

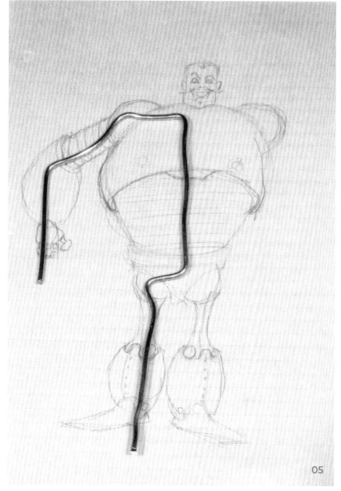

05

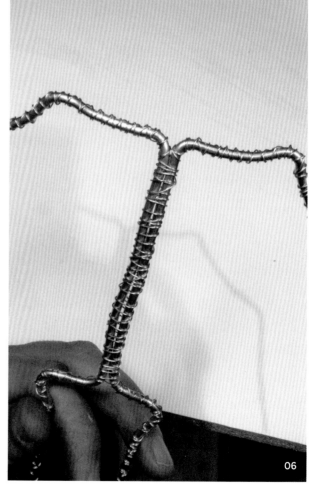

06

03 To start, cut up the clay using a large spatula. Making smaller chunks will mean that the clay warms up more quickly. The amount of clay needed depends on how big your piece is and your clay-warming method, so cut up enough to get you started such as one block to begin with, depending on the size of your sculpture.

04 There are a few different ways to warm the clay. One method is to set the clay in a tray and place it under a lamp. I do not like this method because a lot of the heat is lost to the ambient temperature of the room. An alternative technique is to line a cardboard box (a file box works well) with foil, cut a hole at the top, and put a lamp there. The heat builds in the box and the clay becomes warm. This method is great for beginner sculptors as it is inexpensive and easy to make. It is also fairly transportable and does a decent job of warming the clay.

My preferred method is to use an electric food pan. I like this method because you can select the heat that you want (sometimes you will need the clay hotter for brushing or spreading) and you can keep the heat consistent. The glass cover keeps the heat in and the dirt and dust out. The clay is heated more evenly than through the other methods. The food pan is also compact, which is great for work areas that are already tight on space.

CREATING THE ARMATURE

05 While the clay is warming up, it is time to prepare the armature. Sometimes it is helpful to produce a scale drawing of your character so you can make sure the proportions are correct. Decide how big you want your piece to be and try to draw it or print it out to that size. If it seems too big, resize it to something that is more reasonable.

Start by bending your armature wire into a basic T-pose. You can bend the wire by hand, but having a set of needle-nose pliers is useful for achieving sharp bends in the armature. The pliers usually have a cutting section built into them, so you can use them to cut the wire as well. Use your drawing to figure out how much armature wire you will need.

06 Once you have the basic proportions of your character bent into shape, you can use the florist wire to wrap the components together. The purpose of the florist wire is to add texture to the armature so that the clay has something to grip to. If you just put the clay on the aluminum wire without the wrap, the clay will spin and come undone, which will be very frustrating.

Start at one end of the armature and work your way across. Be sure to hold it securely while you make a start. Keep the spacing about 1/8 to 1/4 inches apart as you wrap the armature. Go down one way and come back up the other way. This will give the arrangement of the florist wire a criss-cross pattern. This is important because if you only go in one direction, the clay can still spin off. When it is all wrapped up, it is time to use the epoxy putty.

"YOU NEED TO LOOK AT THE ATTITUDE OF THE POSE AND MAKE SURE IT WORKS FROM ALL ANGLES"

07 Epoxy putty is a two-part resin compound. There is a resin part (the black section in image 07) and a hardener (the white core). The two combine to form a very strong material. The hardener is a catalyst and heats up the material, curing it to its final hardness. Epoxies can be used for many types of things including home and automotive repair, and hobby and art projects.

You can find two-part epoxy putty at a hardware store, usually in the plumbing section or where they sell glues and other adhesives. I use an epoxy named ProPoxy. It sets in about twenty minutes, but you can get epoxy that sets in five minutes – you will just need to work faster and in smaller amounts.

Start by cutting off about an inch. Use a sharp knife to cut the epoxy because a dull knife will just push the epoxy together and start mixing it. You need to wear gloves for mixing the epoxy; safety is always important when using these types of materials as you can develop an allergy and overexposure can cause health issues. Work in a well-ventilated area. ⓘ

08 With protective gloves on, knead the material together and be sure that it is thoroughly mixed. You need an even color throughout. Any streaks mean that it is not fully mixed and it will not cure properly. Work quickly but thoroughly to ensure you will have plenty of time to apply

the epoxy. There will be no noticeable change in texture, but you may feel it starting to get warm.

09 Add some of the epoxy to the upper area of the armature where the shoulders meet the spine. Mold it around the wire, pressing firmly with your fingers. This will help to keep the armature together and also make sure that you will not be able to bend this area in a way that would not be possible for your character.

10 Add another piece of the epoxy to the hips that is about the same as or slightly less than the piece you used for the chest area. Let the material fully set. Curing time depends on the material purchased and the ambient temperature of where you are working. Colder temperatures will slow the cure, while hotter temperatures will speed up the cure. Epoxies have different setting times so read the manufacturer's instructions for the proper cure and usability times. Once you can no longer make an impression in the epoxy with your fingernail, it will usually be hard enough for the armature to be used.

11 Once the epoxy is set, start posing your character. You can pose the armature by hand or use pliers if you need to achieve a sharp bend. You need to look at the attitude of the pose and make sure it works from all angles. Be sure to allow a little extra room at the bottom of the armature because we will insert that into the board.

07

08

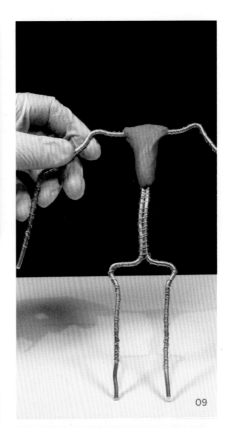

09

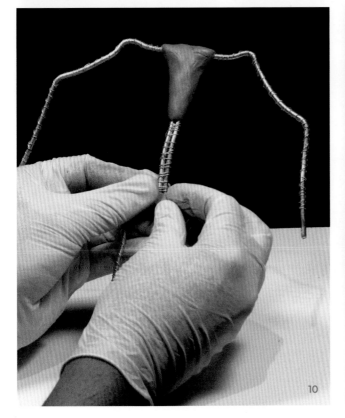

10

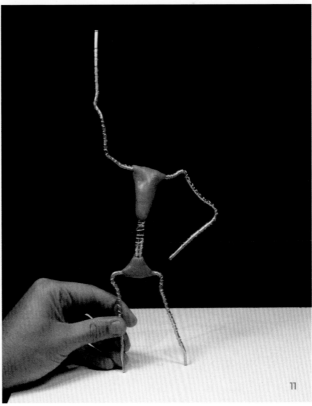

11

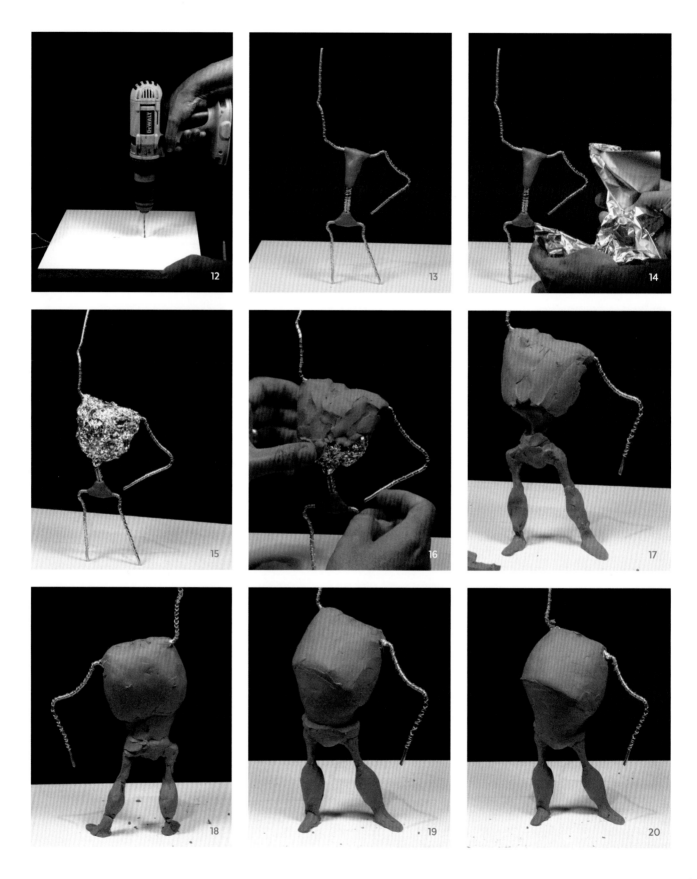

12 Once you have posed your piece, mark the locations for the character's feet on the board. Then take a drill with a 1/8-inch drill bit and drill holes in the corresponding locations. 🔥

13 Insert the armature into the base and adjust the pose if needed. The armature should fit snugly into the holes. If the armature is loose, use superglue to glue one foot into place. Do not glue both feet as you may want to adjust your pose later; having one foot free to move makes this easier.

14 Next you need to bulk out any large areas of your character with aluminum foil. Do not apply a huge sheet of foil, but rather make strips about 4-6 inches wide and wrap them around the armature loosely. Overlap the pieces so that they stay together well. Then scrunch the foil down. Do not pack it too tightly as you need to be able to adjust it if necessary. Make sure that it is tight enough for it to stay on the armature securely though.

15 This character should have a very bulky barrel-like chest, as you can see in image 15. If you are not able to wrap the aluminum foil securely, you will need to add one more round of florist wire to hold the foil onto the armature.

BUILDING UP THE BASIC FORM

16 As you take out the warm clay from the electric food pan, be sure to knead it first as you need to make sure the clay is fully incorporated into itself before you start working with it. Then you can start applying it to your armature. 🔥

It is all about blocking in the forms at this stage. Start with the big shapes and work towards the smaller ones. Spread the clay onto the armature starting with the torso. Make sure that you fully combine each piece you add with the clay below

– do not simply add it to the surface of the piece of clay beneath. Use your fingers to press firmly and work the clay together.

17 Keep adding on and blocking in the larger forms, moving down to the pelvis and legs. Do not worry about details right now. You need to fill in the volumes and then we will move into smaller forms later. Make sure that you avoid only sculpting from the front view by turning your piece constantly. Only use your hands for this part of the process (although you can always use a tool if you cannot reach a certain area). Avoiding using tools this early on will keep you from slowing down and trying to add detail too early.

18 Keep turning the sculpture so that you work from all angles, building up volume on the back and filling out the gap between the pelvis and the ribcage slightly. Refer to anatomy references if needed so you understand the basic structure, although remember that this is a stylized piece.

It is important to not become stuck working from a single perspective. You will see how the forms are shaping together and where you need to adjust if you rotate the sculpture as you work.

19 I want to make it clear in the design of this character that it is not a man simply standing in an armored suit, so changing the proportions will help to convey this. For example the thigh areas are reminiscent of a femur but kept thin so that it is clear there is no leg inside; the arms are long and the legs are short to further break up the human form and maintain the robotic feel.

20 Add more clay to make the torso even larger in order to really push the proportions, smoothing the clay out slightly as you go. Making the angle under the top part of the torso more pronounced will add to the robotic feel. I want it to have a look of something that could be a steam boiler, or a high-pressure container, which will enhance the retro-mechanical feel.

21 Leave the arms until the end to allow yourself room to work around the forms. Add clay for the shoulders, upper arms, and lower arms, adding extra clay to the lower arms to emphasize their size. Rounding out the shoulders into more ball-like shapes alongside the tubular upper arms will be reminiscent of piping, again adding to the retro-feel we are aiming for.

As you bulk out your sculpture, be aware of the composition and attitude of the pose. It is one thing when you pose the armature, but as the figure takes form you need to be willing to make adjustments to the pose to make it read better. Now that the torso is bulked out you can move the arms into place more, bending one more sharply than the other so that it sits on the character's hip.

REFINING THE FORMS

22 Start to add in some details such a belt line, and refine the shape of the mid-section. Again, work all the way around the figure, as constantly turning your piece will help you to see clearly and make good decisions. Using the larger volume of the chest, make sure that it is clear where the ribs end at the back as well. It is a subtle design choice that will make the figure appear more anatomically correct, even if he is a cyborg. I roughly add in the hint of a spine as well.

23 At this stage it is a good idea to draw in a center line. You can use a ruler, spatula, or template to do this - anything with a straight edge. This will help you to gauge your symmetry and forms. It will also help set the position of the head, which we will work on next.

24 Block out a simple skull shape with another piece of clay; the head should be a very basic shape at this stage. You can attach the head using just the warm clay or, if you prefer, you can melt some of the clay where the neck will go using a small torch. I just use the hot clay and make sure it is well blended.

From here, you can complete the blocking out of the rest of the body by adding basic shapes for the feet and building up the hands. The hands can just be fist shapes for now, but think of the proportion and size and make a decision on how big you want them to be. I also enhance the design of the front of the body here by adding a ridge to make it more interesting, in addition to refining the top of the lower legs further to make them more angular.

25 Remember to keep turning your sculpture and avoid adding details. You should still just be using your hands. Be sure to check the depth of your skull shape as there is a lot of volume at the back of the head. Use references to properly shape that area. Blend it all together with the neck.

26 You can now add a few joint marks into the knees and hips. As you start to refine the sculpture further, you will notice that the smaller forms begin to take shape. These details help to shape the design of the character. I want to give a nod to human anatomy while keeping it robotic, so the joints are mechanical-looking while still relating to human joints.

Continue just using your hands here, although you may want to use a brass tube to press circular shapes into the knee joints as I did here.

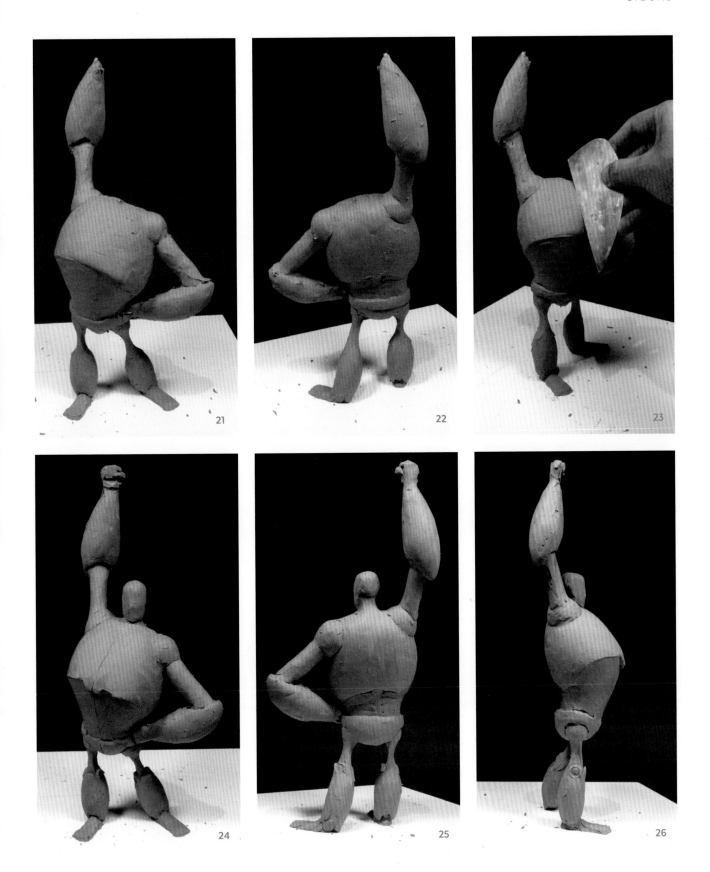

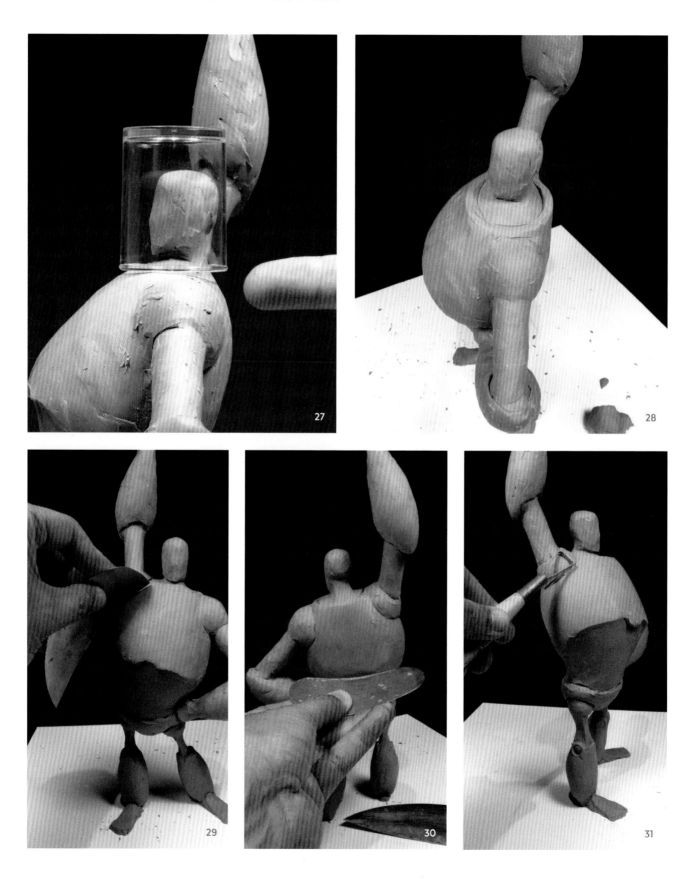

KITBASHING

An alternative way to sculpt is to use found objects, such as pipes, old electronics, and even toy parts. This technique is known as kitbashing. Kitbashing requires some scavenger hunting to find parts and some construction of parts from scratch. Power tools and saws are often needed to shape the parts and then glue or epoxy is used to fix them together. The film and TV industries use this method a lot, for example it was used to construct the *Star Wars* spaceships.

27 Before moving on further with this piece, it is important to consider what it looks like as a full composition. In my sketches the character had a dome over his head so I place a small glass on the sculpture to test what this will look like. The dome is simply a design choice for this character. I want it to look like he still has his human head but I imagine this character will be able to travel through space or inhospitable environments because of his glass helmet.

As you can see in image 27, there is some volume missing from the sculpture to help the dome sit correctly on the torso.

28 Add the missing volume to finish the blocking out of the figure by taking some clay and blending it in at the top. Add as much clay as needed, in whatever shape it takes to fill the volume. Press the dome into the space to make sure it fits well and sits completely flush.

REFINING THE SURFACE

29 You now need to begin to refine the surface. Because this figure is a cyborg character we want big, smooth shapes, so it is a good idea to use kidney shapes and scrapers. Kidney shapes help to reduce any areas that are too built up and fill in areas that are too low. You can find these at most craft stores that sell sculpting supplies or online.

30 Having a couple of different shapes and sizes of kidney tools is helpful. Different shapes will allow you to get into different areas of your sculpture, such as under the ridge on the back as shown in image 30.

There are many different shapes available and you can always modify the kidney shapes and scrapers to give you a specific shape you need by grinding or shaping the tool using a file.

31 For the areas in which the kidney shapes are too big to use, like the armpit region, you can use loop tools instead, as you can see in image 31. Having smaller tools in your kit will make shaping and smoothing tighter areas much easier.

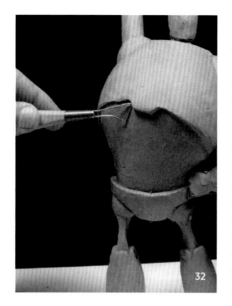

32 For even smaller areas, hold the loop tool at an angle to the sculpture and use the corner to smooth out the surfaces. This is particularly useful for under the ridge on the torso. Continue smoothing the whole body.

33 Once you have completed these steps, carry out one more level of surface refinement. I like to use sanding screens for this. You can get these at a hardware store in the same aisle as sand paper or drywall supplies. They come in different levels of coarseness – you need medium and fine for this purpose. You might also want to use window screen material, which is a finer version of sanding screen material. I find that this gives a pleasing smooth finish.

34 Lightly rub a piece of the sanding screen over the surface of the clay to smooth out any remaining bumps and refine the surface of the sculpture. First work over the whole body with a coarser, medium sanding screen to blend the forms, then use a finer screen to gradually smooth over the surface.

ADDING MORE DETAIL

35 Now that you have a smooth sculpture you can begin to add some more of the details. This character will have segmented sections on his belly and arms. To achieve this look, use a small metal spatula with a blade-like shape on one end and draw the lines into the clay on the abdomen. In order to make sure the lines are smooth, move slowly and deliberately across the clay, doing your best to make the mark in as few strokes as possible. 🎬

36 Continue to make marks for the segments on the arms. You can use something to keep your spacing consistent (such as an ice pop stick or a thin piece of plastic that you can cut to size) or just use your eyes to gauge the spacing. You also need to keep the depth of the marks consistent, which will take patience and practice. The marks are meant to represent a segmented and possibly extendable section of the arm.

37 Next further refine the hinges on the knees. For details that need to be crisp and mechanically perfect you can use tubes or other manufactured shapes. In this case, the knee hinge needs to be a clean circle, so find an appropriately sized brass tube, for example, and use it to make the marks by pressing the end into the clay. You can refine these shapes further as you get into the small details of the sculpture, but for now you have marked the basic shape.

SCULPTING THE HEAD AND FACE

38 Now that the body has a first pass of details, you can move on to the head. It is important to work the sculpture as a whole and maintain the same level of refinement as you go, otherwise one area receives too much attention and it can throw off the balance of the piece.

When it comes to the human face, you can never have enough references, especially as a beginner sculptor. It is also important to study the anatomy of the face to better understand what you are looking at when using references.

Mark the center lines of the head using a scraper. The vertical line will help to establish the symmetry and the horizontal line will set eye placement. The eyes are located halfway down the skull. Many people tend to put the eyes too far up on the head because they are used to seeing a head with hair. Measure from the top of the skull to the bottom of the chin and place your horizontal mark halfway down.

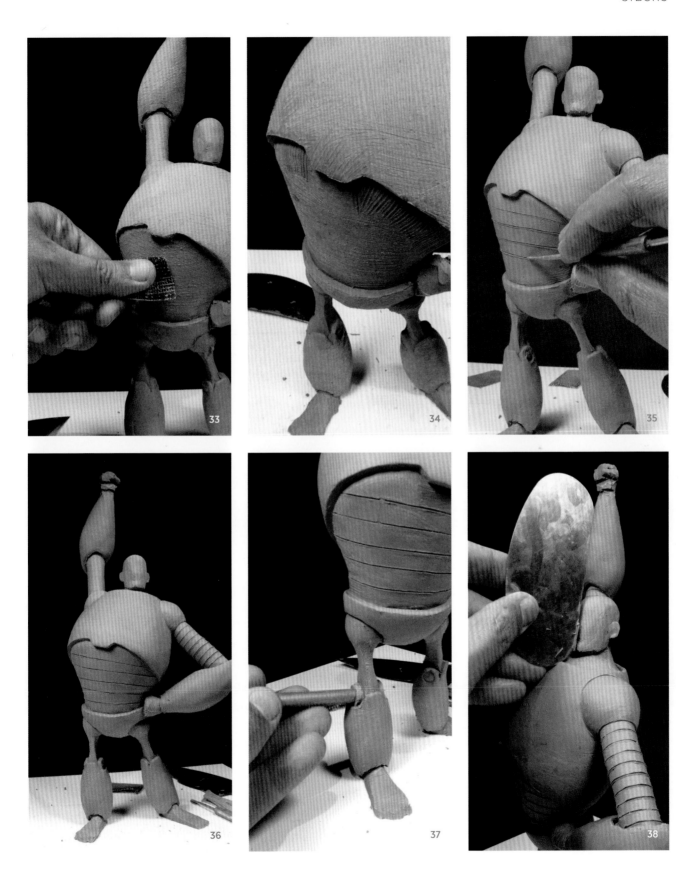

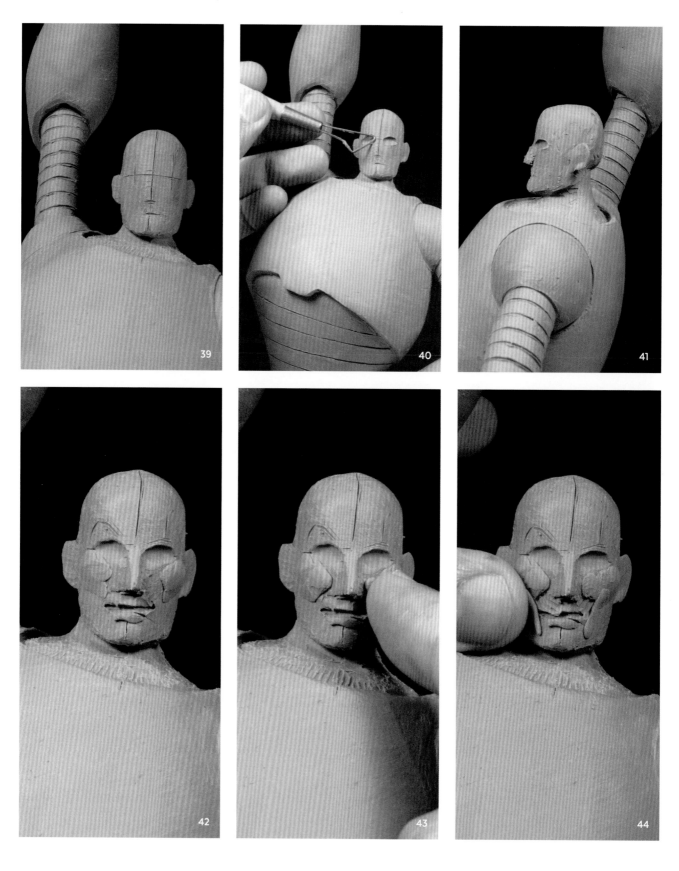

39 The next marks depend on the specific character but since we are creating a human head, I will use human proportions to describe the layout. Halfway down from the eyes to the chin is the bottom of the nose. Halfway down from the nose to the chin is the mouth. The eyes are typically about one eye width apart from each other and the corners of the mouth are located in line with the center of the eyes when the mouth is in a relaxed state. Carry on using one of the foils to make these marks.

40 Use a loop tool to carve out two oval shapes where the eyes will go. Make sure the oval shape extends out to the sides of the head as you can see in image 40; the holes should not just be in the very front part of the face.

41 Next, block in a nose shape to help you visualize the eye area by taking a small piece of clay and forming a pyramidal shape with it. Pinch and apply it with your fingers, blending the edges down to the clay.

42 Continue building the face by adding small pieces of clay for the cheekbones. Carve out a basic mouth shape and add small pieces of clay around it. Mark out the shapes between the nose and the top of the mouth. You will need to consider the expression of the character at this point. Make a mark for where a raised eyebrow would be. Drawing on the surface helps to visualize the expression as well as creates guides on which to sculpt.

43 Use small amounts of clay to build out the forms. As the details get smaller, use smaller pieces of clay and gently apply them with your fingers. It is best to form the shape you want, for example a circle, oval, ball, or worm, in your fingers before you apply it to the area.

44 I have studied anatomy for a long time and have sculpted many portraits, so I am able to carry out this next part from memory and the use of a mirror. However, as you are new to this I want you to keep something in mind at this point: when sculpting a face, there is always a very ugly phase. It is important to not be discouraged by this. You must know and accept that it is part of the process and it will look better once the forms are refined.

Continue placing small pieces of clay in the directions of the forms on the face. Refer to anatomy diagrams to help you do this. This character will have a big smile, so the folds on his face need to be more pronounced.

A MIRROR IS A USEFUL TOOL

A mirror is an invaluable tool for a sculptor. Not only can you use it to study your own face and expressions, you can use it to check your sculpture for irregularities. Turn your sculpture so it faces a mirror and you will notice lots of things that are not quite right. It is important to do this every once in a while throughout the process so that you do not progress too far and then have to make major corrections or destroy an area that you have worked on for a long time.

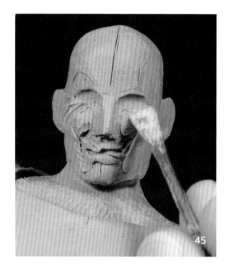

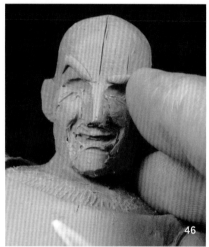

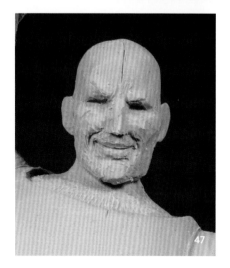

45 Use a small tool to blend the clay together, being careful not to change the expression too much. Gently blend the forms together in a raking motion. It is important to not use too much pressure as that will change the expression; you are just blending at this point.

46 Add two thin strips of clay, one with a higher arch, for the eyebrows. Also add clay to build up the upper eyelid and lower eyelid around the eye socket. We will sculpt the eyeball later.

47 Continue blending carefully and smoothing the surface with a small tool as in step 45. A gentle hand is the best approach. You should see the face and expression slowly starting to come to life. Make sure you factor in the folds around the smile.

48 Check your piece for symmetry and balance. A mirror can be helpful to see where something is incorrect. If you notice that things are not right you can carve away the area and resculpt it. Do not worry – you did it once, so you can do it again. Do not be afraid to destroy what is wrong in order to make it right. Fearless correction is the goal.

49 When working with Chavant medium or any other semi-hard clay (other than polymer clays),

there will be times when some areas will be too soft to achieve clean shapes. This is where the use of compressed air can be useful. When using compressed air in the manner that I will show you in the next step, there is a risk of frost bite or cold burns. It is therefore very important that you read all the safety instructions on the can, use caution, and avoid skin contact with the freezing spray. !

50 Take a can of compressed air (the same kind you would use to blow off dust on your computer keyboard) and flip it upside down. Blow the freezing spray onto the surface of your sculpture in the area you wish to work on, in this case the face. This will cool and harden the clay, making it possible to achieve tighter detail without smudging surrounding areas.

51 You can now begin to add smaller details and further explore the expression. Exaggeration is important when working on an expression. Push the expression in the early stages, because it only gets softer as the process goes on. Starting with a good exaggerated expression will mean that the final portrait will still be demonstrative. Roll out thin worms of clay to start placing the folds of the forehead and brow.

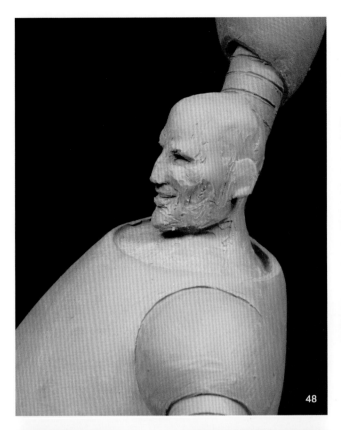

48

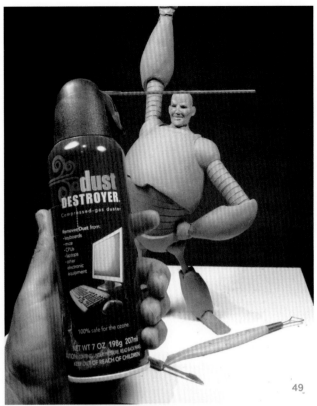

49

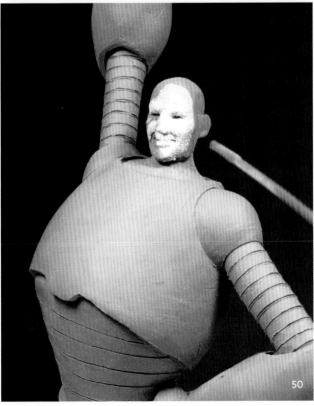

50

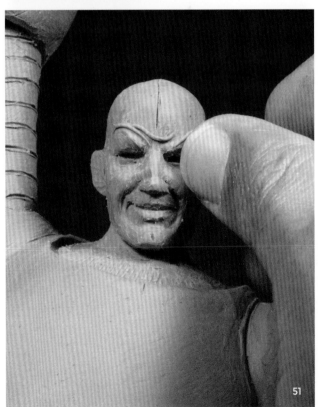

51

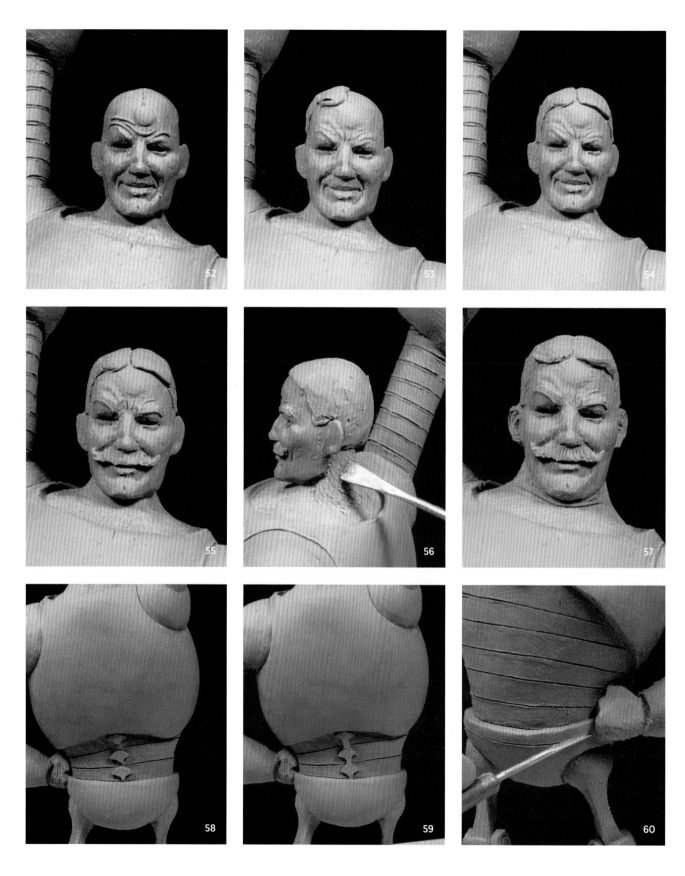

52 Add a bit of volume to the forehead to help round out the form by blending a small ball of clay into the rest of the face, along with the forehead folds. Also take this time to check over the proportions of the head before you move on to the hair. If the structure of the head is not correct, the hair will look odd.

53 After blending the forms together, you can start to block out the hair. It is important to treat hair just like any other part of the anatomy: start by blocking out the larger shapes and just looking for the form. The detail will come as you break up the larger forms and subdivide them into smaller forms. You can keep subdividing until you are sculpting small strands of hair, but I find that a more convincing look can be achieved by subdividing three to four times at most.

54 Taking flat shapes of clay and either a flat wooden or metal tool, apply the clay to the head, concentrating on the larger forms. Do not worry about smaller forms at this time. When you move to the second side of the hair, be sure to maintain a bit of asymmetry to help the hair feel natural. Even if the character has very styled hair, making it just a little different will help to give the hair some naturalism.

If the initial volume and shape of the hair is good, then the subdivided forms will follow. For now though, just focus on the block in.

55 Since you are working on the hair, you can also block in the mustache and eyebrows. Do this the same way as the hair on the head; it is just a smaller shape and volume. Use a small metal tool to apply the clay as your fingers will be too big to place the clay carefully. Think about shape and form and use references or a mirror (if you have a mustache!).

56 As you finish blocking in the hair and start subdividing the forms, check the neck of the character. If you notice that the neck looks too thin, build this area up by using a small tool to add small amounts of clay and blending them into the shape of the neck. As always, keep turning the sculpture so that you can see how the neck is developing from all angles. Keep adding until the neck looks correct. Again, this is a good area to check against references.

57 Now start to add small folds in the neck area. Using that same small metal tool, draw a thin line while holding the tool at a slight angle to bevel the edge of the line. This will help it look more like a fold in the skin rather than a line drawn on.

FURTHER REFINEMENT

58 Now that the head has received its first pass of details, look over the whole sculpture to check where you need to go next. The back needs some added detail, so we will make a start on that. I want a simple detail that is reminiscent of a spine but that still looks mechanical. Start by adding small oval shapes between the segments. Then take a small loop tool and begin to shape the ovals as you see them in image 58.

59 Add a center section of clay that runs all the way down and then blend the forms together. Use whatever tool works best for you in terms of getting into the small areas. You can just blend the edges into the clay to help hold the clay in place.

60 Continue to add details to the whole figure. Start by creating seam lines on the waist. Use the same small metal tool as in step 55 to draw the line in the clay. When you are attempting to draw smooth horizontal lines on your sculpture, try using a Lazy Susan spinning platform. You can hold your tool in one hand and turn the sculpture with the other. This way, your sculpting hand stays steady. Producing smooth lines is important for mechanical figures such as this one.

"YOU CAN MAKE THIS PART USING WOODEN BALLS TO KEEP THEM PERFECTLY ROUND OR YOU CAN SCULPT THEM BY HAND"

61 Next take a small ball tool and use it to create small rivet-like indents around the waist. Press gently into the surface, as you only need a shallow depth to make these marks. These rivets will help give the illusion of a metal figure.

ADDING THE DUMBBELL

62 It is now time to add the giant dumbbell to the character. You can make this part using wooden balls to keep them perfectly round or you can sculpt them by hand. I know that I want to have inset numbers on the weights, so I decide to sculpt the balls in clay (even though they might not be perfectly round). Start by taking a piece of the aluminum armature wire and curling the two ends using needle-nose pliers. This will give the clay something to grip onto.

63 Next, press the clay firmly onto the curled ends and work the clay back onto itself, blending the clay together so it stays in place. Keep building up the form and shaping it into a sphere. Add as much as you want. You can make huge weights or small weights. Either will give a different look to the character. I go with a medium-sized ball that seems well balanced for the overall composition.

64 Scratch up an area in the middle of the dumbbell using a pair of pliers. This will allow the hand to more easily grip the armature wire. You could also add a small amount of florist wire and tack it down with superglue. Now take the dumbbell and add it to the hand.

65 Now that the dumbbell is in place, add the glass dome on top of the head so that you can see the whole composition. Check if you like how he looks and whether the pose feels right. Overall, the piece should be progressing nicely at this stage.

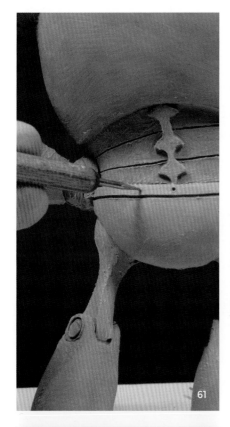

61

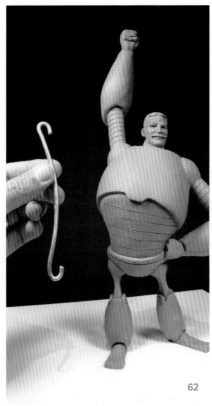

62

63

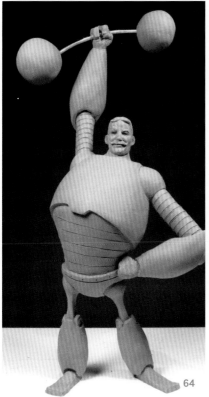

64

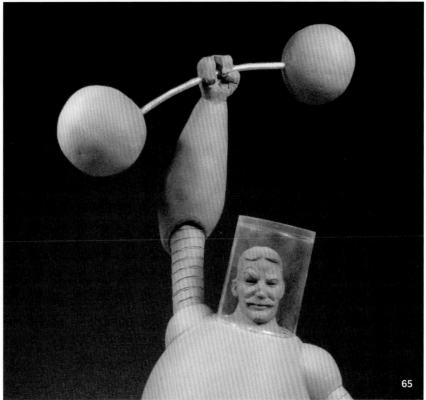

65

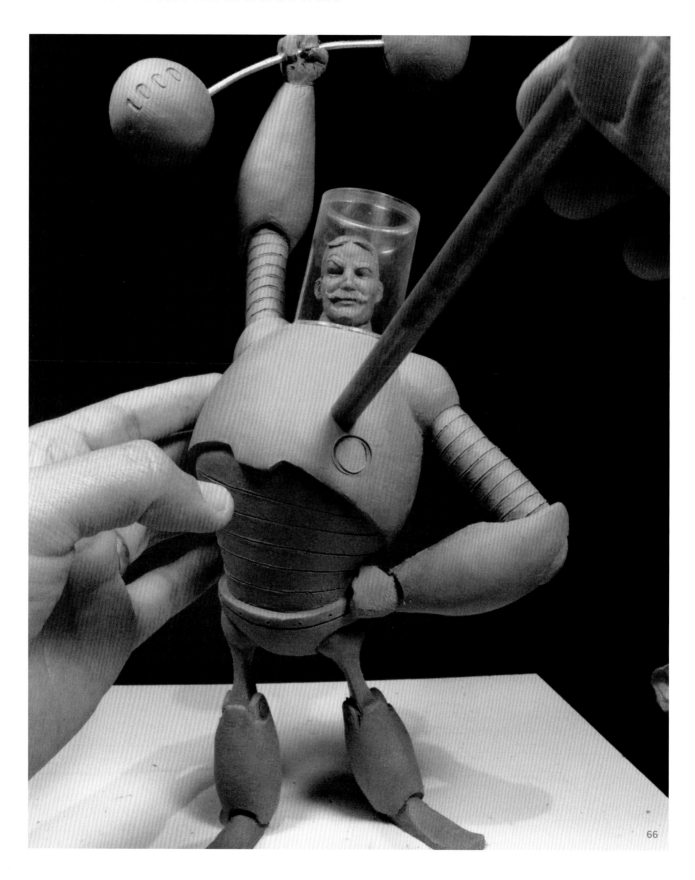

66

TORSO DETAILS

66 It is now time to start adding the small details and have some fun with the surface of the sculpture. Just like you created the knee joints, use brass tubes to create perfectly round shapes for some gauges and meters. Use different sizes and press them carefully into the surface.

67 You can then vary the circular shapes so that they become either buttons or dials. For example, to create a gauge take small worms of clay and lay them down carefully into the larger circular shapes.

If you want more of a button shape on your character, take a small ball of clay and add that to a circle. Using a small tool, blend the clay onto the surface and shape the ball into a half-round shape.

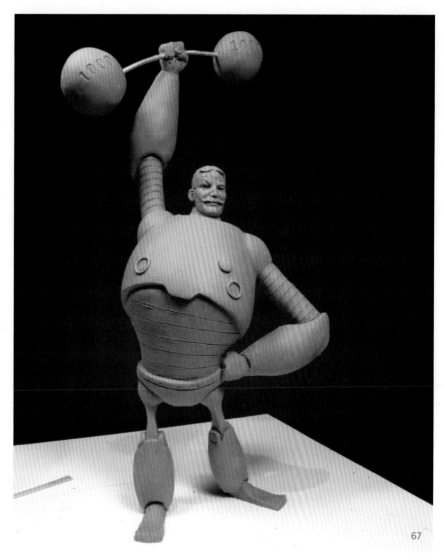

67

68

68 You can use a small blade tool to create the gauge markings. We want the large chest to look like a steam or pressure vessel, so the gauges I choose to make are basic pressure and temperature gauges. You can make buttons, knobs, or whatever type of gauges you want.

SMOOTHING THE SCULPTURE

69 The next step is to smooth down the sculpture, and there are several ways to do this. One way is to take small loop tools and rake tools and slowly smooth away small areas at a time until you have resolved the whole surface. This is a good method if you are producing a very detailed portrait sculpture, but for a mech figure there are faster and better techniques. I will go through two ways to smooth this sculpture so read steps 70-74 before deciding which method you would like to use. First I will use 91% isopropyl alcohol (rubbing alcohol).

RUBBING ALCOHOL METHOD

70 Dip a brush in the alcohol and carefully brush the surface in the direction of the forms. Rubbing alcohol breaks down the surface slightly and also helps the brush glide smoothly. Then it evaporates. You need to be careful to not use too much alcohol on the surface as it can make the clay too soft and muddy; it will be hard to rescue it from there. You should also make sure you use a very soft brush. I like to use sable-hair brushes or synthetics for this purpose. ❗

TORCH METHOD

71 You can brush the whole sculpture down using this method if you like, but to achieve a sculpture with smooth, hard surfaces, I like to use fire! This method is a little more advanced and requires great care and precision. One second too long over an area and you can destroy hours of work. I recommend practicing on a block of clay or unwanted sculpture first, before trying it on your final sculpture. I have two torches (shown in image 71). One is a micro-butane torch and the other is an alcohol torch. The micro-butane torch is very hot and is the more difficult one to use. The alcohol torch, which uses denatured alcohol, is a little more forgiving but takes a bit of practice.

72 If you are using the torch option, start with the micro-butane torch for the body. Moving quickly and avoiding staying in any area for more than just a second, move the flame across the surface. You will see the clay become really shiny as it melts – that is the sign to look for; you must stop before it becomes too shiny as the clay will start to sag and melt away. 🔥

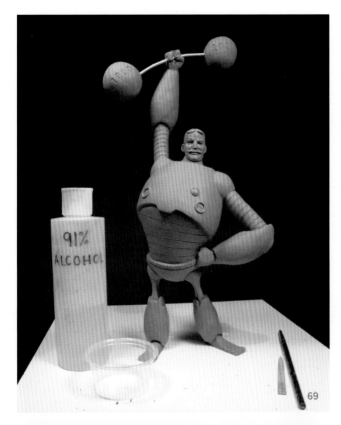

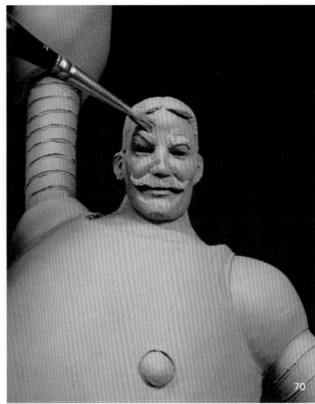

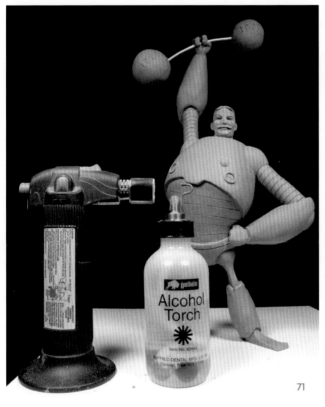

73

74

75

76

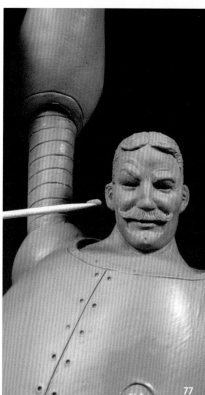

77

FINAL DETAILS

73 Use the freezing spray of the compressed air can again to quickly cool an area that has become too hot. But be careful: the molten clay can blow away if the air is too close to the sculpture. Hold the can further away to avoid creating a crater. Another useful thing about the freezing spray is that if you spray it over a melted area, the clay retains the shine. You can use this to your advantage when creating different textures and finishes on the surface of your sculpture – ideal for a mech character. 🛈

74 Using the alcohol torch on the face will give you the smoothness that you want here. As you read earlier in this book, the way that the alcohol torch works is that it has a wick that pulls the denatured alcohol to the top. There is a small bent pipe that goes from the inside of the bottle to just in front of the flame. Gently squeezing the bottle forces air (mixed with the alcohol fumes) through the small pipe and produces a small torch-like flame.

It takes a little practice to get it right and you cannot tilt the bottle too much, but the flame is much gentler than the micro-butane torch and can be targeted more precisely. Use the same method as for the micro-butane torch, moving quickly and not staying in one area for more than a second. 🔥

75 Now that the whole sculpture has been smoothed, you can add the final details to the surface. Add scribed lines and rivet marks on the side of the torso underneath the armpits with small blade tools and ball tools. At this point, you can go where you like with the level of tiny details you want. I like simple designs so I keep this one fairly basic with the idea that if it were to be painted, I could add decals and labels.

76 Next shape the feet by cutting angled shapes using a hobby knife so they look more mechanical; do the same with the hands. Wanting to push the robotic look further, I make the hands and feet flat and angled, and give them only two or three digits. Hands and feet are a good place to explore more robotic features.

77 With the hard surface aspects complete you can turn your attention to the head and the final details there. For the eyes, start by adding tiny bits of clay into the eye socket area. A sanded tooth pick works well as a tool for this. Make sure that the eyeball is round and push the corners to really emphasize this.

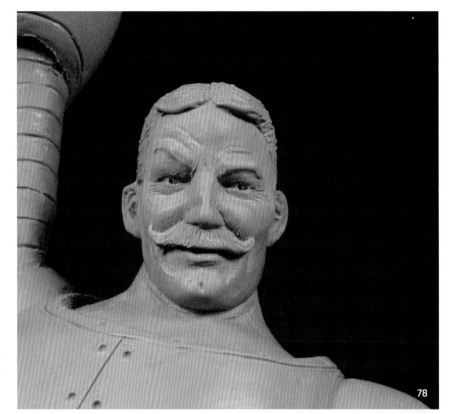

78

78 To make the iris, use the pointed end of the tooth pick and simply make a round U-shape. The small bit of clay in the middle will act as a highlight and give the eye some life. Do the same for the other eye. As an alternative to sculpting the iris and pupil, you can use small beads or bearings for the eye form. This will give you a perfectly round eye and you can sculpt the eye lids around that form. Just be sure that the eye is set back far enough in the skull.

79 Lastly, refine the eyebrows and mustache, and carry out a bit more subdivision on the hair. Using a small wooden tool, gently divide the forms and shape the look. I have a beard, so I use a mirror to look at the details of my mustache.

THE FINISHED SCULPTURE

80 You can now call this piece finished if you are happy with it. As with any artistic endeavor you can keep working away at things forever, but it is important to know when it is time to walk away from a piece. Never perfect, simply finished. Take what you have learned and apply it to your next project. Be sure not to treat any of your work as precious; be willing to start over if it is wrong and destroy large areas of it if they need to be fixed. Fearless correction is what I preach in my classrooms. If it is wrong, tear it down. You will be able to do it again, and you will do it even better.

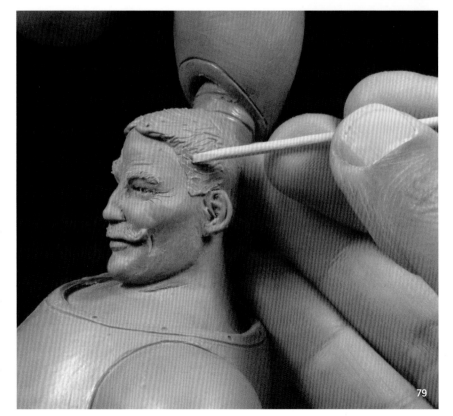

79

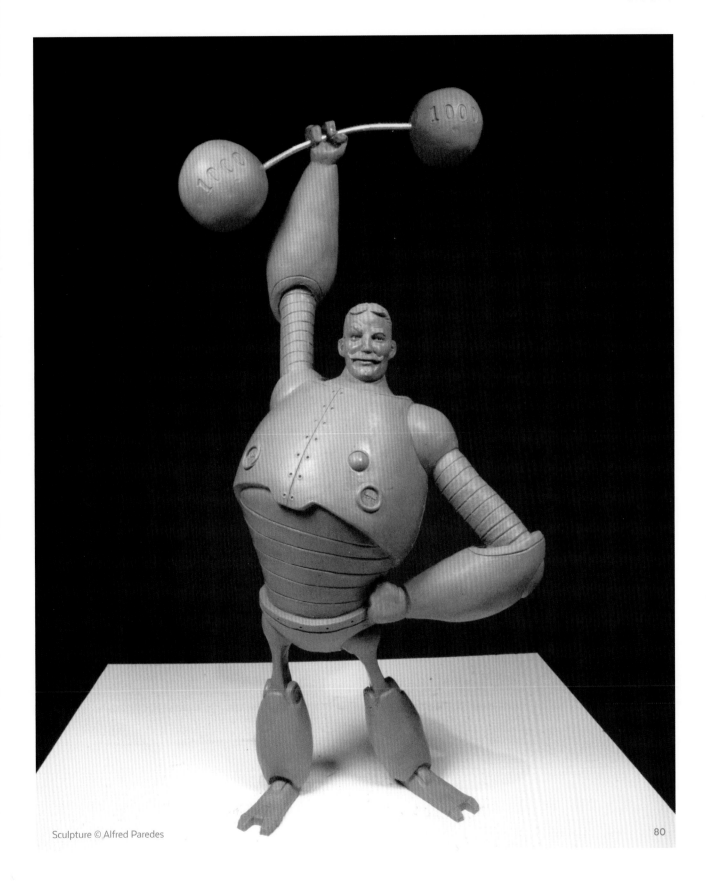

Sculpture © Alfred Paredes

80

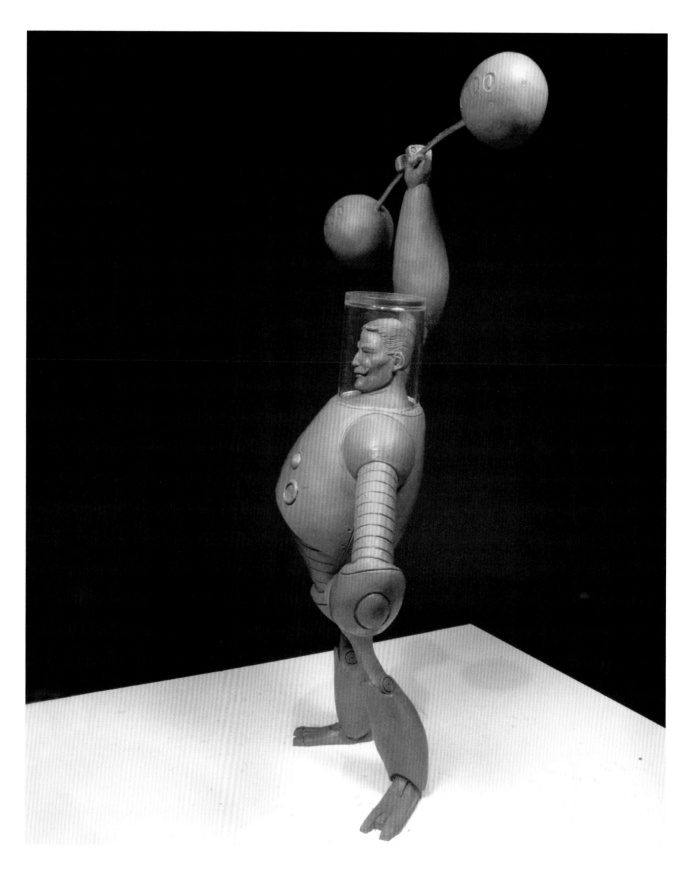

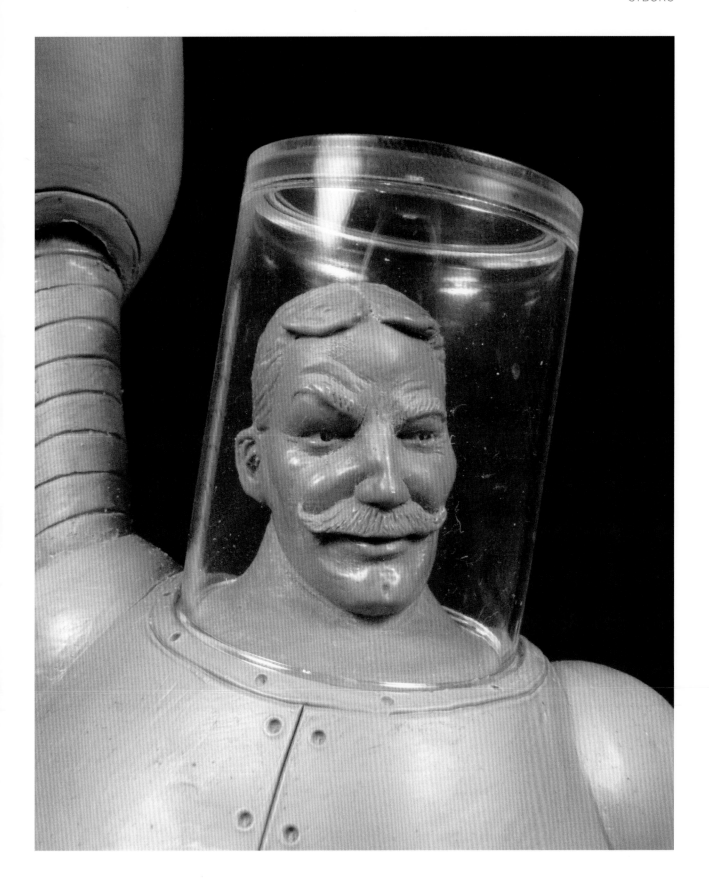

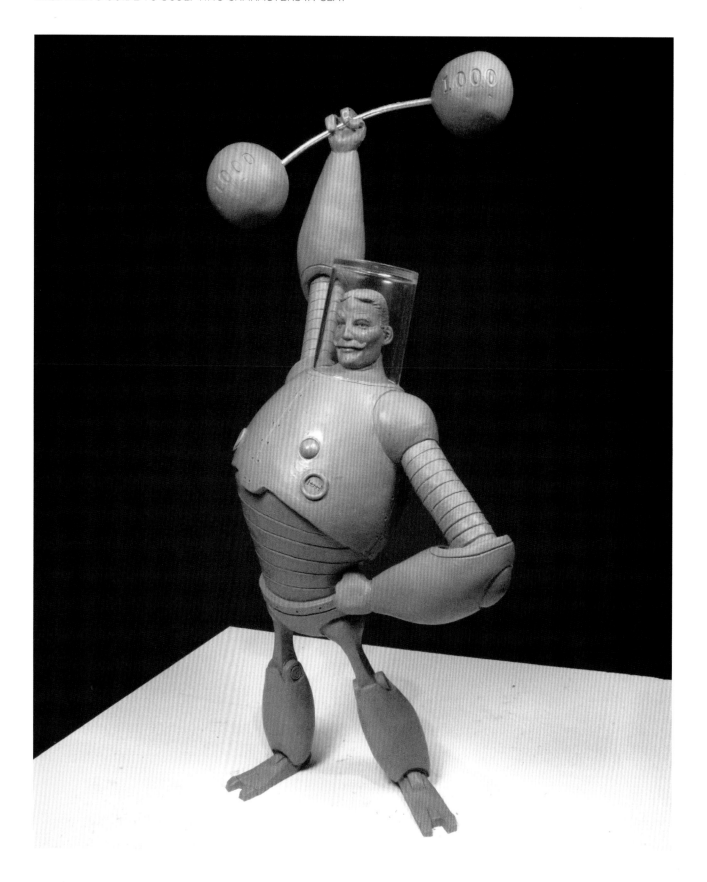

Cleopsis | Wax | © Sideshow Collectables

OCEAN EMPEROR

BY ROMAIN VAN DEN BOGAERT

MATERIALS

Aluminum wire
Brass rod
Bicomponent epoxy putty
Cyanoacrylate glue
Polymer clay (firm)
Thin copper wire
Thin steel wire
Turpentine
Wooden cube base

TOOLS

Ball tools
Brush
Colour Shaper tool
Diamond cutter bit
Dremel rotary tool
Guitar string
Hammer
Heat gun
Knife
Loop tools
Marker pen
Metal ruler
Metal spatulas
Needle tools
Old brush handle
Round carving bit

In this slightly more advanced tutorial I will present my methods for creating a small-scale sculpture. The sculpture will stand approximately 10 cm high, however apart from a few technical details specific to this small scale, most of the methods shown here could be applied to larger-scale sculptures.

When creating a character, an alien in this case, I often work from major themes. I select some design elements I want to highlight in the project, such as the line of action through the body, posture, and facial expression, and start to work directly in 3D; I never really know what the character will look like in the end. Most ideas come to my mind when the elements are assembled in 3D.

In this project we will create an alien, with the stature of a king or emperor. The character will have a humanoid appearance but will also be aquatic and inspired by an octopus or a squid. I particularly want the character to have a theatrical pose, which will represent his high rank.

We will start with gathering tools and preparing an armature, then move on to working with a polymer clay, focusing on ways you can build up texture on your sculptures.

01

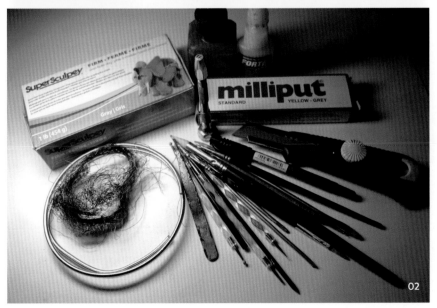

02

PLANNING AND PREPARATION

01 To start, consider your workspace. I work in a shared workshop with other artists and artisans who do not all work in the field of sculpture or design. This environment is very stimulating because I can constantly exchange opinions, viewpoints, and new techniques with my co-workers.

My workspace is divided into several parts depending on the type of project I am working on. In image 01 you can see my main office for sculpting small-scale maquettes and miniatures. Many references and current projects are always displayed and crowded around the desk, despite regular cleaning sessions!

02 It is important to gather all the materials you will need for this project. The equipment you will require is not very expensive or complex. I will work on the sculpture with Super Sculpey Firm polymer clay. Polymer clay is a type of modeling clay that can be baked in the oven at low temperatures.

For some of the specific details, you can use a different modeling clay named Milliput. Milliput is a bicomponent epoxy clay that hardens once the two components are mixed. You also need cyanoacrylate glue and turpentine. You can start to gather your initial tools at this point too: a marker, aluminum wire, and copper wire for the armature.

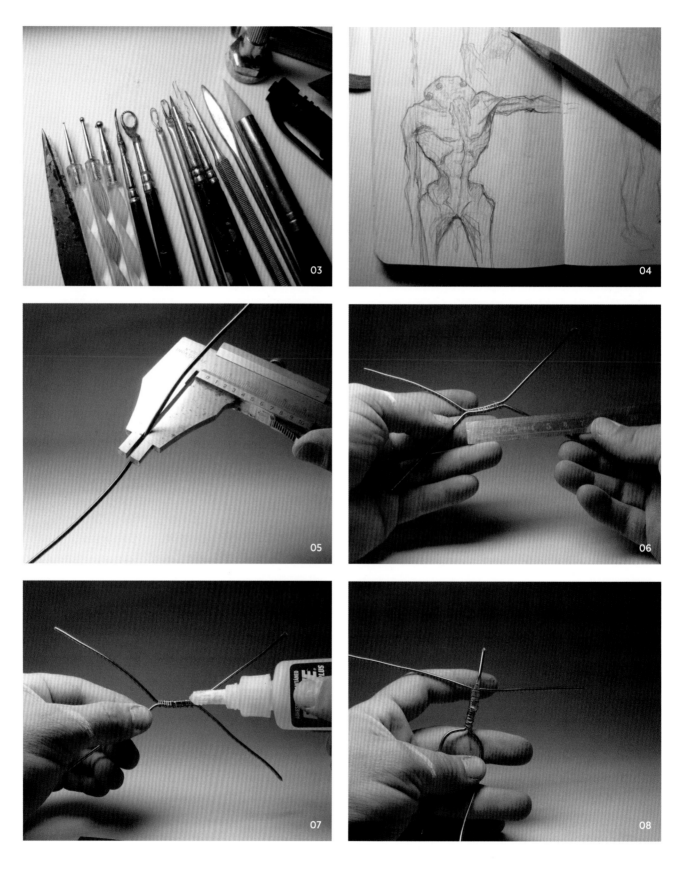

03 The other tools required for this project are not particularly unusual or complex. Most of them are homemade or reworked from standard tools. From left to right in image 03 are: tongs for manipulating small parts; three ball tools, which are very convenient for concave volumes; a curved needle tool; three homemade loop tools of different sizes; a brush for smoothing and the addition of very small volumes of material; a homemade wire tool for creating textures and skin wrinkles; two metal spatulas; and a flexible silicone cone tool named a Colour Shaper.

04 I rarely draw before starting a project – not due to a lack of desire, but because I struggle to draw. I cannot adequately explore on paper the ideas I have in my mind. However, I think it is very important to consider various design options before starting a project. You can draw sketches, gather references, or model a 3D sketch with sculpting software like Sculptris or ZBrush. All means of planning are good!

Despite my normal way of working, for this project I draw some sketches in my sketchbook to test various poses and body shapes. The goal is not to draw the final appearance of the character, but to create a few ideas that will serve as a starting point. Use this step to plan your sculpture in whatever way you feel comfortable.

CREATING AN ARMATURE

05 The first step in armature building is to select the right material to make the armature. You will need a wire that is suitable for the scale at which you are working. The armature also needs to be sufficiently rigid to not deform when clay is added, but flexible and easy to reposition so you can adjust the character's pose.

In the case of a project that involves molding, the wire should be easy to cut into separate parts with a knife. The thicker the wire is, the more difficult it is to cut at the end of the project. In this case, the sculpture will be about 9-10 cm tall

on completion so select an aluminum wire that is 2 mm in diameter. This diameter is sufficiently large to support the sculpture while being sufficiently small to be easily cut at the end of the process.

06 To make the armature of an entire humanoid body, join two aluminum wires of equal length as is shown in image 06. Both wires are joined in the middle by twisting a thin copper wire tightly around the central section. This type of copper wire is often used in power cables and can be found easily online. Care must be taken to join the two wires of aluminum together firmly.

The portion of the armature surrounded by copper wire represents the future torso of the character. If you have to respect specific dimensions for a character, you can measure and adjust the length of this part of the armature. Here we want to sculpt a slender figure whose torso is short and wide. The four ends of the two wires will comprise the limbs.

07 It is very important to ensure that the two lengths of aluminum wire will not move when posing the character and throughout the sculpting process. To achieve this, cover the entire joined portion with a good amount of cyanoacrylate glue. The advantage of this glue is its strength and thinness once dried. For larger sculptures you could also use an epoxy putty such as Milliput to reinforce the armature. Make sure you follow the manufacturer's safety instructions and avoid sticking your fingers together! ❗

08 After binding the two main aluminum wires, add a third wire to support the neck and head. The principle is the same as before; firmly join the third wire to the rest of the armature with copper wire and a good amount of glue. To facilitate the attachment, crush one end of the third aluminum wire with a hammer to make it flat. It is necessary to keep the frame as thin as possible to avoid problems during the sculpting process.

09 Once the glue is dry (this can take a few minutes) fix the shape and proportions of the armature to form a skeleton for the character. This step is very important because the general appearance of the character will depend on the proportions of the different parts of the body that you define now. At this stage use anatomical references to correctly proportion the character.

The alien will have long arms, long legs, and a short and broad chest. Use a marker pen to locate the important reference points of the body such as the shoulders, elbows, wrists, hips, knees, and ankles to act as landmarks. Bend the arms at the shoulders and the legs at the hips. Leave about 1 cm of armature length below the feet so that it can be glued into a wooden base.

10 You now need to fix several important things to complete the armature. First, crush the end of the hands with a hammer to create a support for the palms of the hands. Leave this flat area very long because this alien will have long hands compared to the hands of a human. Second, bend the top of the armature's head to create a larger area for the location of the head.

Third, add more curvature in the armature to replicate a skeleton by bending each limb to create a visually and anatomically correct rhythm. For example, I curve the leg at the tibia level, because this part looks slightly curved in this direction on an actual human body. You must think of the armature as the support for

a complete character, with curves, shapes, and rhythm in different parts of the body. You can also start to position the character at this stage, thanks to the repositionable aluminum wire.

11 In image 11 you can see that I also give rhythm to the armature through the spine. The spine creates an S-shape, which is one of the most interesting shapes in the human body. This S-shape balances the body and will allow you to correctly set the basic volumes of the ribcage and pelvis.

Test various simple poses and determine an interesting spacing of the character's legs. Draw this distance on a wooden cube that will serve as a support in the rest of the process.

12 Next you will need a Dremel rotary tool; these can be found online and in hardware stores. Using the tool and following the measurements for the legs that you have set, drill the wooden base to insert the armature frame in. Then fix the armature in the block with cyanoacrylate glue. We will use the Dremel tool very regularly throughout this process to cut, drill, and sand the sculpture, so make sure you are familiar with the tool's settings and that your work area is clear. 🔔

13 When the armature is securely bonded to the wooden base, it is easy to finalize the pose of the character. Reposition some parts of the body and turn the head to add dynamism. The character will carry a great trident in his right hand so test various poses with a piece of wire to

represent this accessory in order to be sure that the character's attitude is correct.

14 Once the pose is well defined, you can complete the armature. Wrap the thin copper wire over the entire armature. This creates a surface for the polymer clay to grip onto when adding it in the next steps, and keeps the armature as thin as possible. For larger sculptures, you can also use aluminum foil to create this grip surface and save clay.

ADDING CLAY

15 Now you can begin to add the first layer of clay on the armature. This step is very important because if the clay cannot grip properly to the armature there will be many stability problems for the rest of the process. For optimal clay grip cover the armature limb by limb with a layer of cyanoacrylate glue. Then add a thin layer of clay directly onto the fresh glue. This layer should be as thin as possible. Squeeze this thin layer with your fingers in order to press the clay into every cavity of the armature. Again, avoid letting your fingers become stuck to the materials. ⓘ

16 When the first layer of clay is added over the entire armature leave the figure for a few minutes to let the glue dry. The clay itself will still be very soft because it is heated by your fingers. I prefer to wait a bit for it to cool and harden slightly before continuing to add the first volumes of the body.

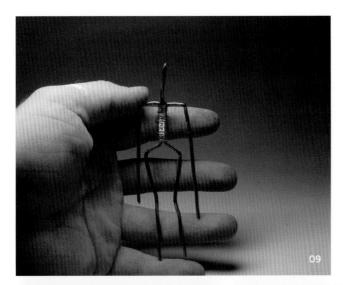

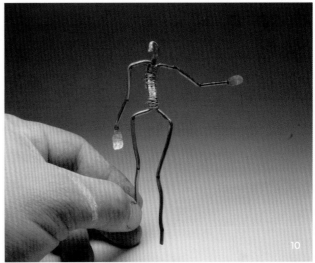

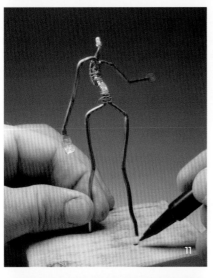

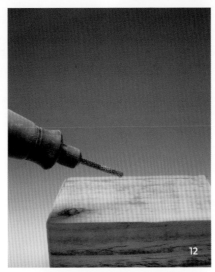

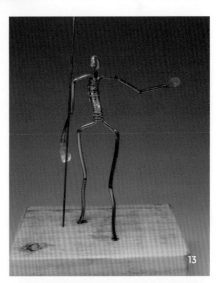

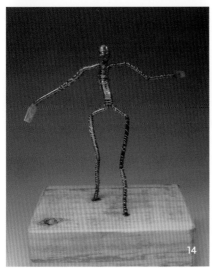

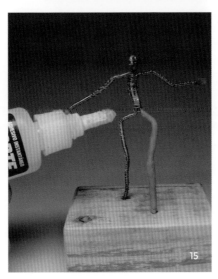

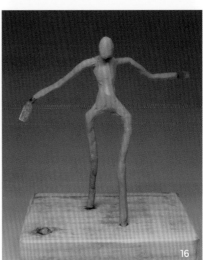

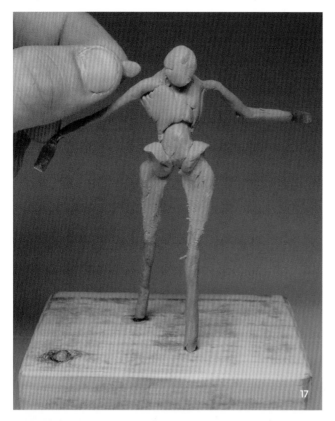

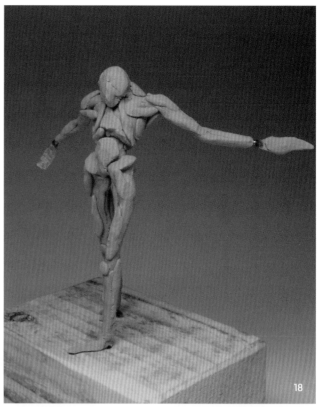

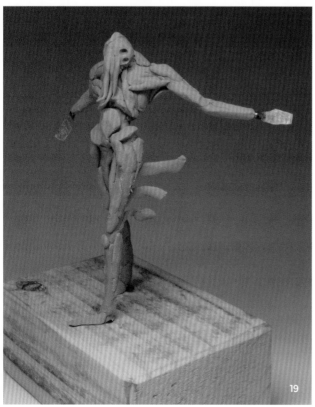

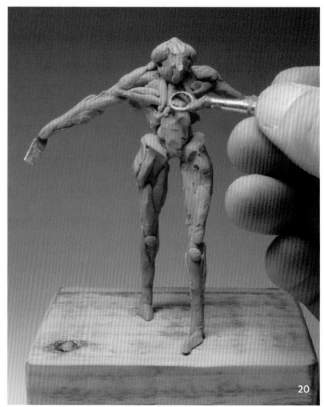

17 When the clay is firmer, begin to add the first volumes. Your main tools in this step are your fingers. I do not recommend using tools here as it is better to follow your instincts, as when creating quick sketches with a pencil.

To gain speed and spontaneity add small volumes of clay, shaped like tubes, one piece at a time without trying to smooth them. The first things to create are the basic volumes of a humanoid body; that is to say the skull, ribcage, and pelvis. Use anatomical references to help you. These elements are distributed around the spine and will allow you to correctly place the other elements of the body in subsequent steps.

TRACE LANDMARKS ON YOUR MODEL

Never hesitate to draw landmarks on your model. Anatomy is a complex discipline, and building a body, whether realistic or imaginary, requires a structured process. I use many landmarks to avoid becoming lost, especially at the beginning of a new sculpture or when the pose of the character is complex and dynamic.

18 Keep adding small volumes of clay with your fingers, again without smoothing them. Give better definition to the main volumes, and then add transitions between these basic volumes. These transitions correspond to the main volumes of muscles, which we will detail later.

The clay tubes that make these volumes should not be placed randomly. Some should correspond to the direction of muscle fibers of the deltoid, pectoralis, and so on, while others should define landmarks of the body. These landmarks are often the evidence of bone just beneath the skin, such as the elbows, iliac crest, acromion, or certain areas of the ribcage. It is through these landmarks that you can find your way around the overall shape of the body and can connect the different limbs through properly positioned muscles. Again, refer to anatomical references as needed.

19 In the same way that you tested different poses with the armature in step 13, you can now test different designs with tubes of clay. Add a few tentacles on the face to give you a vague idea of the head design. You can also test the presence of warts on the legs. There is no armature in these elements; they are just simple visual design tests that you can remove or repose quickly.

CLEANING THE SURFACE

20 After adding the first volumes, proceed to a stage of "cleaning" the figure. The basic idea is to smooth the small, rough volumes of clay in order to continue building the body on a clearer surface. Do this with a medium-sized loop tool, an extremely practical and common tool in sculpting.

The loop tool I use in image 20 is homemade because I find it is often difficult to get the exact size and shape I need in the tools commercially available, especially when the sculpture is very small. The tool is made from a simple bent wire and an old paintbrush. Remove the hairs from the brush then glue the wire onto the end. Slightly taper and striate the wire perpendicular to the axis with a knife. I apply the tool gently to the clay surface to blend the elements together.

SECONDARY VOLUMES

21 I want to introduce an extremely important concept for analyzing the progress of the sculpture. It is the concept of shadow and light analysis. At every step, your eyes need to be attentive to how shadows and lights fall on the clay volumes.

In image 21 you can clearly see that the light is reflected by the iliac crest, external obliques, pectoralis, and the biceps. The body elements should be clearly distinct from each other and identifiable, even though you are still at the very beginning of the process. Some parts should catch the light, while others should be in dark shadow. When an important element does not reflect light or is not in a specific shadow, you should correct it by adding or removing material.

22 The back of the character can be analyzed as a counterexample. Here, the volumes are still tentative and are not really distinct from each other. To solve this kind of problem you have to clean the entire surface with the loop tool, and then you can better define the different elements.

23 Continue to alternate between cleaning phases and finishing the primary volumes. For example in image 23 you can see the characteristic marks of the loop tool where the legs have been cleaned.

Another very important concept to constantly keep in mind is that volume can be simplified by basic geometric forms and facets. The metal spatula allows you to model large flat areas, which create strength and tension in the volumes. Basic volumes should be simple shapes that reflect light or create distinct cast shadows. Work on creating tension in the muscles, especially in the very stretched pectoral muscles.

24 Now gradually create secondary volumes using the same basic principles as for the primary volumes. This is where some anatomical knowledge is useful, and you can also study references or pictures that can be adapted to suit the character you have in mind. For each foot, add a few large volumes that summarize and exaggerate their overall shape.

25 The volumes you built in the last step now need to be cleaned, and the details taken a bit further. Work on the angle of the toes, quickly detailing the nails and some wrinkles to get a good idea of the final design. The credibility of the feet is important for this sculpture because the sculpture is based on them. They are the physical link between the character and the ground, his way to stand up, and a direct link with the world he is supposed to belong to. If the character seems unsteady its credibility will be somewhat distorted.

Once the feet are well-outlined, you can correctly define the ankles. This creates a progression from one part of a limb to the next. Carefully appoint landmarks on the ankles for the medial malleolus and lateral malleolus.

26 From the angle you can see in image 26 the first main volumes and facets are distinct. On the character's left leg for example, there are three different values: a very dark shadow at the back, an intermediate shadow in the middle, and a highlight on the front. Thus the leg is not purely cylindrical but has volume, tension, and asymmetry. On the lower leg, start to build tendons which can be seen on the front of the right ankle. Generally speaking we want to keep very close to classic human anatomy for this character, which we will slightly deform the proportions of to create the alien feel.

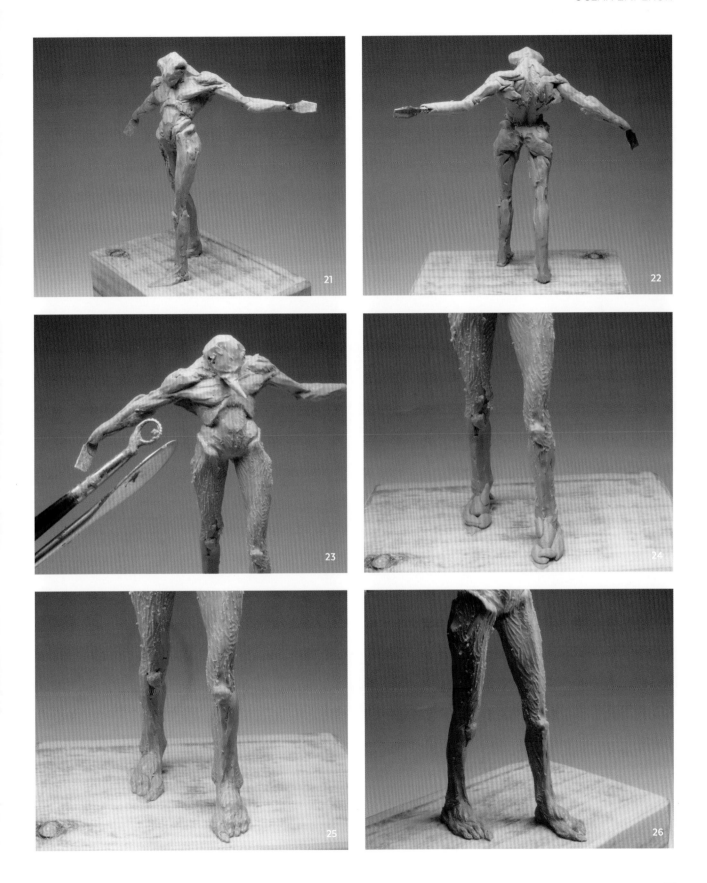

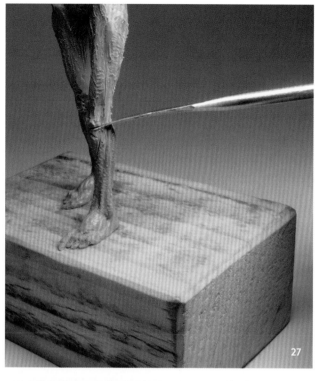

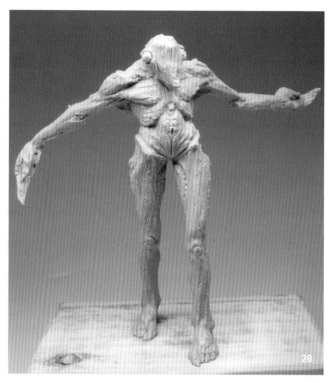

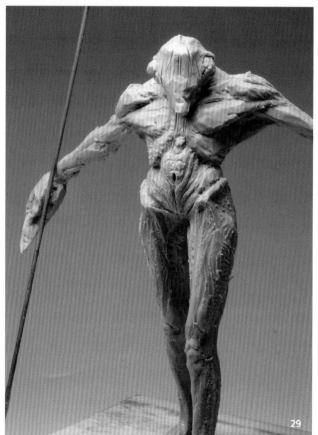

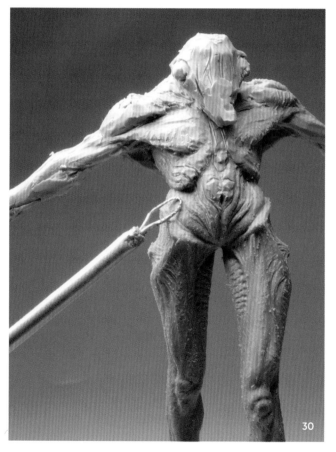

27 Moving up the leg, continue to draw marks on the model to identify anatomical landmarks. Sculpture is a complex 3D process and at the beginning of a project you have only a few landmarks to rely on to build credible anatomy. You can now expand upon this.

Trace the separation between the femur and tibia with a metal spatula. Note that this separation is not horizontal; the inner side is lower than the outer side. In fact there are rarely forms and connections in the body that do not have a shift, as natural forms are a sequence of corresponding curves and counter-curves. The marks made on the leg will direct you to place the patella just above the line.

28 Return to working on the character as a whole. It is important to move forward at the same speed on all parts of the sculpture, or at least to establish the general volumes everywhere. Add some basic volumes for hands to give a general idea of their shape and hide the last of the armature. Place more muscles on the torso and start to play with a design on the abdomen. You can also add the eyes at this stage, as I have done in image 28.

29 Trace the location of the sternum between the pectorals, and exaggerate the prominence of the xiphoid process. Draw some lines of symmetry on the head while testing the location and shape of the eyes. Then, accentuate the iliac crest so that it can clearly catch the light. Other fleshy landmarks exist like the navel, which you can form with a ball tool; you can also test the position of the hand that is handling the trident.

30 At this stage begin to finalize the secondary volumes. Use a loop tool of a smaller size. The one you can see in image 30 is homemade using a thin wire. You can use this small version of the loop tool in exactly the same way as the larger loop tool. Rub the tool lightly on the clay surface to smooth, weld, or separate elements of the body. This tool provides great control over the shapes, and their tension and connections, so you can create a distinct alien design on the abdominal muscles and external obliques. Use the loop tool to detail the knees and legs too.

CRITICIZE YOUR OWN WORK

Take your process step by step and criticize your work at each stage. However, I do not mean over-criticize your work. Always try to evaluate when your results are in line with your expectations, and if they are not, try to work further on the piece. Look constantly at your sculpture from different angles to correct the transitions between forms and fix any symmetry problems. A mirror is a terrific friend that never lies. It will instantly show you your errors and send you back to the workbench. If your current project is at a dead end it is better to leave it for a while and come back to it later with fresh ideas.

PLAYING WITH THE DESIGN

31 There should be a progression between the upper abdomen, which can mainly be defined with the spatula, and the lower body where secondary volumes are created with a medium-sized loop tool. Have fun working on an organic design with ripples on the upper legs, stomach, and ribs. Start with classic human anatomy, and then modify the secondary shapes to create something new. The design is credible because it is supported by realistic primary forms and you can use the same principles to create realistic secondary forms.

32 At this stage focus on the head. Reduce the size of the eyes to better proportion them with the rest of the body. You can also change the overall shape of the head to give it a more alien shape. Observe squid reference images to directly inspire you with the design.

33 Now separate the different main volumes: the head, chest, and pelvis. The pose is tense, so make sure the character has prominent muscle fibers in the legs and chest. You can also play with the design of the skin on the side of the hips.

Refer again to the concept of light and shadow, and ensure that the armpit is very dark compared against the rest of the torso. In a three-dimensional space, the impact of the volumes is defined by the contrast of light and cast shadows. This contrast is a visual guide to help you check that the volumes are strong enough and correctly shaped.

34 The back is a complex part of this character. The main volumes are all placed so we can work on refining the secondary volumes. As the character is aquatic and is likely to swim regularly we need to create a very broad V-shaped back, much like the backs of competitive swimmers. It is justifiable therefore that his upper torso is very muscular, especially the latissimus dorsi and teres major. Take care to dig out the spine deeply and accentuate the cast shadow under the shoulder blades with the inverted loop tool used in step 20.

35 To be sure of the symmetry and strength of the volumes in this area, work over the forms with your largest loop tool. Use the tool to mark the trough of the spine, the upper border of the scapula, and the trapezius muscles. This work on the back will allow you to create the transition between the back and the arms. In fact almost all of the muscles on the upper back are attached to the arms and are involved in their movements.

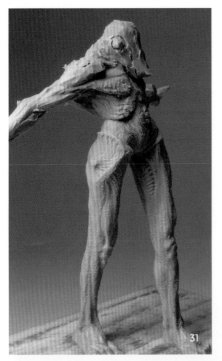

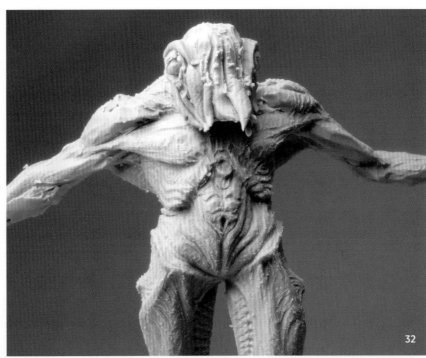

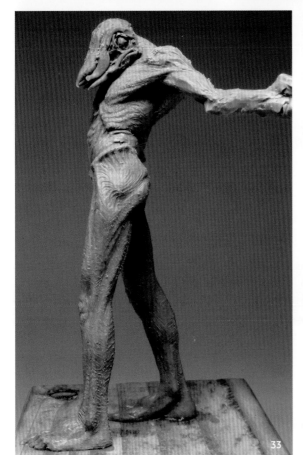

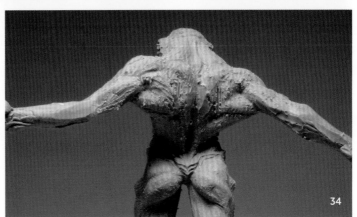

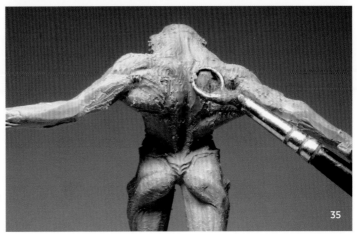

"EVERY TIME YOU FINISH A STEP ON A PART OF THE BODY, YOU SHOULD PREPARE THE TRANSITION WITH THE NEXT LIMBS"

36 Returning to the front of the character, continue to refine the design work on the ribs and abdomen. Design these areas with curves and counter-curves that match the shape of the primary volumes. You can see my finger in image 36, which gives you a sense of the scale of the character – the sculpture is not very big! Because of this small scale we have to proceed step by step and remain strict in order to not become lost in the process. You should no longer handle the sculpture with your fingers to avoid damaging your work; only hold it by the wooden base.

37 Once the secondary volumes are in place and the design is settled you can go further and begin to define tiny variations in the shapes with a small loop tool or tiny spatula. Focusing on the torso, create skin folds and transitions between the primary and secondary volumes. It is often interesting to leave the tool marks on the clay surface. If these tool marks are well placed they can create the beginning of textures, wrinkles, or interesting transitions that you can exploit later when detailing the skin.

38 The main forms are now looking good with areas of the back in highlight and other parts of the anatomy in shadow. You can now go into even more detail. The values of the muscle forms should help to direct the further work on the secondary volumes: for example note the oversized teres major, and the points at the top and bottom edge of the scapula which are now in deep shadow. Highlight the spine at the neck level with a small loop tool. The elements are also now in place for you to sculpt the connection between the back and arms. You can see in image 38 that I do this by refining the triceps.

39 Looking at the front again, work on the transition between the torso and arms. For instance, finish detailing the muscle striations in the pectoralis major and define the secondary volumes of the biceps, diving deeply into the armpit. Every time you finish a step on a part of the body, you should prepare the transition with the next limbs. Here you can therefore begin to finalize the volumes of the forearm.

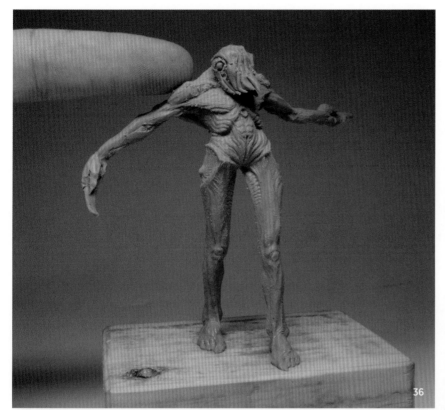

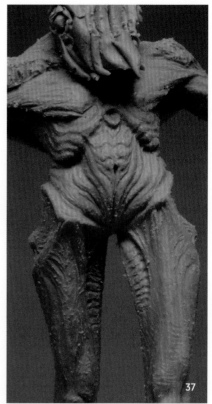

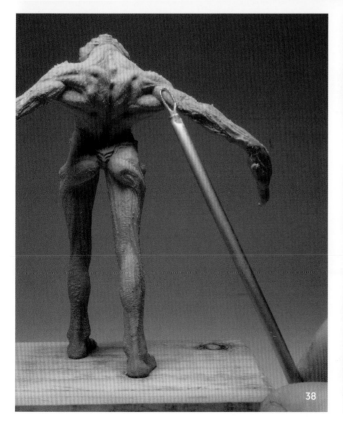

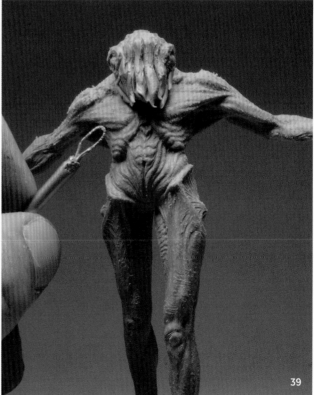

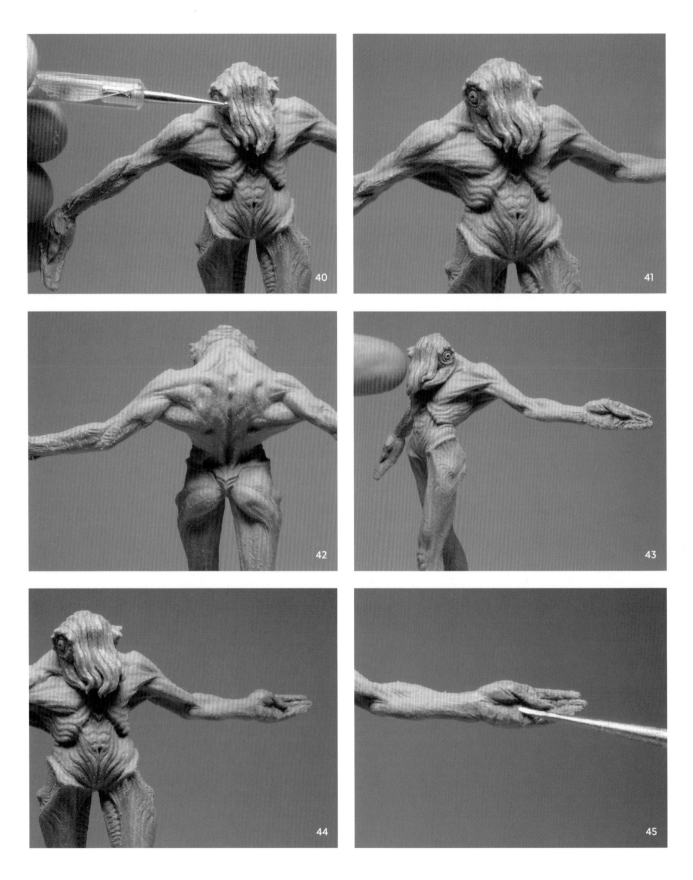

40 It is time to return to the head design. This character's features are mostly inspired by real squid heads. Having defined an overall round volume for the head, separate facial tentacles using a metal spatula. Then work with ball tools to create a wave effect in the tentacles in order to give them rhythm and to work on their symmetry. You can also use the ball tool to work on the eyes, which are surrounded by small growths.

41 The basic shape of the head is now established, so use a ball tool to finalize the different tentacles. When their general form is satisfactory, you can give a little more life and movement at the tip of each tentacle. With a spatula, separate one tentacle from another. Then use a ball tool or brush to slightly bend the tips in the desired direction.

42 Moving round to the back again, finish the work on the shoulders with a loop tool. Add tension to the skin above and below the triceps by using a medium-sized loop tool to make strokes in the direction of the muscle fibers. This creates the feeling that the skin is following the main muscle direction and tension. At this stage it is difficult to develop the details any further with loop tools, and the next layer of details will be made with small spatulas, needle tools, and brushes.

43 Turning the sculpture to the three-quarter view, begin working on the character's left hand. Working on the hands can be tricky because the armature continues only to the palm. As the fingers are not supported and fragile, you have to proceed very carefully.

Work at first with your finest spatula to separate the fingers and add the first forms. When working on the front of the hand, place your finger on the back to support the thin sheet of clay, or place your finger in front when working on the back of the hand.

44 Continue to detail the left arm, forearm, and the volumes of the left hand with a small loop tool. Focus this work particularly on the forearm to prepare the transition from the arm to the wrist. The work on the forearm will allow you to return to the hand and to detail the volumes of the wrist.

45 Your main reference when sculpting arms and hands are your own arms and hands. This work can be rather complex because the arm describes many movements and rotations. Take care to follow the underlying bone movements to avoid any mistakes. You can also continue to work on the hand itself, using your thinnest spatula. Make large wrinkles on the palm and gradually separate the fingers.

"KEEP IN MIND A GEOMETRIC APPROACH TO VOLUMES"

46 Move around to the back of the hand where you can begin to add details. Each finger should look like a sequence of elongated rectangles in the direction of the fingers, which corresponds to the knuckles. Even for details of this delicacy, keep in mind a geometric approach to volumes. Keep supporting the back of the hand with your finger as you work and remember to use your hands as reference.

47 Apart from the right arm, which still requires work, the main volumes of the sculpture are established. To finalize the shape of the eyes, create small protuberances around each one. The eyeball is delimited with a spatula and the shape of the squid pupil can be simulated with a fine needle tool.

TEXTURING THE CLAY SURFACE

48 Next you will need to clean and smooth the clay surface of the whole sculpture before adding the finer details and textures. This can essentially be done with a brush and turpentine. To smooth the sculpture gradually wash the figure with turpentine using a fine quality brush. Do not drown the sculpture in turpentine, as it is a powerful solvent. First soak the entire sculpture surface with a thin layer of it. This allows time for the solvent to mix with the clay surface. Make sure you are in a well-ventilated area when using the solvent. !

Then work over the sculpture zone by zone with the brush, and smooth the surface following the shapes of the primary and secondary forms. The purpose of this is to smooth out imperfections and play with the transitions to make them organic. Do not try to make the surface absolutely smooth; instead enjoy the small marks left by tools which can simulate the texture of the skin. You could occasionally tap the surface with the brush to create this texture.

49 After the initial surface smoothing is complete, you can take the skin texture further. I use a homemade tool consisting of two steel wires to do this. In fact these wires are guitar strings stretched and mounted on the handle of an old brush. When this tool is rubbed on the surface of the sculpture, the thin but rigid wires lightly mark the surface of the clay. The wires tremble slightly and their elasticity allows the tool to follow the volumes of the character's anatomy.

You can see in image 49 how the first smoothing looks on the upper leg and the left side of the character's chest. The surface is soaked with solvent so that the defects and tool marks turn into organic details. You must repeat the smoothing process several times in order to reach a truly organic result, as only carrying it out once means that the use of a tool is too obvious to appear organic. !

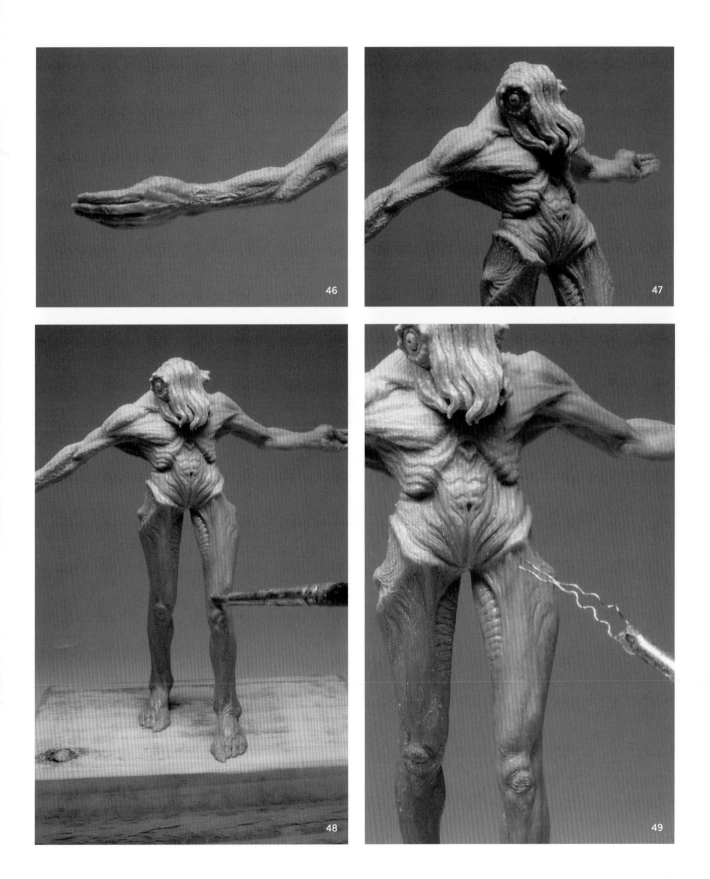

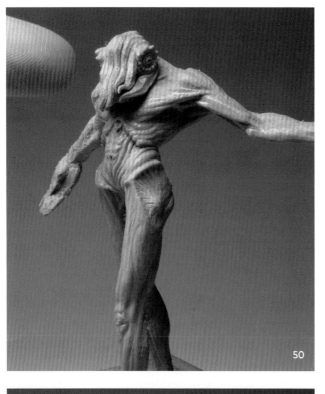

50

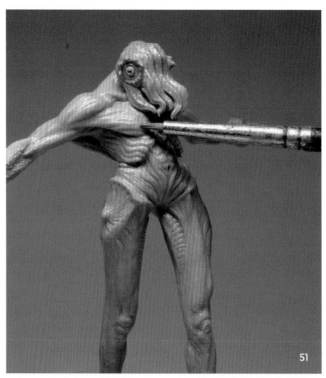

51

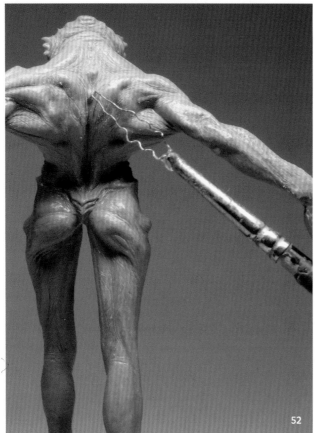

52

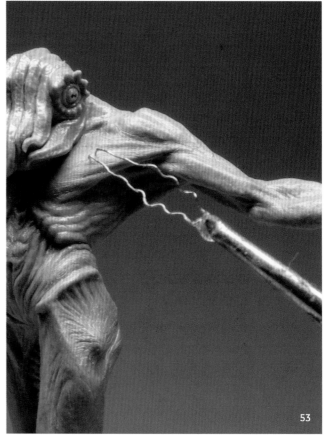

53

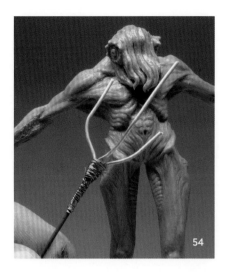

54

50 Repeat the texturing process several times in each zone of the body, crossing the tool marks to create a sense of direction in the skin wrinkles. To understand these skin folds, regularly look at reference images, such as portraits of elderly people from different ethnic groups and photographs of mammals, to give you an idea of how humanoid skin might wrinkle.

51 Continue smoothing the body with a brush and turpentine. Once you have streaked the surface of the skin to create wrinkles, be much gentler with the smoothing. These details fade very quickly on the slightly dissolved clay surface. In image 51 you can see the two consecutive steps: before the wrinkle work on the chest and forearms, and after the creation and smoothing of wrinkles on the upper legs and lower abdomen.

LEARN RULES BEFORE BREAKING THEM

This advice not only applies to sculpture but probably to all disciplines. It is particularly important in character and creature design to learn, understand, and appropriate rules and forms dictated by nature. The credibility of your characters or creatures is decided by the consistency of their forms and anatomy. So learn from nature and you will be able to use the same rules to create new forms.

52 Repeat the smoothing process on the upper body now. After the first stage of smoothing, work on texturing both the front and back with the wire tool. Follow each volume of the anatomy and the muscle contours as much

as you can to create credible locations for the skin wrinkles. The deepest and sharpest wrinkles are located where the skin is often compressed and folded during body movement.

53 Focus now on adding detail to the character's chest. Make wrinkles using the homemade wire tool again, following the general direction of the muscle fibers. Allow the tool marks to slightly cross and ensure that they are not entirely parallel to each other as these marks should look organic.

MAKING ACCESSORIES

54 With the main forms and skin texture in place it is time to begin making accessories for the character. Begin to build a trident for him to hold. This attribute is suitable for the character because it is a powerful weapon associated with the sea and symbolizes Poseidon, the god of the oceans. It suggests that he rules over a great underwater kingdom and helps to convey the concept of power. Firmly tie three strands of thin steel wire to the end of a brass rod with a thinner copper wire, in the same way that you created the armature.

55 Test the placing of the trident while it is still in the very early stages of development. If necessary adjust the size of the weapon so that it is relative to the size of the character. I want this trident to be deliberately elongated to stretch the view of the sculpture as a whole.

56 To embellish the prongs of the trident use a bicomponent epoxy putty called Milliput. Mix the epoxy for three or four minutes until the two components are mixed homogeneously. This putty is quite sticky so you can use it directly on the steel wire. It is advisable to use gloves when using the epoxy in order to avoid skin irritation; if you use your hands wash them thoroughly with soap and water afterwards. ❗

Apply a small amount of putty to one of the prongs with your hands. Then continue to wrap the putty around the wire with a Colour Shaper. The important task here is to add the putty all around the wire, making sure the wire is covered. Add more clay than you think you will need.

57 Rather than using the epoxy to secure the armature as you may have seen elsewhere in this book, we will use it as a sculpting material. The big advantage of Milliput putty is that it is possible to set it once the two components are mixed, and it becomes especially hard when it is dry. This putty is far easier to sculpt and sand when set than polymer clay. To maximize the drying, I often heat these pieces with a small heat gun, so the Milliput becomes as hard as a rock. ❗🔥

Once dry, use a Dremel tool and a round carving tool bit to carve the shapes you want in the Milliput. Because of this step you do not need to take particular caution with the shape of the accessory before drying; it is not a problem if you add excess material as the work is done primarily by carving and not by addition like with polymer clay. 🔥

CHARACTER DETAILS

58 Return to the skin and character details now to enhance the realism of the sculpture. For example there could be veins under the skin. To make veins, roll a fine clay tube with your fingers. Then place the clay tube where you want it with a brush.

It is easier to put very fine clay tubes on a surface previously dampened with turpentine. Turpentine allows the vein to bond to the surface and also allows it to melt in with the rest of the skin. Once the vein is set in the right direction you can make a wave effect like a real vein with the tip of a brush. You will note in image 58 I have removed the trident for now while I detail.

59 Continue to detail the character by adding nipples. You can do this by superimposing two small volumes of clay that are melted with turpentine. For this type of detail work I often use polymer clay as a completely dissolved, almost liquid material. Mix the clay with turpentine using a metal spatula until you achieve a creamy clay. Then add the almost liquid clay with the tip of your brush. You can add extremely fine details on the skin with this technique to create a series of small aligned dots. ❗

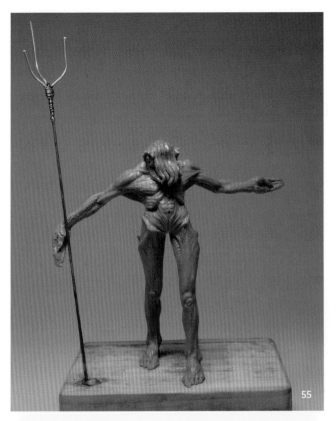

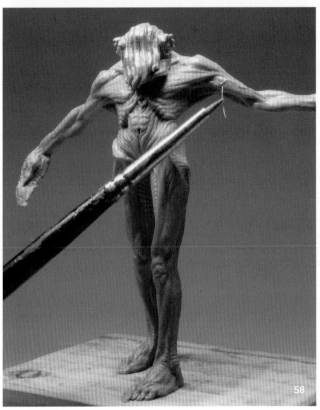

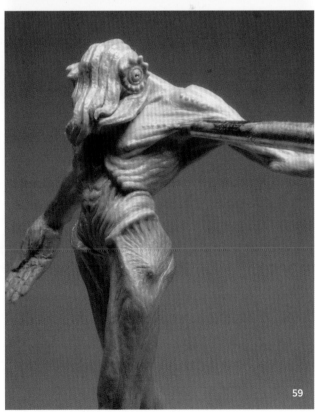

60 Apply the method of liquid-clay additions to different parts of the body such as the chest and shoulders, and also throughout the iliac crest and on the tentacles. It would take hours to achieve this kind of texture by working with the unaltered clay. By mixing it with turpentine you can quickly and precisely control the number and regularity of your additions and the appearance of the skin texture.

DETAILING THE HANDS

61 By this step you have completed a lot of the detail work. Most areas are smooth, and much of the skin texture is complete. However, the character's hands still lack detail. Work now on the forms of the character's left hand. Use a combination of a thin spatula, curved needle tool, and very fine ball tool to define the fingers and skin folds. When you are happy with the forms, smooth the hand with turpentine as you did with the other body parts. ❗

62 Use the same tools to shape the character's right hand now, in the same way as the left. Separate the fingers and joints with the spatula while remembering to support them from behind because they do not contain an armature. Smooth the hand with turpentine as before. ❗

63 Place the trident back in the character's right hand to check that the entire sculpture is coherent. The position of the trident in the hand is still not final. For now sculpt the thumb resting on the palm, but when the hand is finished you can lift the thumb from the palm to slide the trident underneath as in the next step.

64 After completing the hand, gently lift the thumb off the palm with a thin spatula. This way you can drag the handle of the trident between the palm and thumb. The character will now be able to carry the trident theatrically, as in a parade.

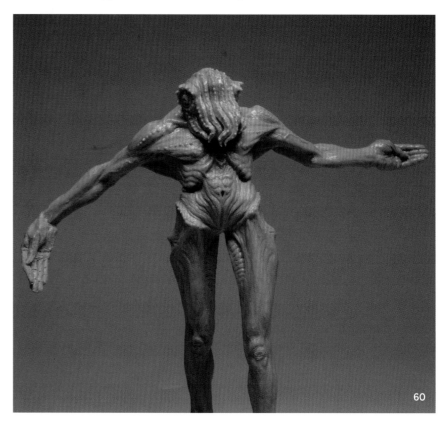

60

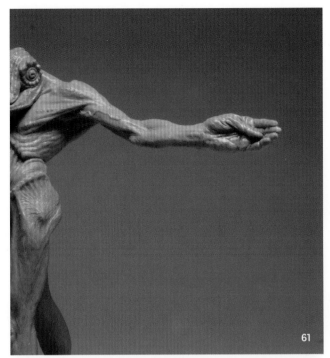

61

62

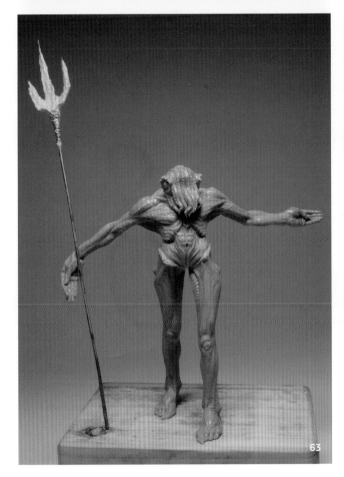

63

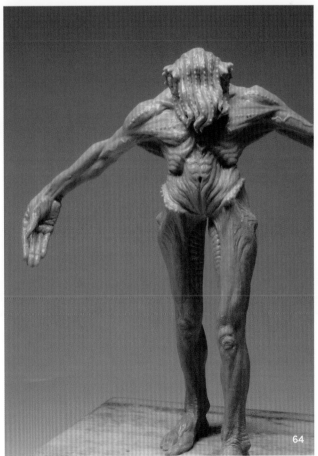

64

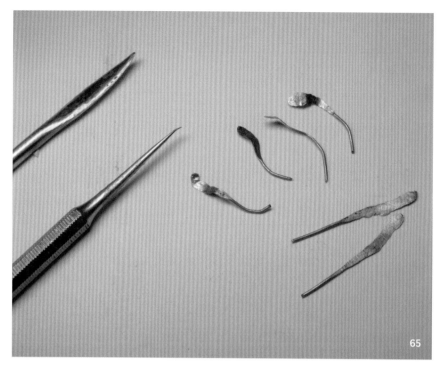

65

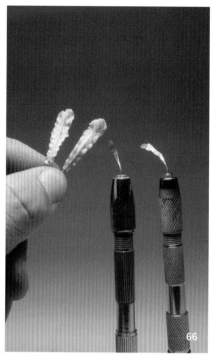

66

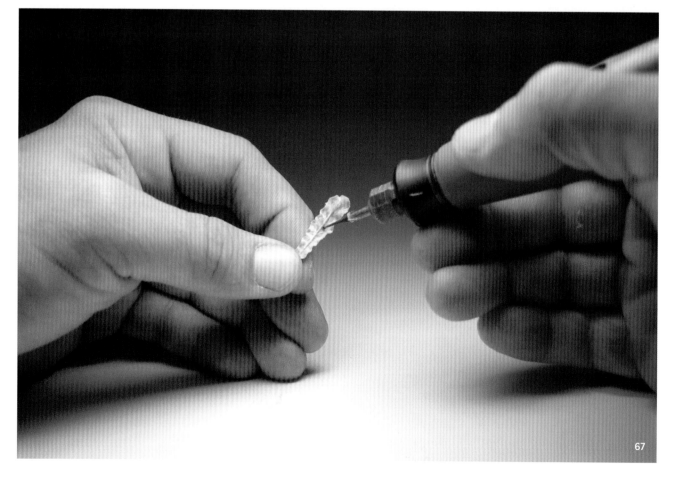

67

ADDING CONTEXT

65 You can also create a base and some contextualization elements for this character. Begin to make seaweed spare parts to add to the base on which the character will stand. To start, cut small pieces of wire and smash one end with a hammer, taking care to ensure your fingers are positioned away from where the hammer will strike. The top of the wire is very thin, yet rigid, and will serve as a perfect armature to add epoxy to. Try to bend a ripple in the wire to simulate the movement of seaweed floating in the water.

66 The advantage of producing very thin armatures with these small pieces of wire is that you can work on each piece independently. Attach each piece of seaweed to a support (such as the miniature drill bit holders shown in image 66) and add a layer of epoxy putty on both sides of the small armature.

After about twenty minutes the putty will start to harden, but for now it is malleable and not sticky. It is the perfect texture with which to refine the edge of the sheet and create ripples on the external border of the seaweed. If the sheet is imperfect it does not matter because you can rework the shape once the putty has hardened.

67 When the seaweed leaves have dried slightly, harden them using a heat gun. Then correct any defects with a small Dremel tool. To refine the thickness of the sheet highlight the central rib by indenting either side of the small armature wire. Create streaks to reinforce the movement of waves on the external border. When working with dry putty you should wear a mask because epoxy dust can be harmful if inhaled.

FIRING THE SCULPTURE

68 The sculpture is nearing completion, but it will need to be fired before it can be finished so now is a good point to review your work. The character looks like an underwater king; his posture is intentionally theatrical with his arms outstretched. The positioning of the character's right hand reminds me of poses found in Leonardo da Vinci's paintings or religious iconography of the Middle Ages. The placement of the squid eyes suggests the character is attentive to the slightest movement and there is a sense of power in the well-developed swimmer muscles. This is what we wanted to achieve: a powerful-looking emperor.

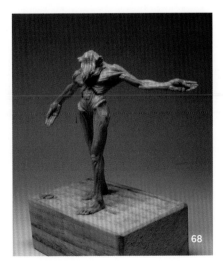

69 After a final check, the character is ready to be fired. Super Sculpey and other polymer clays can be fired at low temperatures (between 110 and 130 degrees Celsius) in a standard household oven. However, if you regularly fire polymer clays I urge you to buy a furnace dedicated for this use only. Do not breathe the fumes when cooking because any harmful solvents used on the sculpture will be vaporized. The longer you fire the clay the harder it becomes. Fire your sculpture for half an hour. There should be no visible shrinkage. 🔥⚠️

If you want to increase the strength of your sculpture (especially if you have to cut the character in separate parts for casting) you could make a mixture of Fimo and Super Sculpey to sculpt with. Fimo is a pliable type of polymer clay known for its ability to capture fine details, which can be a difficult task when using the softer Super Sculpey clay. Mix about one or two parts Fimo into the Super Sculpey.

70 The character is now cooked but upon reflection you may think the character needs another element in the design to break up the very human aspect of the alien body. To resolve this add some characteristic squid fringes to the character's arms, which can be used to propel the character like fins. To do this, create a tube of epoxy putty to place under the arm. Apply the clay tube with a ball tool, then narrow its border and make it undulate in the same way you created the sheets of seaweed for the base. This small element will make the design even more specific to an aquatic environment.

71 Check that you are satisfied with the look of the finishes and the cooked character as a whole. Areas that appear a bit brown will have been heated a little more in the furnace but they should not have modified the surface nor deformed the clay. Even the character's right thumb, which does not contain an armature, should not have moved during the cooking process. Now the sculpture is quite stiff so you can drag the handle of the trident between the palm and the thumb.

CHANGING THE BASE

72 You now need to remove the sculpture from its base without breaking it, which requires some delicacy. You cannot simply pull or force the legs from the base because Super Sculpey is not strong enough, especially for a small sculpture like this one. I prefer to use a diamond cutter on a Dremel tool to dig around the attachment points of the base to clear the sculpture, as shown in image 72.

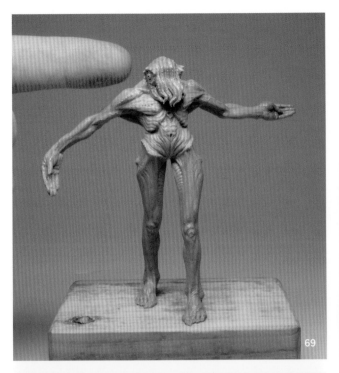

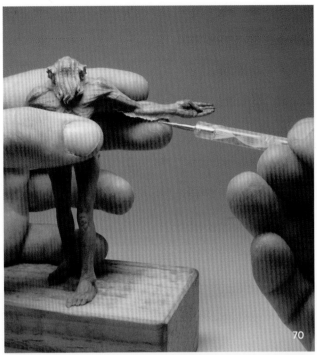

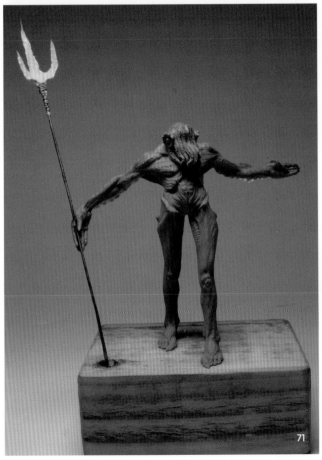

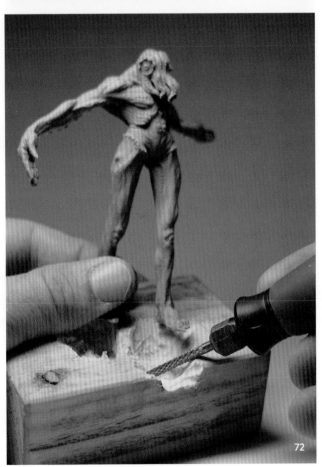

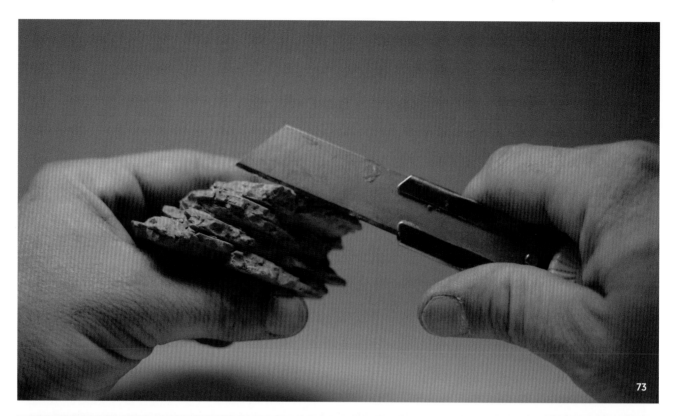

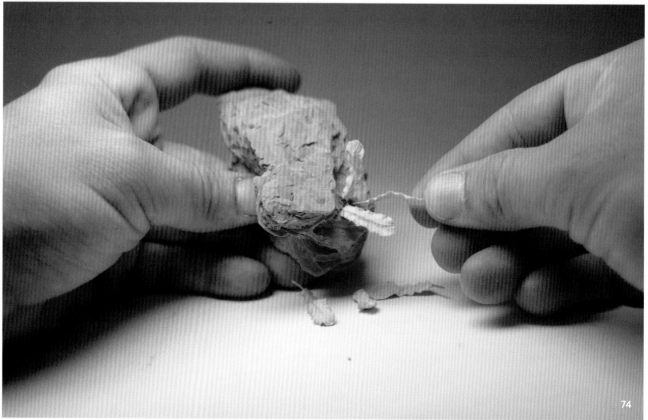

"THE TEXTURE OF THE BROKEN CLAY IS REALLY VERY SIMILAR TO THAT OF LIMESTONE"

73 We need to create a new base that is more appropriate for the character. A rock would be good for this – a kind of underwater promontory where the character will watch over his aquatic kingdom and subjects.

Take a big block of polymer clay and knead it before putting it in an oven to bake at 110 degrees Celsius. Stop cooking after about 10–15 minutes. The clay will be more solid, but still very fragile because the cooking is not really complete. With a knife, cut the block to create horizontal layers in the rock. Break off as many small parts as possible to create fresh fractures without tool marks. The texture of the broken clay is really very similar to that of limestone.

74 Finalize the base, taking care to break the entire surface of the initial block of clay, and remove all signs of fingerprints and tool marks. With the Dremel tool drill small holes to insert seaweed leaves. You can make the leaves using the same method used in steps 65–67.

75 The final step is to fix the character to the surface of the base and smooth the surface with a knife. At first my base is not wide enough and tilted too far back. To correct this problem you can add fresh clay directly on the base and fire it again. Recreate the stone texture on the base with the knife until you find the right width and proper inclination for the feet of the character.

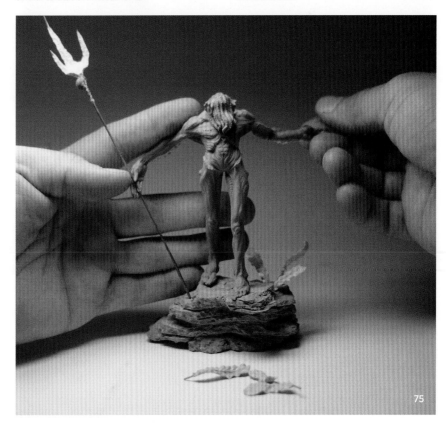

75

239

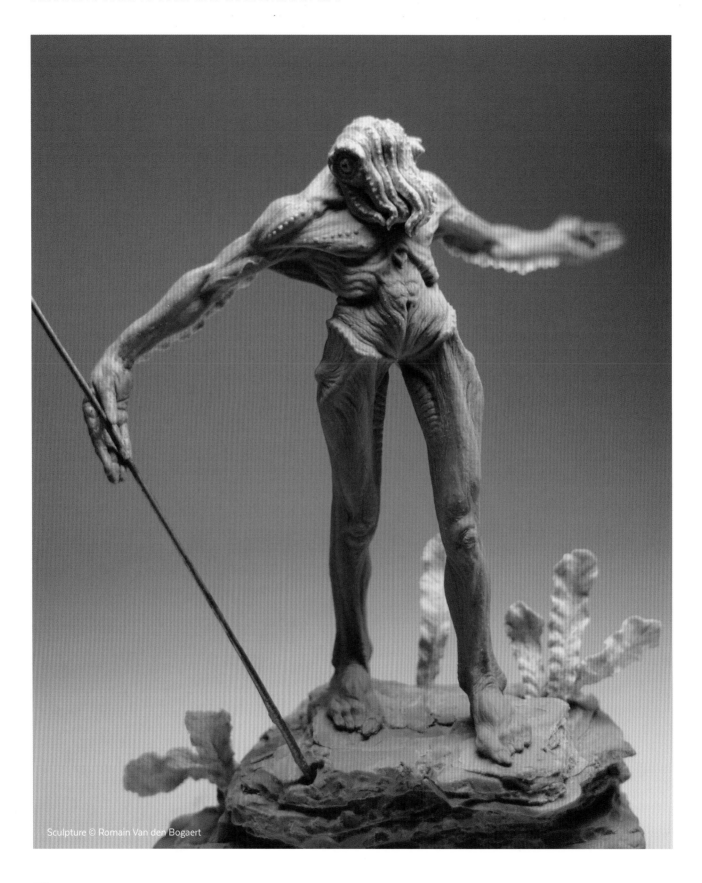

Sculpture © Romain Van den Bogaert

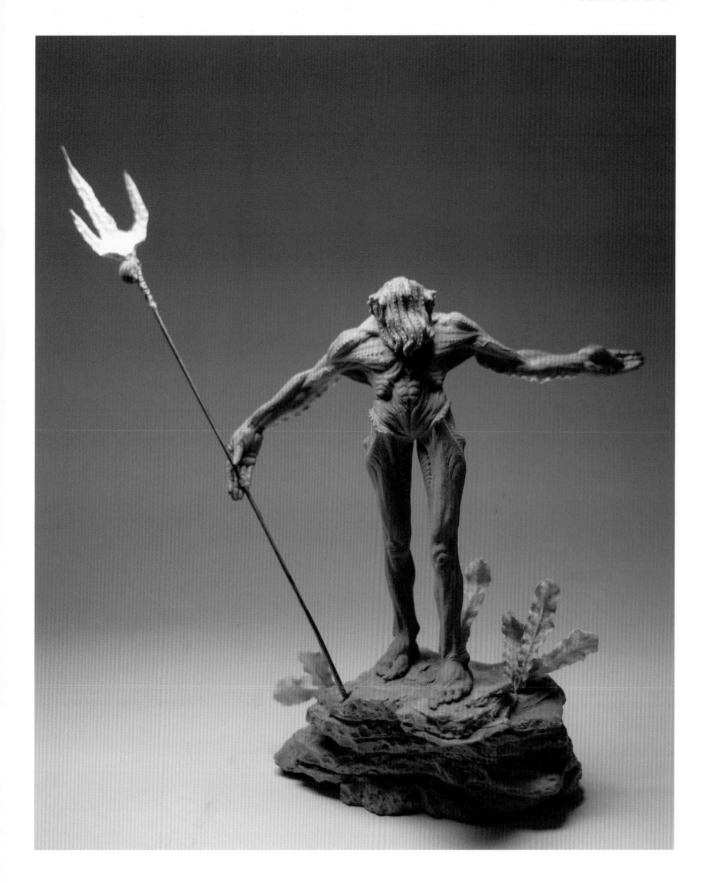

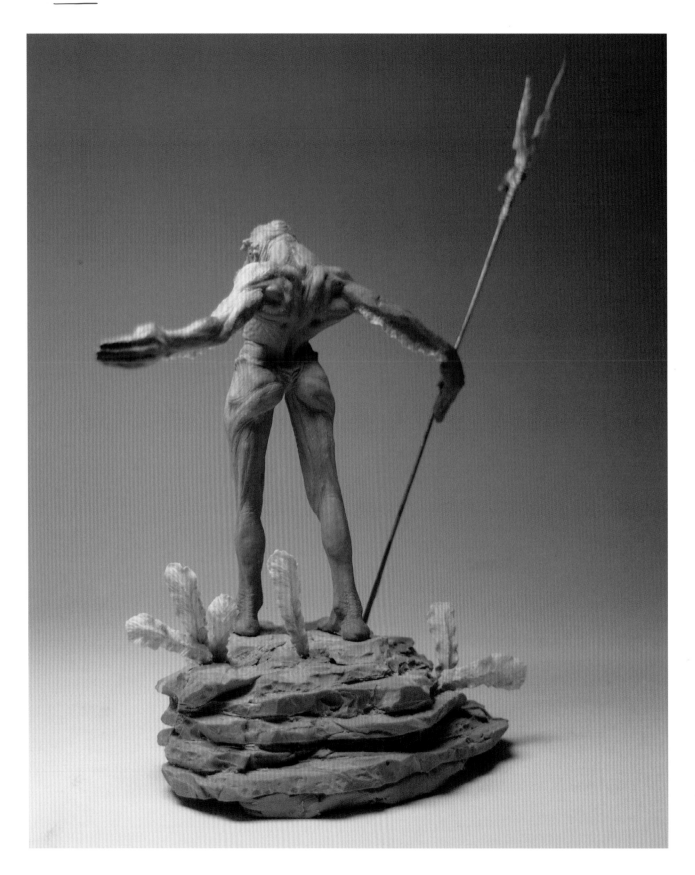

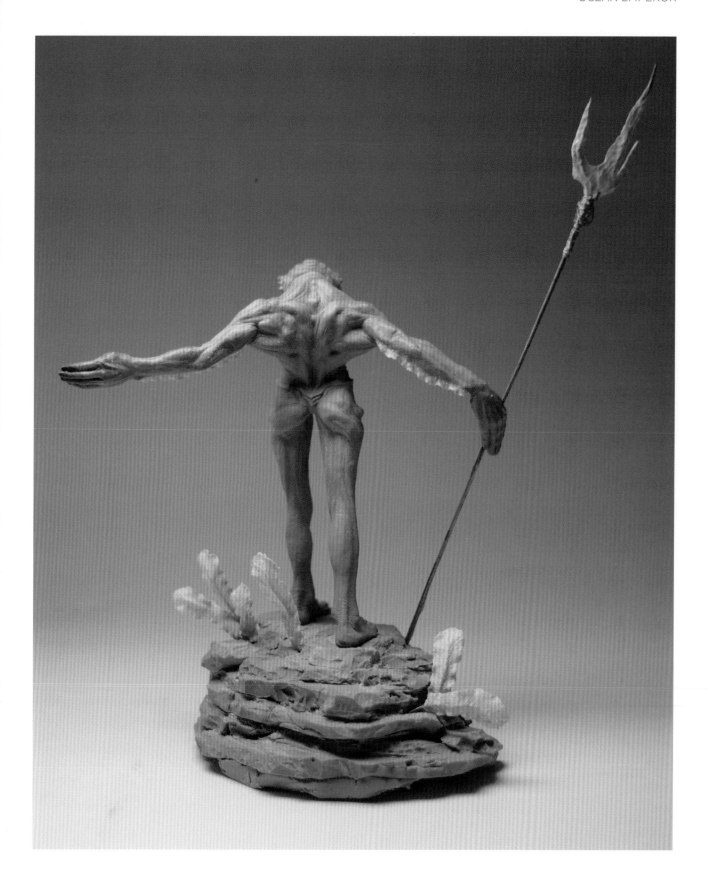

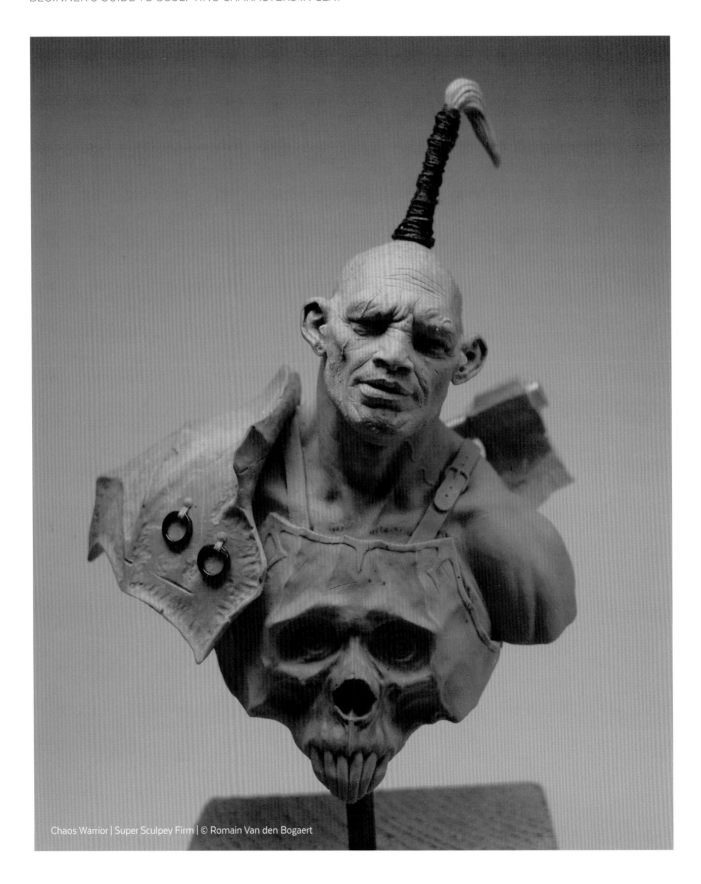

Chaos Warrior | Super Sculpey Firm | © Romain Van den Bogaert

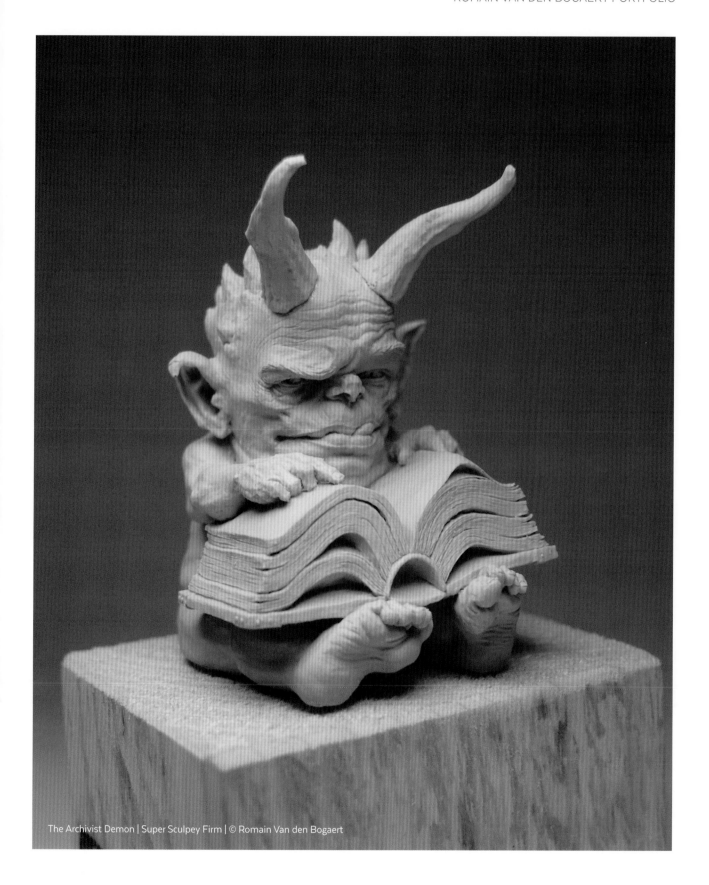

The Archivist Demon | Super Sculpey Firm | © Romain Van den Bogaert

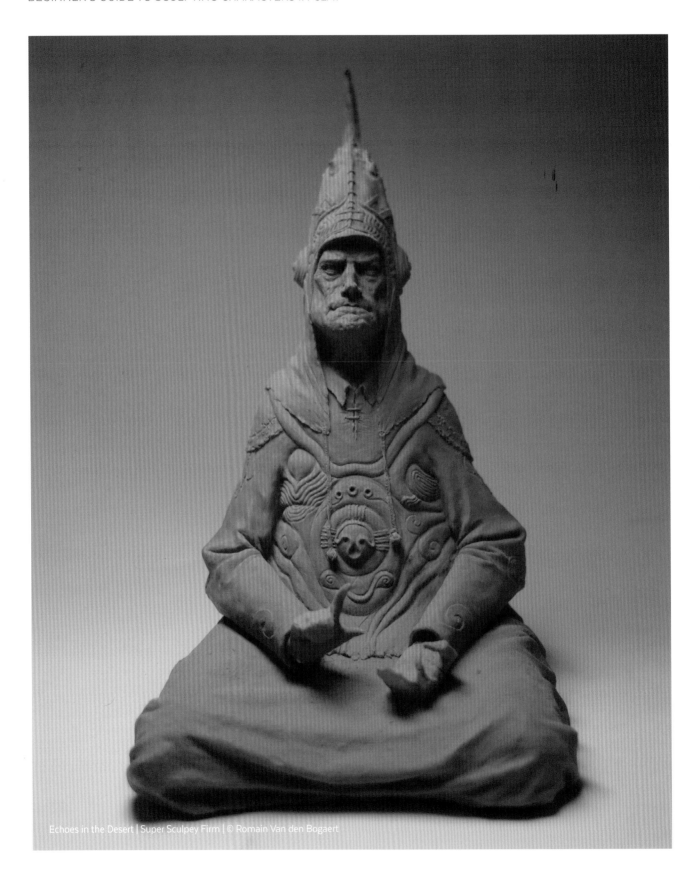

Echoes in the Desert | Super Sculpey Firm | © Romain Van den Bogaert

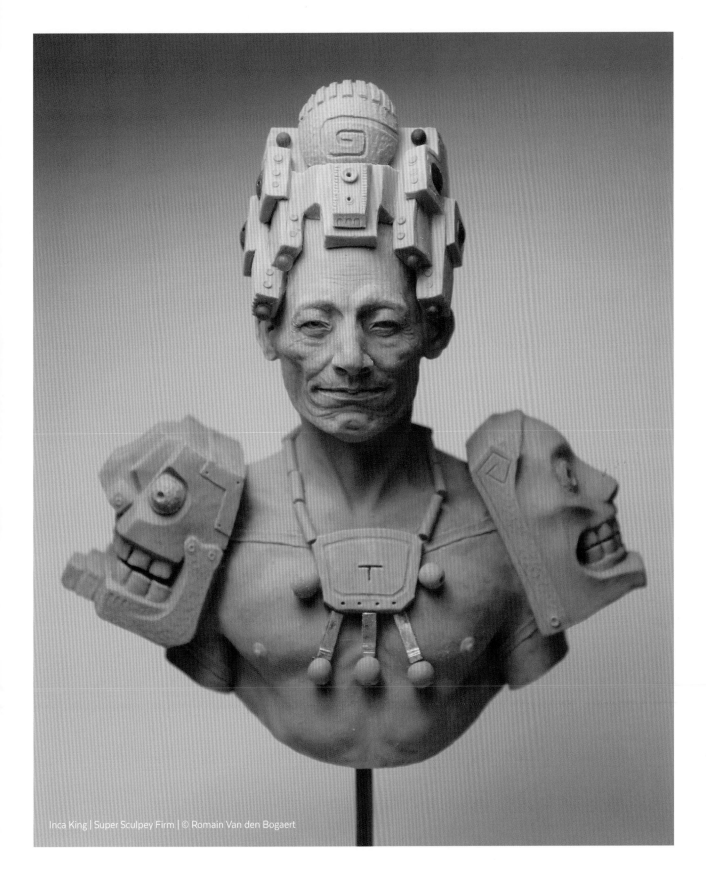

Inca King | Super Sculpey Firm | © Romain Van den Bogaert

GLOSSARY

ARMATURE

A basic, skeleton-like support structure for a sculpture. Clay is added to the armature in the preliminary stages of the sculpting process.

BASE/MOUNT

The structure on which a sculpture stands. The sculpture's armature will often be secured to the mount or base to make the sculpture stable and to ensure that it will balance on a flat surface.

BLENDING

The act of merging separate volumes of material together to create a smooth, unified surface.

BLOCKING

Using rough, generalized forms to quickly create the basic shape of an object before the forms are refined or detailed.

BURNISHING

A process of making a material surface smooth or shiny, usually by rubbing the surface to compact the material.

BUST

A sculpture that focuses only on the head and upper body of a character. Busts usually incorporate the character's head, shoulders, and chest.

CARVING

Digging into a material with a tool or finger to reshape the forms or make distinct marks.

CLAY BODY

The main volume of clay used to create the sculpture.

CLEANING

The process of removing excess material from the surface of a sculpture using a combination of tools and solvents. Cleaning creates a clear surface for you to continue sculpting.

CONCEPT ART

A painting, drawing, or sketch of the character or object to be sculpted. The concept art should be referenced throughout the sculpting process.

CONTRAPPOSTO

A traditional, balanced pose where the figure's weight rests on one leg and the other leg is outstretched for stabilization. The hip and shoulders automatically tilt away from each other in this pose.

CURING

Allowing soft or liquid material to harden. Curing usually occurs by air-drying and can take time. Some clays will not cure as they are designed to stay soft.

DENSITY

The level of firmness of a material. Density is sometimes referred to as a material's "grade."

ÉCORCHÉ

An anatomical depiction of the human body where the skin has been removed so that the musculature below is exposed.

FIRING

Setting or "cooking" a completed sculpture by exposing it to a high heat in an oven or kiln. This process is not suitable for all types of clay.

FORMS

Shapes that are indicative of the structure they are supposed to represent. For complex structures, such as the human head, multiple different sizes and shapes are needed. Forms should generally be rough at first, then gradually refined.

HARD SURFACE

The texture and finish of a rigid material such as metal or formed plastic. As hard surfaces often react differently to other textures (for example polished metal is highly reflective but skin or cloth is generally matte) they can require different sculpting techniques to replicate.

KILN

A specialist oven or furnace used to fire sculptures. Kilns can reach considerably higher temperatures than conventional ovens.

LANDMARKS

Marks used to signify key anatomical points on the body, sometimes called "bony landmarks." These marks act as useful guides to ensure your sculpture is anatomically correct.

LINE OF ACTION

The intangible flow of force through a moving body or object. Identifying a line of action in a character's pose can improve the dynamism of the sculpture.

MAQUETTE

A small preliminary model of the intended sculpture.

MATTE

A surface which reflects little or no light, and therefore does not have a shine.

MODELING

The act of shaping materials using tools and hands.

POSE

The stance of the character or the positioning of the character's limbs. The pose can be used to imply the character's personality or an activity the character is engaged in.

PRIMARY FORMS

The basic initial shapes of a sculpture. Primary forms are generally created during the blocking-in phase of the sculpting process.

RAKING

The act of driving an indented tool across the surface of a material to create lines or small troughs in the surface. Raking is often used as part of the surface cleaning process where excess material is removed by the teeth of the rake tool.

REFERENCES

A collection of images or objects that can be used as technical guides when sculpting. References can be used for anything from character design and anatomy to textures and accurate lighting.

ROUGHING OUT

The act of making rough forms or marks to be used as a guide or practice for more refined details later in the sculpting process

SECONDARY FORMS

Refined shapes, which are built on top of the primary forms. These forms usually lack detail but break down the main volumes of a sculpture into more accurate, defined sections.

SET

When a material has been allowed to dry or cure into a hardened state. This can be done by air-drying or firing depending on the type of material.

SCALE

The proportional ratio of the sculpture's measurements in relation to the measurements of the character or object it represents

SCULPTING MEDIUM

The main material used to create a sculpture.

SMOOTHING

The process of making the surface of a material flat and even. Depending on the intricacy required this can be done with tools such as kidney shapes, rakes, and sometimes with the use of solvents.

SOFTBOX

A lighting device used in photography to diffuse light and reduce shadows. A softbox is a useful tool if you need to create professional photographs of your sculptures.

TEXTURING

The act of displacing material, either with tools or fingers, to create an uneven surface. Texturing is used to differentiate between different surfaces on a sculpture and add realism.

THREE-QUARTER VIEW

Observing an image or object from an angle where one quarter of the object is turned away. Generally this view is mid-way between the front and side view.

T-POSE

A classic pose often used in anatomical references where both legs are directly below the character's body and the arms are held out stretched at a right angle to the torso.

VALUES

The apparent contrast between different forms when an object is lit.

VOLUMES

A mass of material, or a collection of smaller forms.

RECOMMENDED RESOURCES

READING

Bridgman, George. *Bridgman's Complete Guide to Drawing from Life*. New edition. New York: Sterling, 2009.

Hogarth, Burne. *Dynamic Anatomy*. New York: Watson-Guptill, 1958.

Hogarth, Burne. *Drawing the Human Head*. New York: Watson-Guptill, 1965.

Hogarth, Burne. *Dynamic Figure Drawing*. New York: Watson-Guptill, 1970.

3dtotal Publishing, ed. *Anatomy for 3D Artists*. Worcester, UK: 3dtotal Publishing, 2015.

3dtotal Publishing, ed. *The Artist's Guide to the Anatomy of the Human Head*. Worcester, UK: 3dtotal Publishing, 2017.

www.paulekman.com

ANATOMICAL REFERENCE FIGURES

Male and female écorché, nude, planar, and half-and-half anatomy reference figures from 3dtotal.com Ltd. Available from **shop.3dtotal.com**

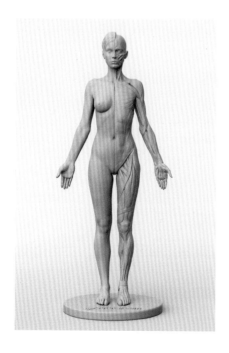
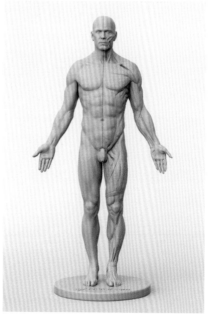
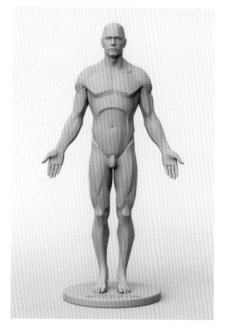

CONTRIBUTORS

JENNIFER HENDRICH

Sculptor

jenniferhendrich.com

ALFRED PAREDES

Sculptor

apsculpturestudio.com

SEAN KYLE

Sculptor and concept artist

seankb.artstation.com

ALEXANDER RAY

Sculptor

cainepro.com

GLAUCO LONGHI

Senior Character Artist at Sony Santa Monica Studio

glaucolonghi.com

THE SHIFLETT BROTHERS

Sculptors

shiflettbrothers.com

DJORDJE NAGULOV

Modeler

artstation.com/artist/nagulov

ROMAIN VAN DEN BOGAERT

Sculptor and character designer

romainvandenbogaert.com

INDEX

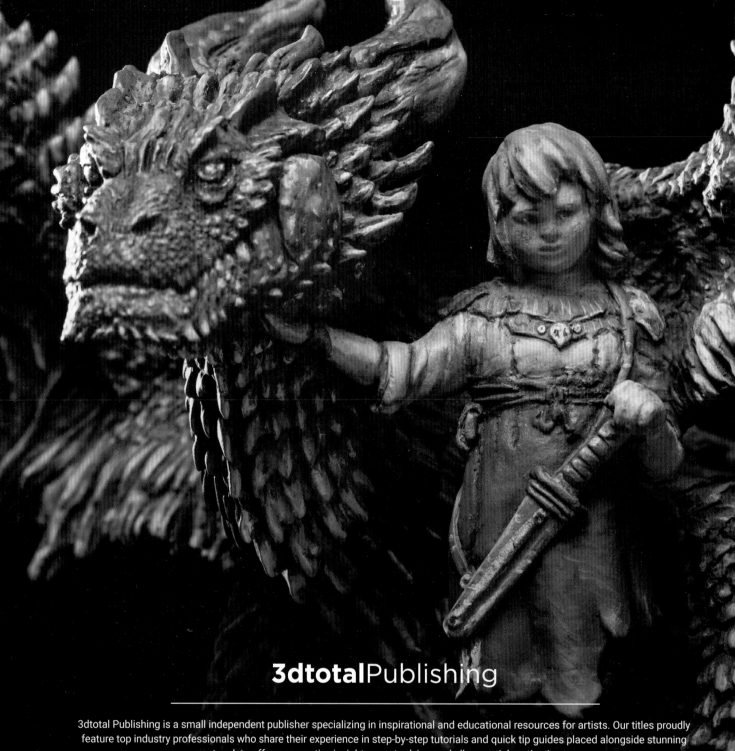

3dtotalPublishing

3dtotal Publishing is a small independent publisher specializing in inspirational and educational resources for artists. Our titles proudly feature top industry professionals who share their experience in step-by-step tutorials and quick tip guides placed alongside stunning artwork to offer you creative insight, expert advice, and all-essential motivation.

Initially focusing on the digital art world, with comprehensive volumes covering Adobe Photoshop, Pixologic's ZBrush, Autodesk Maya, and Autodesk 3ds Max, we have since expanded to offer the same level of quality training to traditional artists. Including the popular *Digital Painting Techniques*, *Beginner's Guide*, and *Sketching from the Imagination* series, our library is now comprised of over forty titles, a number of which have been translated into different languages around the world.

3dtotal Publishing is an offspring of 3dtotal.com, a leading website for CG artists founded by Tom Greenway in 1999.

3dtotalpublishing.com | 3dtotal.com | shop.3dtotal.com